UP IN THE

Derek Jarman – painter, theatre designer and film-maker – held his first one man show at the Lisson Gallery in 1969. He designed sets and costumes for the theatre (*Jazz Calendar* with Frederick Ashton and *Don Giovanni* at the Coliseum). He was production designer for Ken Russell's films *The Devils* and *Savage Messiah*, during which time he worked on his own films in Super 8 before making his features: *Sebastiane* (1975), *Jubilee* (1977) and *The Tempest* (1979). From 1980 he returned to painting (a show at the ICA) and design (*The Rake's Progress* with Ken Russell in Florence), and made the films *Caravaggio* (1986), *The Last of England* (1987), *War Requiem* (1988), *The Garden* (1990), *Edward II* (1991), *Wittgenstein* (1992) and *Blue* (1993). His books include: *Dancing Ledge* (1984), *The Last of England* (1987; now republished by Vintage under the title the author intended for it, *Kicking the Pricks*), *Modern Nature* (1991), *At Your Own Risk* (1992) and *Chroma* (1994). Derek Jarman died in February 1994.

BY DEREK JARMAN

Derek Jarman

UP IN THE AIR
Collected Film Scripts

WITH AN INTRODUCTION BY MICHAEL O'PRAY

VINTAGE

Published by Vintage 1996

2 4 6 8 10 9 7 5 3 1

First published in Great Britain by
Vintage, 1996

Vintage
Random House, 20 Vauxhall Bridge Road, London SW1V 2SA

Random House Australia (Pty) Limited
20 Alfred Street, Milsons Point, Sydney
New South Wales 2061, Australia

Random House New Zealand Limited
18 Poland Road, Glenfield,
Auckland 10, New Zealand

Random House South Africa (Pty) Limited
PO Box 337, Bergvlei, South Africa

Random House UK Limited Reg. No. 954009

A CIP catalogue record for this book
is available from the British Library

ISBN 0099302268

Typeset by Deltatype Ltd, Ellesmere Port, Cheshire
Printed and bound in Great Britain by
The Guernsey Press Co. Ltd., Guernsey, Channel Islands

CONTENTS

INTRODUCTION

Michael O'Pray

Up in the Air contains the major unrealised film scripts Derek Jarman wrote between 1976 and 1987, and also the script of *Jubilee*, which was made in 1978 but, unlike his other dialogue films, has never before been published. The failure of these brilliant scripts to reach the screen was due not only to Jarman's reputation for making provocative films but also to the economic plight the British film industry found itself in after the late 1960s.

It is true to say that, for Jarman, scripts were never simply means to ends. They were always intensely personal writings that expressed strong beliefs and emotions. When they failed to materialise as films, they were not shelved and forgotten. They remained as projections of his inner world. They always seemed to have a life for him, to be part of himself, and I suspect it was painful for him to leave them behind. For this reason I believe, Jarman wanted them to be published. He saw it as one of his final acts. He was also a great pillager of his own work, so that images, scenes and moods found in these scripts were incorporated into his realised films. One of the fascinations of this volume is seeing this process at work.

From 1970 until his death in 1994, Jarman made scores of films. This enormous output can be divided very roughly into three broad categories. In the first are the feature films upon which his reputation rests – *Sebastiane* (1976); *Jubilee* (1978); *The Tempest* (1979); *Caravaggio* (1986); *The Last of England* (1987); *War Requiem* (1989); *The Garden* (1990); *Edward II* (1991); *Wittgenstein* (1992) and *Blue* (1993). The second includes films which were more anti-narrative in form and often not full-feature length – *In the Shadow of the Sun* (1974–80); *Imagining October* (1984) and *The Angelic Conversation* (1985). The third comprises the many short Super 8 films which include *The Art of Mirrors* (1973), *Gerald's Film* (1976) but also his music videos, especially those done for Marianne Faithfull, The Smiths and the Pet Shop Boys, and other films like the

vii

sequence for Don Boyd's portmanteau film *Aria* (1987), his collabora-
tive film *The Dream Machine* (with Cerith Wyn Evans, John Maybury
and Michael Kostiff, 1984) and the Super 8 compilation *Glitterbug*
(1994).

Jarman's film scripts were nearly always written with the strong
literary quality we have come to know through his autobiographical
writings such as *Dancing Ledge* and *Modern Nature*. He had the
ability to evoke scenes through the power of language. His scene
instructions are studded with ideas and references revealing how he
understood a particular scene's meaning and context. In *Jubilee*, for
instance, he titles scene 9 'H.Q. Healey's Budget Strategy in Ruins',
suggesting that the film's depiction of social collapse had some basis in
the chaos of the late 1970s when Callaghan's Labour Government
collapsed.

The British film industry has been in massive decline over much of
the past thirty years and, like many film directors in this country,
Jarman had a never-ending struggle to gain financial backing. In his
case this was frequently exacerbated by the often transgressive nature
of his films, which frightened off many potential Wardour Street
backers. Jarman's first foray into feature film-making, with *Sebastiane*
in 1976, happened at a time when the most talented British film-
makers like Ken Russell, John Boorman and Nicholas Roeg had
already left for America in search of financing.

Against all odds, Jarman managed to raise funds from friends to
make his first three feature films, which established him as a *bête noir*,
assuming the mantle of his mentor Ken Russell. As Jarman readily
admitted, he made Super 8 films and videos not only because he liked
the artistic freedom they gave him, but also because he had had no
choice for many years, especially between the release of *The Tempest*
in 1979 and the making of *Caravaggio* in 1986, during which time he
was starved of backing. It is therefore no accident that three of the
scripts in this volume were written during this period. It was his anger
at this situation and his producer Nicholas Ward Jackson's prompting
which in 1982 led him to write his first book, *Dancing Ledge*, which is
not only a wonderfully irreverent and entertaining autobiography but
also a deeply felt broadside at the British film industry. It is against this
background that these scripts should be read.

Akenaten was one of Jarman's first major projects, along with his
scripts for *Sebastiane, Dr Dee* (which became *Jubilee*) and *The
Tempest*. All these scripts were intended as possible feature-length
films with a larger budget than the odd pounds he could afford for the
Super 8 films he had been making since 1971. The final draft of
Akenaten published here was probably prepared while he was

INTRODUCTION

working on *Sebastiane*, although he had already planned a project on the infamous Egyptian dynasty before he met *Sebastiane*'s producer, James Whaley, in January 1975.[1] Unlike the other scripts, *Akenaten* 'remained as a gilded book with beautiful watercolours'.[2] The bloody and incest-ridden story of the Egyptian dynasty is the first of many films in which Jarman traces powerful figures – and sometimes families – as the embodiments of corruption and terrible powers. In *Akenaten*, he is not concerned to create an allegory for modern times as he was to be with, say, *Jubilee, The Tempest, Caravaggio, Edward II, The Last of England, War Requiem* and *Wittgenstein*, all of which have at their core varying forms of the ruling classes or elites. On the contrary, he is interested in *Akenaten*'s mythical proportions, its luxuriant exoticism and strong sexual themes.

While he was at work on *Akenaten* Jarman was still wrestling with his ambitious Super 8 film *In the Shadow of the Sun* which contained a sequence where 'an Egyptian pharaoh materialises in the surf', while the short Super 8 film, *The Gardens of Luxor*, may, under its original title of *In the Shadow of the Sun: Akenaten and Tutankhamun*, be seen as an earlier version of *Akenaten*. At a time when there was much interest in obscure religions and periods of history, Ancient Egypt was in any case a topic of fascination not only to Jarman, but to the general public. The hugely successful Tutankhamun exhibition had travelled to the British Museum in London in 1972, and the influential American underground film-maker Kenneth Anger had shot segments of *Lucifer Rising* with Marianne Faithfull in Egypt in the early 1970s.

From the script we can glean that *Akenaten* was to have a visual style akin to the opening sequence of *Sebastiane* with its bold but exotic depiction of Diocletian's party-cum-orgy. Jarman's notes to *Akenaten* reveal that he knew the budget would be low and on this basis decided to avoid narrative costumes – 'just shaved heads'. Later he relents and says that the costumes should be 'very simple white dresses, gold ornaments, no HOLLYWOOD RAZZMATAZZ'. This very early script clearly shows the importance that stage design and costumes had for Jarman. He would often in the future deploy a particular piece of clothing, or a physical attribute to symbolise character and narrative meaning. Jarman disliked the neurotically painstaking attempts at so-called 'authenticity' endemic to much British drama set in the past.

Jubilee was shot in 1977 in the hope that it would be ready for that year's Jubilee celebrations. As it turned out, it was released the year after. A prophetic film, it also sets Jarman's agenda – the critique of

[1] *Dancing Ledge* p.140
[2] Ibid, p.163

contemporary times through a vivacious merging of history with both the present and the future. Like Walter Benjamin's angel of history, the film gazes back into the past from the standpoint of contemporary England and then proceeds to create an image of the future. A grim comedy, *Jubilee* was inspired by the burgeoning punk movement of 1976 to which Jarman had direct access, and by his fascination with the 16th-century Elizabethan alchemist John Dee. With its marriage of these two aspects it seemed symbolically appropriate for the Jubilee celebrations of the second Elizabethan queen.

After the release of *The Tempest* in 1979 Jarman entered a long period in which he survived on making pop videos and doing design work with Ken Russell returning again to the Super 8 and beginning to use video. He also 'embarked on *Neutron, Caravaggio* and *Bob-Up-A-Down* with a variety of young collaborators who wanted to learn film'.[1] *Bob-Up-A-Down* was a collaboration with Tim Sullivan. In September 1981, he remarks that he started the 'medieval allegory' years before and related it to the *Roman de la Rose* but 'based on Julian of Norwich and Richard Rolle'. In the same month, he travelled to Granada Television in Manchester to rework the screenplay with Sullivan.

Jarman rather unfairly calls *Bob-Up-A-Down* a 'worthy' film, belying the brilliant screenplay which reflects a raw, brutal and menacing yet poetic world of dark motives, superstition and transcendental love. Jarman's fascination with the past, and especially with cultures in which magic and ritual play a central role, is particularly evident here. The sequences are so powerfully described that the story captures the reader's imagination and conjures up vivid images of the intended film. Its fairytale-like quality transforms the story into an allegory of doomed love that, maybe, sums up his own feelings about being gay. In his foreword to the script, written years later, he imagines a cast – Tilda Swinton as Prophesy, Vanessa Redgrave as the Anchoress and Nigel Terry as Bob – further helping us to flesh out the images the script evokes.

Derek Jarman encountered the writings of C. G. Jung in the early 1970s. They had a great impact on him, providing him with a symbolic system which he could adapt to his own ideas. Although *Bob-Up-A-Down* is not straightforwardly Jungian in its conception, as is *In the Shadow of the Sun*, it does however seem to contain aspects of the psychoanalyst's fascination with mythology. The figures of the Anchoress and Bob, for instance, representing a potent mix of the

[1] *Dancing Ledge* p.207

Christian and the primeval, while black-garbed Bob himself symbol-
ises both a dark satanic force and a good force against the petty world
of the village.

Around the same time, Jarman was also working on *B Movie: Little
England/A Time of Hope* with the young actor Julian Sands who had
appeared, albeit masked, in Jarman's promo film for Marianne
Faithfull's *Broken English*, shot in September 1979. *B Movie* is a
postscript to *Jubilee*. The terrain is the same as that of the earlier film,
beginning with the death of Ginz who has become a modern-day
Cromwell. There is, too, the odd echo of *Jubilee* – at one point, for
instance, the border guard to Dorset (one of Jarman's favourite
counties) uses the same lines as in *Jubilee*. The script is, however, much
funnier, with a cartoon-like energy and wit. Reading it today, it is
much nearer the political bone than it was at the time. Jarman's main
plot idea of the sale of the Isle of Dogs on the open market to an
aspiring pop star – Adam Ant was earmarked for the role – and his
working-class 'Rocker' parents no longer seems like the far-fetched
stuff of social satire as the present-day Tories steadily sell off Britain!

B Movie has all the helter-skelter pace and fun of a British *Carry On*
film. Unlike its parent film *Jubilee*, it does not use an historical
bracketing device, but is firmly set in a future Britain. The characters
have a cartoon-like energy, and its often malicious violence is always
tempered by humour. It is one of Jarman's most explicit political
pieces, its sympathies very much with the left and clearly embracing
republicanism, and much fun is had at the expense of Jarman's
favourite targets – the Church, generals, the upper classes, the
Heritage industry and television. Characteristically, he lovingly
engages with the camp aspects of post-war English popular culture,
encapsulated by Adam's Teddy Boy father and Marilyn Monroe look-
alike mother, Red Flag the shop-steward, and the tart-with-the golden
heart Monique. It is one of the few scripts or films by Jarman that does
not cast a dark shadow.

Neutron was written in 1983 with the young left–wing politico Lee
Drysdale whom Jarman met when the latter was hired to guard the set
of *Jubilee*. Drysdale's flamboyant clothes, knowledge of film, revolu-
tionary politics and energy obviously entranced Jarman. Their own
differences – the claims on society and the responsibility of the artist
and of the political activist – were absorbed into the script after the
two argued, according to Jarman, for 'much of 1980'.[1]

Neutron seems to be the only unrealised filmscript that got close to
being made and one that Jarman worked on for many years. It was

[1] *Dancing Ledge* p.209

designed by Christopher Hobbs and cast. In September 1980, Jarman and Guy Ford travelled to Geneva to meet David Bowie who, after seeing *The Tempest*, agreed to do the film but only if the money could be raised without using his name. Bowie was to play the artist Aeon although, as Jarman points out in his notes to the script, the pop star wanted to play the subversive hero Topaz. For the meaner role of Topaz, Jarman wanted the playwright Steven Berkoff with whom he was colloborating in late 1981 to make a film of Berkoff's play *Decadence*.

The script has all the makings of a mainstream feature film in the genre of Scott Ridley's *Bladerunner* except that it has more political insight than that film and is much darker. Jarman seems to recognise this when he admits that Drysdale 'brought a darker cinematic side' to the colloboration. It is set in a post-nuclear apocalyptic future in which society is run by a repressive police state run on fanatical religious lines, using the words of the apocalyptic prophet John the Divine. Much of the derelict urban landscape is inhabited by mutant children who, feral-like, haunt the shadows. The emotional centre of the story is the couple – Aeon and Sophie – who are thrown out of their successful, affluent lives, a garden of Eden, into a post-nuclear explosion nightmare. In some ways, they are precursors of the heterosexual lovers (Swinton and Spencer Leigh) in *The Last of England* who are similarly torn apart and then swallowed up by an apocalypic scenario. In both films, the couple's relationship is represented through reveries and memories, and in both, one of them is executed (the man in *The Last of England*, the woman in *Neutron*). The two films also contain images of refugees being systematically persecuted; they both use mock Last Supper scenes. The mood of horror, despair and, ultimately, impotence is shared by both films, although *Neutron* is scripted in a more orthodox way with dialogue and straight narrative as opposed to the experimental and more schematic *The Last of England*. Jarman confessed later that he thought that 'much of the atmosphere of *The Last of England* would have been realised in *Neutron*.'[1]

Neutron is based on C. G. Jung's *Aion* (the Greek rendering of Aeon) which explores the phenomenology of the self with reference to alchemy, Nostradamus and Christian mythology. The religious aspect of *Neutron* is embodied in ever-present PA systems emitting sayings from the Bible's final and most eccentric text, the Book of Revelation. The script's apocalyptic vision expresses Jarman's feelings about modern society within a mythological structure. Unlike *Jubilee* it has

[1] *The Last of England* p.182

only two characters who represent opposing ideas, attitudes and sensibilities – the poet Aeon and the politico Topaz – Eros and Thanatos, Yin and Yang, Christ and Antichrist. The woman Sophie exists largely as a memory and represents a lost utopia. In its use of mythology, it is in some ways a precursor of *The Garden* which uses the Christian story as an organising element. However, *Neutron* does not have the personal subjective sensibility of the later film. Its tight structure, powerful visuals and post-apocalypic theme would have made it perfectly apt for the early 1980s when *Bladerunner* (1982) and *Brazil* (1985) successfully occupied the same terrain.

After finding out that he was HIV positive, just days before Christmas in 1986, the mood of Jarman's films swung between a bitter anger and a calm stoicism, at times leavened by a strong sense of love and reparation. *Sod 'Em* is an example of his work where the negative feeling seems to dominate. An early version of Marlowe's *Edward II*, which he made in a more orthodox way later in 1991, *Sod 'Em* shows Jarman focusing intensely on the pantheon of famous gays – Wilde, Shakespeare, Newton, Marlowe. Once again the film is set in a near future of state repression specifically aimed at gays due to the homophobia stirred by AIDS. He obviously has the model of *The Last of England* in mind, especially Simon Turner's innovative soundtrack of music, voice-over, found-sounds and poetry. *Sod 'Em* indicates a dramatic shift in Jarman's sympathies: the 'straight' world is now included in the ranks of the enemy. His feeling is one of belonging to a beleaguered minority no longer with any real allies in sub-cultures, like punks or Teddy Boys, or in left-wing figures like Red Flag. Sexuality divides Jarman's world. In Marlowe's play, Jarman finds a fitting tale of utter isolation, persecution and love destroyed. In the first scene, Jarman dissolves from Edward in his medieval cell to a bird's-eye view of contemporary Britain bathed in a burning orange light. Like *The Last of England* it pillages real images from the *Sun*'s front pages, to Jarman in his father's home movies and the Reichstag in flames. Its critique of Thatcher's Britain is much more confrontational and less sieved through allegory or satire, with attacks on the Welfare State, the power of the Secret Services and their activities against lawfully elected government in the 1970s, unemployment and so forth.

The language is a mix of modern-day reportage and the Elizabethan poetics of Marlowe, including occasional extracts from the original play but also phrases from T.S. Eliot's *Four Quartets* in a spoof sequence on the House of Lords. Another Last Supper scene appears, only this time in form of the Reaper's Cabinet meeting which Jarman used in his later film of *Edward II* with Isabelle, Thatcher-like,

presiding. As Edward runs through the sewers from the police, the intercoms, like those in *Neutron*, quote the Book of Revelation. The doomed heterosexual couple of *Neutron* is replaced by a gay one. In *Neutron* the priest in the lift is asked to raise a voice on behalf of the suffering and he responds 'Fuck the lot of you'. In *Sod 'Em* the Queen responds 'Fuck it!' when her husband asks her to defend the Faith.

The film's collage style and mood, switching between anger and restorative calm resembles those of *The Garden*, made a few years later, except that the use in the later film of the Passion of Christ lends it a more distanced quality. There is also vivid autobiographical material in *Sod 'Em* – as in the sequence 'Just the Two of Us' when Edward talks to Johnny, describing his restless nights and renewed love of life.

Another sequence has an image of two men making love which gives way to a blank screen on which a caption informs the audience that 'for a society that cannot face the reality of love I have plunged this screen into pornographic darkness' – this blank screen is a forerunner of that used in his last film *Blue*.

It is significant that, in *B Movie* and *Sod 'Em*, and to some extent in the character of Topaz in *Neutron*, Jarman espouses a militant stand against the repressive powers. We are reminded that he was extremely fond of William Burroughs' writings, in which he propounded the 'wild boys' gay militancy to which Jarman was not unsympathetic.

Up in the Air must puncture the myth that Jarman was an intuitive, even naïve, film director in comparison to his contemporaries. On the contrary, in *Neutron* and *Bob-Up-A-Down*, for instance, the characterisation, dialogue, *mise-en-scène* and overall narrative structure are rigorously worked out. All the films collected here are complete in every detail and those acquainted with his work can almost see them unfold in their mind's eye as they read. For those of us who feel deprived of the films he would have made but for his tragic death, these unrealised scripts are some kind of recompense. With their bold, vivid style, mischievous wit, unflinching ambition and great energy, they provide a fascinating and stimulating addition to his body of work – the paintings, designs, writings, garden and, of course, films.

AKENATEN

Babylonian
Costume

AKENATEN

Why did I develop a passion for Ancient Egypt? Some desktop Howard Carter cursed with curiosity, a dream of immortality, the Mummy's Curse.

In the early seventies I spent hours tracking down books in second-hand bookshops until I had over a hundred, from Victorian travel books to an obscure little pamphlet on the construction of a wig. I started to learn the hieroglyphs, but gave up, though I incorporated them into the little slate paintings I was making.

Out of my readings the story of the monotheistic sun-worshipping heretic stood out. Its side characters Nefretiti and Tutankhamun almost alive in funerary mask and statue – an attempt to murder the old gods, the hacking away of the name from tomb and temple, and Akenaten himself shaped like a queen bee – so strange.

I wrote the script deep in the Leyden Papyrus, and the Old Testament. This would be no *Cleopatra*. It was to be as simple as butter muslin with fine white limestone walls, sand and perhaps a gold bracelet or a scarlet ribbon. It was to be low budget. Very low. I had managed £30,000 for *Sebastiane*, but my casting ambitions were high – Bowie as the Pharaoh, maybe Lindsay Kemp as Amenhotep – but the project suddenly lost my interest. I had read myself into and out of the story. It was put on the shelf, though later Philip Glass made his opera.

I think if I made it now it would have no real necessity and would be merely decorative – perhaps not. It is strange to be

3

a film director, for work unmade is lost. If these had been plays, and I a playwright they would be considered if not performed.

Well, *Akenaten* was quite a success. It got good reviews and looked stunning. David Bowie's performance was enigmatic and it managed to eschew bombast. The dialogue, though rather poetic somehow fitted the subject, it never grew stilted. It was a good first film, controlled, unlike *Sebastiane* which wandered off and made itself.

The film takes place in Egypt, about 1400 BC.

Amenhotep, the richest and most powerful Pharaoh, rules Egypt, at the zenith of its power. The whole known world pays him tribute.

One day, Akenaten, the son he has banished since childhood, returns from the desert and the destruction of Egypt's greatest dynasty begins.

This is the story of Akenaten, his mother Tiye, his wife Nefretiti and his two sons by Tiye, Smenkhare and Tutankhamun.

1. EGYPT

The SPHINX *at Giza stares into the sun. Tourists pass by taking a photo or two. The voice of the* SPHINX *is used as a narrator through the film.*

Or alternatively, where the desert meets the sea, a group of gypsies have stopped. People gather round to watch, including our cameraman, who records the event as if he has just stumbled across it. Various figures are changing into costume, but in the foreground one dressed as the SPHINX *announces:*

SPHINX: [*Voice over*] I am the Sphinx. I've watched the centuries pass and know their secrets. All history is mirrored in my eyes. The great Pharaohs have prayed before my oracle, but none more terrible has stared me in the eyes than Akenaten, the son of Amenhotep.

Like the perfume of myrrh which drifts on a windy day over the waters I remember Amenhotep, richest of all the Pharaohs. He reigned for many years with his wife Tiye, daughter of the charioteer Yu Ya. He built great pylons in the temple of the Sun God Amonra at Thebes, inlaid with lapis, gold and precious stones with flag-poles of electrum

5

gleaming against the sky.

He built a lake of pleasure for Tiye which he filled with golden fish. My story begins on that lake with the Pharaoh's dream of the sun disc Aten, one afternoon among the blue lotus blooms. That day Akenaten, the king's son, was born.

A star appeared blood-red in the summer night. The waters of the Nile failed and a great famine fell on Egypt. The Pharaoh consulted Hapu, the oracle of the Sun God Amonra. He prayed to the God, but there was no answer. In the sanctuary, the Nile water in the silver divination bowl curdled.

Hapu prostrated himself before Amenhotep and his Queen with all the people of Egypt, and the Pharaoh, seeing the harvest was destroyed by the birth of his son made an offering of the child to the desert sands. On that day the blood-red star vanished and the Nile rose, so the people gathered a great harvest.

2. BABY AKENATEN

The SPHINX *slowly fades out and is replaced by an image of the baby* AKENATEN *crying in the desert sand.*

SPHINX: *[voice over]* So the years passed in peace. The Nile rose and fell and the Great God Amon protected his people. The Pharaoh grew old and sick and retired to his southern palace to await his death.

3. BANK OF THE NILE

The camera slowly zooms into the globe of the rising sun to a single tentative and expectant note on a harp. This dissolves into steps in the bank of the Nile where the beautiful princess NEFRETITI *is drawing water to put in the silver bowl for the morning offering.*

NEFRETITI: Come forth O Sun
 Come and look at me
 Come and look at me

The days are long, the nights are peaceful
Time spins a golden diadem
For Nefretiti
My life is spent in laughter
Awake Egypt. Awake sleepers of Thebes.
See the fish which lies beautiful on my
Fingers in the dawn light.

4. INTERIOR OF THE PALACE

Ceremony of the rising of the sun. A gong sounds, bells ring. To a long-drawn-out chant a group of priests whirl like dervishes in front of the statue of Amon. The oracle HAPU *consecrates the water in the silver bowl before the god.*

HAPU: Awake in peace great Amonra. Awake in peace in the eastern desert. There is no God greater. Awake in peace, upper Egypt. Awake in Peace, lower Egypt. Praise to Amonra, Lord of Thebes, the Master of mankind.
 [HAPU *hands the silver bowl to a young boy who kneels in front of him.*]
BOY: In peace I receive this bowl.

5. THE BEDROOM OF AMENHOTEP

The camera pans across the king's bedchamber. A fine white plastered room. In the centre, a large golden bed supported by leopards. On it Queen TIYE *is sleeping, guarded by a panther. In the corner, the Pharaoh* AMENHOTEP *is seated listening to a songbird in a cage. He is sick, covered with make-up and jewels to hide the ravages of time.* TIYE, *who is in early middle age, still retains her great beauty. The camera describes the whole scene slowly to the bird's song. The young* BOY *enters the room with the silver bowl and prostrates himself,* AMENHOTEP *beckons him over. He kisses the Pharaoh's feet.* AMENHOTEP *kisses him on the lips. The* BOY *seats himself in front of him and gazes intently into the water.*

AMENHOTEP: What is the time?

BOY: The sun is rising.

[AMENHOTEP *dips his hand in the water.*]

AMENHOTEP: Shadows of the dead come before me.

[*He pricks his finger with a golden pin. A drop of blood forms, which falls in the bowl.*]

AMENHOTEP: Let the boy see the light.
Let the spirit who I have
commanded come in. Let him
answer everything I ask truthfully.

[*The* BOY *closes his eyes.*]

BOY: A shadow falls across the sun.
A black storm howling in the desert.
In the storm rides a warrior, like a hawk,
Wearing the skins of wild panthers.

AMENHOTEP: Preserve me. Make my vessel prosper.

BOY: I see a writhing serpent with honey on its lips, crawling from the desert, the royal diadem on its head. The people fly before it. It swallows the Nile and crushes the land with its silent fury. Egypt is on fire. The great pyramids are burning. The Sphinx speaks the name of the serpent. It is Akenaten.

[*At the name of* AKENATEN AMENHOTEP *seizes the bowl of divination with a cry, spilling its contents. The young* BOY *drops to his knees. Queen* TIYE *wakes with a start, the panther snarls. The songbird ceases to sing.*]

BOY: I have spoken the name of the dead.

AMENHOTEP: Akenaten is coming. He is alive.

BOY: Do not strike me.

[*The* BOY *attempts to crawl out of the* PHARAOH's *sight.*]

6. INTERIOR OF THE PALACE

HAPU, *the oracle, is seated before the statue of Amonra, receiving petitioners. In the distance the chant of the priest can be heard. On his knees, in front of the oracle, the general* AY, *the brother of Queen* TIYE.

AY: Lord Hapu. Give your blessing to Ay, the King's brother, conqueror of the Medjoi, Prince of Punt. Prosper

the armies of Pharaoh. Prosper the land of Egypt so that all the world acknowledges the works of Amenhotep.

HAPU: It is granted.

AY: Hapu, I require a charm of love.

HAPU: What is the girl's name?

AY: I cannot say.

HAPU: The God will demand her name for the charm to work.

AY: The King's daughter, Nefretiti.

[HAPU *touches the god's image.*]

HAPU: Hail to thee, Amonra, father of the Gods.
Cause Nefretiti to burn with desire for the general Ay,
like a dragonfly for the lotus flower,
like a swallow for water.

[*He turns to* AY.]

HAPU: Bring incense to be burned and golden offerings for the god. At all times wear an amulet of the lotus, carved of mother of emerald. Build a garden, planted with every flower and sweet herb . . .

[*The* BOY *enters in great distress, his crying interrupts* HAPU. *He carries the silver bowl.*]

BOY: The sacred water was spilled in the Pharaoh's sight.
The name of the dead appeared in the water,
Pharaoh's son. Prince Akenaten.

HAPU: Akenaten!

7. INTERIOR BEDROOM

AMENHOTEP *is made up to look as young as possible by a group of child beauticians.*

AMENHOTEP: A little shading over my eyes, not under . . . over, a little more white on my left cheek. Some more red on the lips, Aches. It gives the illusion of youth.

ACHES: I forget all my cares in your sight.

AMENHOTEP: Sweet Aches, gold for your flattery. It makes me happy and helps me step into the sunlight.

[*He looks at himself in a mirror.*]

AMENHOTEP: Perfection, Aches, perfection!

8. MORTUARY TEMPLE

Three naked youths hold an enormous state umbrella.
AMENHOTEP *walks with the aid of a jewelled cane. The
King's architect,* TUTMOSE, *stands in attendance. The tomb
is a dazzling white geometric space.*

AMENHOTEP: Tutmose, I had this idea that my statues
should sing to the morning sun, as clear as the temple
singer Meryt.

[*He gestures with his hand.*]

AMENHOTEP: I thought of it this morning when I was
listening to my songbird.

TUTMOSE: It will stretch my art to the limit.

AMENHOTEP: You must make the largest statue ever made.
Write, 'His Majesty was pleased to build a very great
monument, without equal since the beginning of time.'

TUTMOSE: Wonderful!

AMENHOTEP: Add, 'I built them as a monument to my
father, the Sun God Amonra, and adorned them for
eternity with granite, quartzite and precious stones, built
to last for ever.'

[TUTMOSE *claps his hands with pleasure.*]

9. LAKE TARU

Queen TIYE *sits in her pleasure pavilion on Lake Taru which*
AMENHOTEP *built for her many years before when he
married her. With her are the princess* NEFRETITI *and the
temple singer,* MERYT. NEFRETITI *is making bread.* MERYT
sings to her harp. TIYE *stares into the sun.*

TIYE: King Amenhotep loves your singing, Meryt. If you
were not consecrated to the Gods, he would have married
you the moment he heard you singing.

MERYT: Would you like me to sing to you, Lady Tiye?

TIYE: Ah! The song I sang when I was young. I never get
tired of it.

[MERYT *sings.*]

MERYT: I am very dark and beautiful, daughters of Thebes,

My hair is wavy, black as the raven.
My lips are like scarlet thread.
While the King was on his couch he smiled at me,
And honoured me above all women.
His love is mine and I am his.
Our love runs like sparks through the stubble.

TIYE: Time changes the world, all our ambitions fulfilled, but our dreams have passed away like mist in the morning sun. The temple boy saw the name of Akenaten, my sweet son, in the bowl of divination this morning. He dropped the bowl and it awoke me from my sleep. Akenaten returns, he said. He is dead. Do not open old wounds. He is dead.

[NEFRETITI *interrupts* TIYE, *who is talking to herself*.]

NEFRETITI: Lady Tiye, drink this rose water while I braid your hair.

TIYE: Amenhotep's love was the passing of a shadow, exposing my son Akenaten to die in the desert sands.

10. SANCTUARY

AMENHOTEP *consults* HAPU.

AMENHOTEP: I wish to know more about the shadow of my son which troubled the water.

HAPU: I will provide a spell stronger than death. He shall not return from his death. I shall seal it up and he will not turn back.

AMENHOTEP: I am old, Hapu. All that I desire is peace, a little sleep, to rest in the shade of the oleander. I have riches and honour. I fill the hands of those who love me with gold. Give me peace.

11. DESERT

A long shot of the desert, a bird cries. The heat boils off the surface. In the distance the sound of horses and wild war cries. Suddenly over the horizon the wild nomadic BOYS *of* AKENATEN *appear riding naked on black horses. They are painted blue. The dust settles. The desert returns to silence.*

11

12. PALACE INTERIOR

HAPU *is finishing a wax figure. He binds it with thongs and pierces it with pins. He places it on a red hot metal disc which burns like the sun on top of a brazier. The figure melts and the wax flames up.*

13. DESERT

An enormous wall of fire. The wild BOYS *circle round an* elegantly dressed VIZIER OF PHARAOH. *They whip him to pieces with their long plaited hair, into which razor-sharp spikes are woven.*

14. HAREM

On a divan Queen TIYE *and her ladies sit bored and disconsolate.* AMENHOTEP *ignores them and swims in the pool with the* CHILDREN.

AMENHOTEP: Kiss me. Kiss me. This jewel for the one who wins. That's it. A little harder.

[*He touches his ear. A* YOUNG GIRL *bites it.*]

BEKETATEN: Father, I'm nearly of age. I'll kiss harder if you marry me.

AMENHOTEP: You're too young, Beketaten, too young. How old are you?

BEKETATEN: I've forgotten. A lady never reveals her age. [*She laughs.*]

Please, I want to leave Thebes.

AMENHOTEP: Well . . .

BEKETATEN: Yes, it's yes. I knew you would say yes. My mother's much too old for you.

[*The swimming is suddenly interrupted by a cry from Queen* TIYE. *The* CHILDREN *stop laughing and playing.* AMENHOTEP *looks worried.*]

MERYT: They've seen Akenaten, my Lord, in the Northern Lands. Your son is coming.

[*She falls on her knees.*]

MERYT: He has slain the vizier of Bubastis.

15. THE PHARAOH'S BEDROOM

In front of the statue of Amonra, AMENHOTEP *has lit a myriad votive candles.* AMENHOTEP, AY *and* HAPU *kneel.*

AY: Give me the word and I will send your armies against him.

AMENHOTEP: It is written in the water, Akenaten will return, it is the will of God.

AY: He slew the vizier of Bubastis and desecrated the shrine of the Goddess of Love. He has slain the apis bull and destroyed the shrine of Ptah.

AMENHOTEP: He is my child, Ay, he is the Son of the Sun. He is the reincarnation of the God. No mortal hand will be raised against him. I will receive him in peace, for the Gods of the endless desert which encroaches our land, have returned my son to his inheritance. There is no turning back from death, but my son returns from the dead.

16. SUNSET

The sun sets over the western hills. AMENHOTEP *watches.*

AMENHOTEP: Cast gold dust in his path, make a road for the Prince, for he comes, from the land of the sunset in the western desert, like an eagle to revenge his birth.

17. TEMPLE AMONRA

The ceremony of the dying sun. The ship of the sun, 'The Ark', is carried in by priests dressed as the various Egyptian divinities. A group of bald priests keep up a solemn and low dirge over which the voice of the temple singer MERYT *laments in a long-drawn-out cry. The pharaoh follows the Ark under his jewelled canopy. The priests shower him with golden confetti. Everywhere there are torches and flickering candles. General* AY *and* HOREMHEB, *the chamberlain, in attendance.*

AY: Amenhotep is a fool, his superstition exceeds all bounds. We are all to be sacrificed to a vision in a slop bowl.

HOREMHEB: General Ay, you know as I do, things are not always predestined.

AY: But you've heard the news from the delta.

HOREMHEB: I have, but I am prepared to play for time. The priesthood of Amonra is powerful. Amenhotep has poured the spoils of Egypt into the temple treasuries. Hapu has spent the whole day casting spells, but his power is failing. You and I, dear General, can turn with the wind, he is certain to capsize.

HAPU: The sun is overcast, the sky is darkened, the planets are stilled. May the god triumph over the snake Apophis which lies in the night. May he journey safely across the great abyss.

18. PAVILION OF TIYE

It is a hot sunny afternoon. The court lies around in the sun. Flies buzz. The occasional sound of a fish rising to the surface. The CHILDREN *sit with fishing lines and play marbles.* AMENHOTEP *is asleep.* MEURYTATEN *is manicuring her nails.* NEFRETITI *sits watching some women lazily washing clothes on the steps of the Nile.*

19. THE BOUNDARY STONE OF THEBES

In the sun the nomadic BOYS *crouch in a circle. The remains of a meal are around.* AKENATEN *dressed as a golden eagle with the appearance of an Assyrian god. He plays with a child's toy and laughs. One of the boys looks at the boundary stone.*

BOY: What does it say?

AKENATEN: This is the northern boundary of Thebes. All land beyond this point is consecrated to the God Amonra.

20. THEBES

Matte shot of the City of Thebes. In front AKENATEN *and the wild* BOYS.

SPHINX: *[Voice over]* A great hush fell over the holy city of Thebes. A silence so profound, the sound of a butterfly's

wing would have broken it. A single bell announced the hour had come and Akenaten walked through the streets in silence.

Then he started to sing and his voice echoed through the halls of the southern palace. The people fell on their faces before him and no-one dared to look him in the eye for fear of evil. The boys who followed him danced to the sound of his voice. Guided as if in a dream they came to the audience hall where Amenhotep sat alone and received his son.

21. THRONE ROOM

AMENHOTEP *sits alone on his throne. A long silent shot. We hear the sound of* AKENATEN *singing and the cymbals and flutes of his* BOYS coming nearer and nearer. He stops singing and stands before the old PHARAOH. AMENHO-TEP's *eyes slowly open and meet* AKENATEN's *gaze. A tear falls down his cheek.*

22. BANQUETING ROOM

A great welcoming banquet has been eaten. The court lies around. AMENHOTEP *sits on a divan surrounded by his* CHILDREN. TIYE *and* WOMEN slightly to one side. They are protected by SOLDIERS. AKENATEN *and the nomadic* BOYS sit around. Their outlandish costumes are obviously a source of amusement to the CHILDREN. *They sit uncomfortably in these exquisite and sophisticated surroundings.* BEKETATEN *whispering.*

BEKETATEN: He's not really my brother, is he?

NEFRETITI: Ssh, Beketaten, your father told you to be on your best behaviour.

BEKETATEN: Well, I find him most unattractive. He looks more outlandish than the ambassadors from Mitiyani. Look, that one hasn't any clothes on at all.

NEFRETITI: One day Akenaten will be Pharaoh.

BEKETATEN: Look at the way they eat. I think it's disgusting.

15

NEFRETITI: There's a rumour he was suckled by a lioness.
[*There is an uncomfortable silence. One of the wild boys
has found* NEFRETITI's *silver hand mirror. He looks at
himself in it with disbelief. It is the first time he has seen his
image. He drops the mirror as if it were bewitched, then
cautiously picks it up. The boys look at themselves and
start to laugh.* AKENATEN *beckons* NEFRETITI *over.*]
BEKETATEN: Don't go, Nefretiti. They're savages.
[NEFRETITI *walks towards* AKENATEN. *She stops before
him. Slowly he takes off the eagle's golden head to reveal a
face of great beauty. He kisses her slowly on the lips. The
Egyptian court stands aghast.*]

23. INTERIOR OF THE KING'S BEDROOM

AMENHOTEP *is prostrate before the statue of Amonra. In
the background we hear the sounds of a violent and drunken
orgy. The room is lit by flaming torches.*

24. NILE

The BOYS *are swimming in the Nile.*

25. BEDROOM

AMENHOTEP *and* TIYE *are asleep.* AMENHOTEP *sleeps
fitfully. He gasps in his sleep.*

A gong sounds the hours. A cock crows.

Suddenly, with a terrible start, Queen TIYE *is sitting up in
bed, dazed. The cock crows. She turns to* AMENHOTEP *and
kisses him. In the same instant she realises that she has been
sleeping with a corpse.* AMENHOTEP *has died in his sleep.
She screams and screams* . . .

26. FUNERAL CORTEGE

Drawn by MOURNERS *who represent the hours, the funeral
cortege of* AMENHOTEP *winds its way through the desert
followed by Queen* TIYE *and the jackal-headed priests of*

Anubis. Far behind the cortege NEFRETITI *follows. The* MOURNERS *are covered with dust and resemble refugees rather than the funeral cortege of a great Pharaoh.*

27. DESERT

The scene is intercut with the nomadic BOYS *hunting. On a high dune, looking over the endless desert,* AKENATEN *sits on his throne.*

AKENATEN: In the desert I am at home, the Pharaoh of the sun. Living in truth. I have desert eyes which can see further than the horizon. Look! My princes ride like a whirlwind of gold. I shall renew Egypt, breathe fire into her, recreate her for the wildest joys of life. All creation shall rejoice in my return.

28. TOMB INTERIOR

Queen TIYE *sits alone in the tomb. She has prepared a votive meal for her husband's corpse.*

SPHINX: [*Voice over*] Then the great wife of the Pharaoh, Queen Tiye, went down to the tomb. She anointed him with perfume and laid him to rest. He was no longer on earth but in the sky. He kissed the sky like a hawk. He leaped towards the heavens like a grasshopper, but the great wife of the King sat in desolation in his tomb.

29. PALACE. THEBES

In an empty room NEFRETITI *is sitting wearing a floral garland. Blood-red flowers scattered all around her on the floor. She is deep in thought and doesn't notice her uncle* AY *standing beside her. She drops a flower.* AY *bends to pick it up.*

NEFRETITI: They're beautiful, aren't they? The fishermen scatter them on the water at sunset.

AY: They believe these flowers sprang from the blood of Osiris when he was slain. They throw them on the water to propitiate the god.

NEFRETITI: Why have you come, Uncle Ay?

AY: To ask you to marry me, for the sake of Egypt. Akenaten will never understand our ways. All that is best in Egypt will be scattered to the wind.

NEFRETITI: My heart is his.

[AY *goes on his knees before* NEFRETITI.]

AY: Love, Nefretiti, is as long as a day. Like this flower it will wither at sunset.

[AKENATEN *enters.*]

AKENATEN: I'm going into the desert to hunt for lions.

[*He looks at* AY *on his knees.*]

AKENATEN: Are you weaving garlands as well, Ay?

AY: The funeral rites are sacred. They are lost in time.

[*He takes a flower from* NEFRETITI.]

AKENATEN: Life's for the living. Leave those, Nefretiti, come with me.

NEFRETITI: I promised to take these to Queen Tiye for our father's tomb. Wait for me.

AKENATEN: Be quick.

[*He picks her up and whirls her around until the room itself is spinning with the petals of red flowers flying around them.*]

30. LAKE SIDE

NEFRETITI *is swimming.* AKENATEN *sits by the water's edge.*

AKENATEN: From the moment I saw you, I fell in love. You look beautiful in the water.

NEFRETITI: You wouldn't believe the surprise you gave me when you took off your helmet.

AKENATEN: Why? What were you expecting?

NEFRETITI: The rumours in the palace were so fantastic. I expected something like the demon Bes!

AKENATEN: Ay seemed to think we had destroyed half the cities of the North before we arrived at Thebes.

NEFRETITI: I didn't believe that.

AKENATEN: We came unarmed. We only opposed those who opposed us. We were swift and won easily.

NEFRETITI: Father welcomed you. He would let no harm come to you.

AKENATEN: I returned to Egypt not for revenge, but to know my mother and father.

31. SANCTUARY OF AMONRA

In the sanctuary of Amonra, HAPU *has made an effigy of Akenaten, life-size, on which he is placing amulets and magic talismans. General* AY *watches. This scene is intercut with* AKENATEN *and* NEFRETITI *making love in the desert. As* HAPU *places a scorpion of lapis lazuli on the face of* AKENATEN, *we see that* AKENATEN *has got sand in his eye.* NEFRETITI *tries to wipe it away. She succeeds and they kiss. Over the whole sequence is the sound of a howling wind and* HAPU*'s voice.*

HAPU: Scorpion of lapis
 The eye of Atum
 The heart of Osiris
 The beauty of Isis
 The breath of Anubis
 Wild god of the desert
 Perform my command
 I send you to Akenaten
 Set his body on fire
 Put flame in his mind
 Madness in his heart
 So that the people of Egypt
 Weep before the sun rises in the morning
 Akenaten, I cast fury on you
 And call forth your death

32. DESERT

In the sand, where NEFRETITI *and* AKENATEN *are making love, a scorpion materialises. They do not notice it. It settles on* AKENATEN *and stings him.*

33. TOMB INTERIOR

AKENATEN *is delirious.*
Lying on a funeral bed attended by the PRIESTS *of Anubis and* HAPU. *Outside his followers keep up an insistent war-like chant. Queen* TIYE *bleeds him into a silver bowl. She is mumbling words we cannot hear and anoints him with blood. She cuts his hair and ties it to the feet of a hawk, which is released.*

The chant of the nomadic boys gets very loud and stops. The sound is of an immense cavern with water dripping. The footage of AKENATEN'*s delirium is printed scarlet and consists of the following images:*

1) *Queen* TIYE *making love to* AMENHOTEP.
2) *A* CHILD *exposed under the blinding sun.*
3) *The sun.*
4) AKENATEN *kissing his mother in close up until the blood runs over her face.*

34. TOMB INTERIOR

There is complete silence. The sick room dissolves into two large staring eyes. It is the young BOY *of the divination bowl. We see the following set-ups:*

1) *Queen* TIYE *, almost naked and unconscious, sits in a corner covered with flowers.*
2) AKENATEN *sits upright on the tomb of his father, with his eyes closed.*
3) *The mummy of* AMENHOTEP *has fallen to the floor and is broken.*
4) *The young* BOY *runs back to* HAPU, *who is sitting motionless. The* BOY *taps him, thinking him alseep.* HAPU *topples over. He is dead.*
5) AKENATEN *kisses* TIYE. *They exchange rings.*
6) AKENATEN *and* TIYE *make love.*

35. DESERT

AKENATEN *in the desert. He lies prostrate in the sun, naked.*
AKENATEN: Great sun of the desert, Aten,

When you arise the world lives.
When you set, the world dies.
I, alone, know you in your true name.
Aten,
Lord of Truth,
I, Akenaten, your son,
Will recreate the world for you
As you created me.
Your beauty holds my heart captive.

36. DESERT ENCAMPMENT

AKENATEN, *invalided, sits on his throne with Queen* TIYE.
*He wears golden eye-shades to shield him from the sun. He is
surrounded by his* BAND, *who are now dressed in gold and
armed with golden bows.*

ASTARTE: Praise to the living Aten,
 Living for ever in eternity.
 Akenaten, living and great.
 Lord of the heavens,
 Lord of the earth.
 King of upper and lower Egypt.
 Living in truth.
 Lord of diadems.
 Praise to the great wife of the King,
 The beloved Tiye,
 And to the lady of the two lands,
 Nefer Neferu Aten, Nefretiti,
 Living healthy and youthful to eternity.

AKENATEN: Last night, my father, the sun disc Aten,
drowned himself in the great green sea. He called me,
Akenaten! My son, child of the desert, living with the
people of Egypt. I am blinded by the countless reflections
of myself on earth. I am mocked by the priests of Amonra
in Thebes. Like an old sycamore tree they have forgotten
the seed from which they grew, but the time has now come
for the tree to be felled. My son, seize the axe.

ASTARTE: Today the twin sons are born to the Pharaoh

Akenaten and great Queen Tiye. The eldest, the first son of Pharaoh, shall be named Smenkhare. His brother shall be Tutanaten.

AKENATEN: May the sunlight shine on you and make you strong. May you ascend and rise into the sky to the living sun.

[AKENATEN *points to the sun. The camera follows his gaze into the sun.*]

SPHINX: [*Voice over*] The Lord Akenaten cast a spell across the two lands, calling his people. He said: I am alone, the living Aten, appearing, shining, withdrawing, returning. Let none break step, for I am the light. Then he said: I command a city to be built at the mid-point between Thebes and Memphis, so that the kingdom shall be held in balance. And he commanded all the people to build a city so that the truth might have a perfect house. And he called the city Akhetaten, which means the Aten is satisfied.

37. ATEN, A MODEL OF THE CITY

Slowly out of the sun appears the city of the Aten in all its glory.

SPHINX: [*Voice over*] All the nobles of Egypt journeyed to the great City of the Sun to see the god in the window of appearances where he gave audience each morning, and blessed them in the name of the Aten, the living truth. None broke step. So that the name of Aten echoed to the four corners of the world. And Akenaten established peace on earth, it seemed that the peace would never end. Only Queen Tiye was silent, with the silence of the old, passing her days in Thebes. She watched her sons Smenkhare and Tutanaten grow in their father's footsteps.

[*The camera slowly pulls back from the model of the city of Aten.* AKENATEN *is dressed as the god of the Sun, on either side of him are his two sons* SMENKHARE *and* TUTANATEN. *They are now eighteen years old, they are similar yet dissimilar, equal yet unequal. They are watch-*

ing a butterfly which sits chained to AKENATEN's finger.]

AKENATEN: When I lived in the desert as a child I learned to dream. At first it was difficult, my dream world was a barren wasteland of rocks and sand, I counted grains of sand in my sleep. The world was an empty room. Then I learned of the land of the great river, the nomads who adopted me described the temples, the cities and gardens of Thebes. Even the great Sphinx itself which held the land captive to its strange half-human gods. My dreams flew me to this land which I had never seen, now I dreamed of a boat on the river, the flowers at the water's edge which the temple girls wove in their hair, I dreamed of the temples themselves and the great Pharaoh, my father. But whatever I dreamed was lit by the great sun of the desert, my dreams were like this butterfly, more beautiful than gold or lapis. They flew from flower to flower, each more perfect than the last, but finally they rested in the shadow of the sun.

38. OBSERVATORY. AKENATEN

A bright hard gemetric room. A hard white light pervades it. AKENATEN *sits in front of a sacred plant. He spreads his hand over it in benediction. A* PRIEST *holds symbolic earth, air, fire and water.* NEFRETITI *sits with him. She is blind in one eye and much older.*

AKENATEN: Healing light fall on this plant
 so its green-ness is restored
 Healing water fall on the plant
 so it is refreshed
 Let the air embrace it
 And the earth on which all creation rests
 succour it

[*He touches the plant with the symbols of life. Suddenly* NEFRETITI *interrupts.*]

NEFRETITI: As the plant grows stronger our love dies.

[AKENATEN *drops the wand he is holding.*]

NEFRETITI: The world lies in ruins. The temples and

23

palaces of Thebes are destroyed. Your empire in the west is crumbling. When I sit in the sunshade in the Temple of Aten, I think of the suffering on which its foundations are laid and the fall of the gods of my childhood.

AKENATEN: Nefretiti, have faith. The rays of the Aten will shine across the land. The two lands will unite in joy. Egypt shall live in peace.

NEFRETITI: You have changed the nature of God, but human ambitions remain the same. Look at your sons, Akenaten. Every day they grow further apart.

AKENATEN: Before the high Nile Smenkhare shall be crowned. Queen Tiye will come from Thebes. We will be united. I shall have sculptures made to show the world our happiness in Akhetaten. Sculptures like the world has never seen, reflecting my vision in the clearest light. The superstitions of Amon and the priests of Thebes will soon no longer be remembered. The Aten will be established as the god of all mankind, and my sons shall rule a new world. For I have been given the knowledge of what exists. I know the structure of the world, the activity of the elements, the beginning, middle and end of time. The alterations of the solstices and the season's changes, the cycle of the year and the constellations of the stars. For the Aten, the fashioner of all things, has taught me and has given me the great task of teaching the world this truth.

39. STREET, THEBES

In a narrow street, with sheer, featureless walls in bright white limestone. Two bands of youths meet. TUTANATEN, *with three or four* BOYS, *is returning from hunting in the marshes, armed with throwing sticks and carrying game.* SMENKHARE'S GROUP, *which is larger, is richly dressed and going to a feast. In every way the groups are contrasted.*

SMENKHARE'S FAN BEARER: Make way for the firstborn Prince Smenkhare.

[TUTANATEN'S BOYS *fall back against the wall unwillingly,*

24

but as the other group passes, one of them deliberately trips him up. They are at each other's throats.]

SMENKHARE: Keep your friends in order, Tutanaten, or I'll have them whipped down the royal road at dawn.

[*The fighting becomes more violent.* TUTANATEN'S BOYS *are outnumbered and losing. A dagger is drawn and one of them is stabbed in the hand.*]

TUTANATEN: Stop them, Smenkhare!

[SMENKHARE *pays no attention.*]

SMENKHARE: You shall give homage on your knees for this insult. You and your household shall be called before the God.

[TUTANATEN *tries to help his wounded friend.* SMENK-HARE *bars his way with the royal sceptre. One of Smenkhare's friends tries to help the stabbed boy.*]

SMENKHARE: Don't foul yourself with their blood, Bek. The waters of the flood would not wash you clean.

[*He spits in the face of the wounded boy.*]

40. THE ROOM OF SMENKHARE

The room, though small, glitters with gold, every available surface is gilded. Incense burns and drifts in eddies across the room. The BOYS *lie in each other's arms, fanned by young* GIRLS. SMENKHARE *sips wine from a cooler with a long straw. He plays draughts with his favourite,* BEK. *Two women, dressed in animal skins, are wrestling.*

SMENKHARE: Tutanaten becomes more intolerable every day.

BEK: Civilised life is wasted on him. He lives like a savage.

SMENKHARE: He spends all his time hunting in the marshes.

BEK: Well, we taught him a lesson this evening. He's not as strong as he looks. You should send one of your slave girls after him. He would be the laughing stock of Akhetaten imprisoned in Meri's arms. She could smother him once and for all.

41. THE SHRINE OF THE ATEN

AKENATEN *sits in the centre of the floor in front of the symbol of the Aten. A young* BOY *holds a lamp which throws flickering shadows across the room. A chant like a long-drawn-out sigh, now near, now far, spirals around the room.*

PRIEST: This is my beloved son. I have given the two horizons to him.

AKENATEN: Lord of the Serpent Diadem and the double crown of Egypt. Lord of perception, whose work shines through the world, whose beauty captivates hearts. It is I who made the house of god, who created the light. In Akenaten. So you dwelt on earth amongst the peoples. Praise unto you, Aten, who made all.

42. NARROW STREET. NIGHT

AKENATEN, *with a hood thrown over him, so he is not recognised, walks down the street accompanied by the* BOY. *In corners people lie asleep. The night is alive with strange noises.*

43. THE BOUNDARY OF AKHETATEN

The moon hangs high over the great temple of the Aten. In the distance we hear the howling of jackals. AKENATEN *paces up and down in the desert. The* BOY *stands holding the sacred fire.*

BOY: He waits for dawn to steal across the eastern desert, for his father to rise, so they may go down and bathe in the field of rushes.

[AKENATEN *faces eastwards and stretches his hands to the sky.*]

AKENATEN: It is I who restored you.
It is I who built your city
It is I who set your world in order
Do everything my heart desires.

BOY: He waits for dawn to steal across the eastern desert driving away the serpent to rescue the world from death.

AKENATEN: The stars are silent, the bones of the earth tremble. Awake great Aten.

BOY: There is no sleep for the god. Each night he struggles with the moon. On his watchfulness depends eternity.

[AKENATEN's *agitation approaches a frenzy. He collapses. The first light of dawn crosses the desert.* AKENATEN *mumbles to himself, his face buried deep in the sand.*]

AKENATEN: He has swallowed the dark night. The spirits are in his possession.

[*With a sigh of relief he falls asleep in the dust. The young* BOY *faces the rising sun.*]

BOY: He is a god
　　Older than the oldest
　　Thousands serve him
　　Even to the limits of the horizon
　　For ever and ever.

44. A BOAT ON THE NILE

AKENATEN *and* SMENKHARE *lie in a boat in the sunlight.* AKENATEN *is heavily protected from the sun. The boat drifts in the reeds at the water's edge. A fisherman throws his net in the water. It falls in an arc. Some children swim in the water.* AKENATEN *pulls off gold rings which glitter on his fingers and throws them to the children. They dive for them and shout for more.* AKENATEN *speaks slowly.*

AKENATEN: We left the house of Amon in Thebes one hot afternoon and sailed northwards. The moment we left I felt an immense joy, like a bird released from a cage. All along the bank the people ran, trying to keep up with the golden barge, begging me not to leave them. The water was thick with little boats and people swimming. The women wailed and beat themselves, but I was happy. Thebes was oppressive. Every moment of the day was ordered from the second I awoke in the morning. Day followed day in endless monotony. The people lived through me. I was their connection with the past. They spent hours contemplating their god, asking for the riddle

to be answered. They died waiting. And then with supreme folly tried to preserve themselves in case the question should be answered in death. Withered flowers from the oldest tombs had more beauty to the people of Thebes than the blossoms of jasmine on their own doorsteps.

The journey down the Nile fulfilled all the dreams of my childhood. The golden oars glowed in the water. They rose and fell and the sailors sang to their rhythm. The green of the new corn stretched to the pink desert. On the thirteenth day of the sixth month we arrived at the site of the new city, and I drove in a chariot of electrum to mark the boundaries. I defined the boundaries myself.

I answered the riddle in the eyes of the Sphinx that afternoon. The answer was life. The blush on a cheek, the blossom opening on the lily pond, a moment without shadows, and I built this truth here in Akhetaten and vowed I would never leave it.

45. IN A SMALL CLEARING IN THE REEDS AT THE WATER'S EDGE

In the clearing is an exquisite muslin pavilion. A serving boy splashes water on the muslin to keep it cool with a bunch of scarlet flowers from a gold bowl. In the pavilion a meal is set. AKENATEN *and* SMENKHARE *lie in the cushion.* SMENKHARE *unbinds his hair which falls around his shoulders. We are aware of his great beauty. He combs his hair out.* AKENATEN *picks a fig from the bowl, bites into it and throws it to his son.* SMENKHARE *smiles. He takes a bunch of grapes, bites one and offers it to* AKENATEN. *Their lips meet.*

AKENATEN: Fine child.

[*He runs his hand through* SMENKHARE*'s hair.*]

AKENATEN: The people shall sing of your great beauty.

46. CAVERN OF THE ORACLE

NEFRETITI *rides across the desert with* TUTANATEN. *She leaves him guarding the horse and clambers up a steep ravine*

*in the mountainside to the mouth of a cave. The cave
entrance is decorated with painted signs on the rocks. Deep
in the hillside, lit by a single shaft of light, an old* PRIESTESS
*guards a ruined statue of Amonra. She is dressed in rags and
has feathered wings attached to her arms. When* NEFRETITI
*enters the cave she throws herself to the ground. She covers
herself with a handful of dust.* NEFRETITI *places offerings of
bread and milk before her. An old* MAN *breaks the bread,
dipping it into the milk. He feeds the oracle.*

NEFRETITI: Sickness has crept into me. My body is heavy
 with sadness. The physician's remedies cannot cure my
 heart. Make him aware of my sadness. Open his eyes and
 ears.

 [*There is a silence.* NEFRETITI *grasps the old lady's hands.
 A tear imperceptibly runs down the cheek of the* PRIEST-
 ESS.]

PRIESTESS: He has stolen away the hearts of the gods, and
 swallowed their understanding. He has erased the name of
 Amon, so he has no power in the city of the horizon.

 [*In the shadows of the cave behind* NEFRETITI, TUTA-
 NATEN *has stolen in and listens.*]

PRIESTESS: The centre is no longer marked. The houses of
 the gods are caves. They wander in the wasteland without
 food or water.

 [TUTANATEN *dislodges a stone. The* PRIESTESS *looks up.
 Seeing the young prince, she throws herself at his feet.*]

PRIESTESS: Tutankhamun. Embrace the gods in your
 arms, their lands and their possessions. Wake from the
 sleep of Akhetaten. The gods of Thebes have assigned you
 to your throne. Living Horus, put these words in your
 heart. The sky is given you, the earth is given you. Sharpen
 your knife.

47. SHRINE OF AKENATEN

SMENKHARE, *very drunk, staggers around the room. He
embraces Akenaten's statue.* AY *enters. With military
formality, he bows very low.* SMENKHARE *tips* AY's *head up*

with his jewelled slipper.

SMENKHARE: Old Ay, Nefretiti's hound.

[*He bites into a fig and throws it to* AY, *who catches it and holds it uncomfortably.*]

SMENKHARE: Why don't you eat it?

[*There is a silence.*]

SMENKHARE: I've called you for a special announcement. I am betrothed to the Lord Akenaten, and you shall have the honour to announce it to the city.

48. GARDEN NIGHT

NEFRETITI *and* TUTANATEN *sit with* AY *under a group of palms at the river's edge.* TUTANATEN *skims stones off the water's surface.* AY *paces up and down in the flickering light from the oil lamps.*

AY: I remember when the palace at Thebes was alive with your laughter.

NEFRETITI: I've never forgotten.

AY: Your beauty grew each year. I fell in love with you. Laughing and entertaining the Ambassadors from Keftiu, outshining everyone.

NEFRETITI: Trying on the strange dresses they brought as gifts. It all seems so long ago.

AY: Tutanaten will never know the world that was lost for Akenaten.

NEFRETITI: Take care of him, Uncle Ay. He has only you to protect him now.

AY: He is safe while he remains between the boundary stones. No-one dies in Akhetaten.

NEFRETITI: But the oracle spoke of blood.

49. THE EDGE OF THE DESERT

AKENATEN, *dressed in ghostly white with fluttering red ribbons, is carried by the bald-headed* PRIESTS *of the Aten. They lead a gilded sacrificial ram wearing the sun disc, dressed with garlands and hung with many small bells. In the desert they pass the old oracle of Amon who is buried up to*

her neck in the sand. She has been flayed alive. Her skin is pinned out before her and is covered with script. SMENK-HARE *draws the curtains of his golden litter. The* SCRIBE *kneels in the dust. The procession is led by a* GIRL *who dances and clashes golden cymbals.*

SPHINX: [*Voice over*] Then in the morning Akenaten led the priests to the Western Boundary. He lifted his hands to heaven and said, 'Great and living Aten, my father. Look on the sorceress of Amon and know the slaughter I make for thee. My knife is firm against the enemy.'

And he ordered the ram to be sacrificed and he bathed the feet of the chosen in the blood of the sacrifice, so that they would travel without danger to the land of the rising sun. And he said, 'My son shall ascend the throne. The god shall rule on earth, scattering light to the edge of the abyss. Men of Akhetaten, seek the sacred fire which burns in the west so that my son Smenkhare shall be crowned at the source of life.'

[*The* PRIESTS *sacrifice the golden ram and the blood is poured into libation bowls.* AKENATEN *anoints the feet of the* RUNNERS.]

For many days the men of Akhetaten journeyed across the desert to the lake that burns in the west, so that the love of Pharaoh for his eldest son should be consecrated in the ashes of the old gods, and the light of the Aten should shine upon him and grant him eternity.

50. THE LAKE OF FIRE

In the middle of a featureless desert, under a great blue sky, a lake of fire burns amongst the rocks. The RUNNER *falls to his face and kisses the earth. There is a great roaring sound which issues from the ground. A torch is kindled in the fire.*

51. THE TEMPLE OF THE ATEN

On a high white altar, with steps leading to it, in the middle of a great circle of fire, AKENATEN *kneels. His body is painted scarlet.*

52. THE GOLDEN ROOM OF SMENKHARE

SMENKHARE *has been made up with vivid make-up. He is dressed in gossamer-thin bridal veils by the* WOMEN *of the harem.*

AKENATEN: [*Voice over*] Behold you are beautiful, my love.
Behold you are beautiful.
Your eyes are fire.
Behold you are beautiful, my love.
The time of singing has come.
You have ravished my heart
with a glance of your eyes.

53. NARROW STREET

SMENKHARE *walks in procession down the street. The* WOMEN *of the harem scatter corn before him.*

54. TUTANATEN'S ROOM

TUTANATEN'S *room is plain but beautiful, opening on to a garden with white muslin curtains blowing in the breeze.* TUTANATEN *stands in the bath. A servant oils him with perfume from an alabaster jar. He smiles at* NEFRETITI. *She has taken amulets out of her sleeve. She lays them against his body.*

NEFRETITI: Take the amulets and wear them. The eye of Horus always brings safety and good health. The Tet will protect you to the four cardinal points.

[*She touches his forehead and neck with them.*]

NEFRETITI: The Nefer will bring you luck and happiness.

TUTANATEN: Even against the sacred fire?

NEFRETITI: Yes, even there.

[TUTANATEN *is handed golden chain mail by his servant. He slips it on.*]

TUTANATEN: Well, my armour should do that. It was a gift from Uncle Ay. It's beautiful, isn't it? And look, not a chink, even with the sharpest dagger.

NEFRETITI: It is beautiful.

TUTANATEN: Beautiful, and also charmed. It's the armour King Tothmes wore on the battlefield of Meggido. Uncle Ay was given it by Amenhotep when he took command of the armies. People shall distinguish me from my brother.

NEFRETITI: Be careful, Tutanaten. Your brother is ruthless. He won't be bound by ties of blood.

55. TEMPLE OF THE ATEN

One by one the semi-transparent veils of SMENKHARE *are removed. They flutter in the wind and are cast into the flames. Flowers and corn are cast into the flames.* SMENKHARE *walks up to* AKENATEN. *They embrace and start to make love. The lovemaking is cut with the flames and the sun and an ecstatic hymn to the Aten.*

SMENKHARE: O living Aten, beginning of life, Your eyes shall look on his beauty until they set.

56. GARDEN

Blood drips on the ground. It falls in a trail across the decorated pavement, splashing the symbol of the Aten. The blood drips on flowers and falls in drops which diffuse amongst the golden fish in an ornamental pond. On a beautiful garden seat in an arbour of exquisite delicacy, NEFRETITI *sits motionless. Her hands spread before her like a supplicant. Her eyes are closed, her white dress turned crimson. She has cut her wrists.*

57. SHRINE OF AKENATEN

AKENATEN *paces back and forth, carrying a torch which throws up sinister shadows. A frightened* ATTENDANT *kneels on the floor in the moonlight, which casts a ghostly light through the open windows. The body of Nefretiti lies on the floor.* AKENATEN *puts his hand over the* ATTENDANT's *mouth and silences his muttered prayers.*

AKENATEN: The dead are comforted by silence. Prayers offend them.

[*The* ATTENDANT *looks at him wide-eyed in fear.* AKE-
NATEN *falls to his knees and clutches the dead body.*]
AKENATEN: You captured my heart, my sister.
 You ravished my heart
 with a glance of your eyes.
 How sweet was our love,
 sweeter than wine or the fragrance
 of spice, like a locked garden planted
 with the rarest flowers, nard and saffron,
 calamus and cinnamon.
 Trees of frankincense, myrrh and aloes.
 Awake, north wind,
 Come, south wind.
 Blow upon my garden.
 Bright bird flying through the blue sky,
 Beating the light air with your wings.
 You have gone, leaving no trace
 of your journey.

58. DESERT

In the desert beneath the moon, AKENATEN *drags the body
of Nefretiti through the dust. At a distance a* BOY *follows
carrying a vase and a torch.* AKENATEN *places the body on
the ground and lies down beside it. The* BOY *keeps a vigil,
sitting on a rock. Suddenly, with a start,* AKENATEN *stands
up. The sun is rising over the horizon. He calls the* BOY *and
takes the vase from him. He pours libation round the body
and over it. He flings the torch at the body, which explodes
in an enormous sheet of flame. The* BOY*'s face is lit with
horror.*

59. NIGHT. TUTANATEN'S ROOM

TUTANATEN *is sleeping fitfully. A stone is thrown into his
room, by the frightened* BOY. *He takes the oil light and looks
into the shadows. He jumps out of the window into the
garden. He draws a dagger. Diving into a bush, he pulls out
the young* BOY.

BOY: Prince Tutanaten!
[*He falls on his face.*]
BOY: He has destroyed my lady. He has murdered her soul.
[TUTANATEN *grabs his armour.*]

60. BOUNDARY STONE

Nefretiti's body is reduced to ashes. AKENATEN, *looking like a holy man, has smeared them on his body. He is naked and sits among the ashes of his wife in the dawn light.* TUTANATEN *hides his eyes.* AKENATEN *remains unaware of* TUTANATEN.

61. SMENKHARE'S GOLDEN ROOM

SMENKHARE *is asleep. A servant pulls a curtain and the light shines across the livid make-up on the prince's face. He wakes with a start.*
SMENKHARE: What is it, Bek?
BEK: It's Prince Tutanaten. He's fled with your father's servant.
[SMENKHARE *is suddenly wide awake.*]
SMENKHARE: Call the guard. The prince is forbidden to leave Akhetaten. Quick Bek, fetch my hunting dogs.

62. DESERT

SMENKHARE, *armed horsemen and tracker dogs are following* TUTANATEN'S *trail in the desert.* TUTANATEN *sits in a cave. He is dishevelled and unshaven.*
TUTANATEN: We are safe here. Do not cry.
[*The* BOY *buries his head in* TUTANATEN'S *cloak.*]
TUTANATEN: What is your name?
BOY: Tothmes.
TUTANATEN: Tothmes!
[*He grabs him in his arms.*]
TUTANATEN: Look, Tothmes. They'll never discover us here. This cave was always my secret. I found it when I was

35

a boy like you, hunting eagles. I know the hills like a jackal. Look over there, behind that rock.

[*The* BOY *looks where* TUTANATEN *indicates*.]

BOY: Bread and dried fruit. Enough for days.

TUTANATEN: When my brother and his dogs have left, we'll pack enough provisions and then we will go to my mother in Thebes.

BOY: Thebes!

TUTANATEN: Yes, Thebes. The beautiful hundred-gated Thebes. The city of my ancestors.

63. DESERT

AKENATEN *sits in a state of trance in the ashes of Nefretiti. The* COURTIERS *sit at a distance watching him. There is a complete silence. No one moves.* AKENATEN'S *eyes are closed, his appearance wild and detached.* SMENKHARE *sits facing his father. He calls* BEK *over. He moves with great caution. They talk in subdued whispers.*

SMENKHARE: Take everyone back to the city. I shall sit with my father.

BEK: Shall I bring the healers?

SMENKHARE: No, it will pass.

[BEK *leaves. The whole company gradually withdraws in silence, stealing away leaving* AKENATEN *and his son alone*.]

[*A servant has brought water, which* SMENKHARE *has placed silently before* AKENATEN. *Neither has moved.* AKENATEN'S *eyes remain closed.* AKENATEN *is burning in the sun.* SMENKHARE *motions a servant who holds a sunshade over the Pharaoh*.]

SMENKHARE: Akenaten, living in truth.

[*There is a pause.* AKENATEN *opens his eyes and looks at* SMENKHARE.]

AKENATEN: Your love flows through my mind, like a drug mingled with wine.

[SMENKHARE *smiles, then looks at the ground*.]

AKENATEN: Your love drifts through my dreams like water

over polished pebbles. I did not make death and do not delight in it. I created all things to live. When life is extinguished the body turns to ashes, and the spirit dissolves like empty air. It is as though she had never been.

64. THEBES IN RUINS

TUTANATEN *and* TOTHMES *walk through the city of Thebes. Great columns and fallen statues gaze blindly at the sun. Everywhere is ruin and desolation. A half-starved dog howls in the deserted temples.*

SPHINX: [*Voice over*] The great columns of Thebes are fallen. The gods are without life. Akenaten has stolen their hearts. He has sealed the light in Akhetaten. There the days of eternity are counted, but Thebes is cast into darkness. The work of generations since the beginning is destroyed. He has destroyed the name of the gods to the end of the earth. So none will remember them. Like a wolf he entered Egypt and made war on the gods.

65. THE NILE

Queen TIYE *sits alone on a stone in the waters, as if she is standing on the water. Her ragged dress floats about her. She screams with a violence that sends the birds flying in all directions. Her presence is awe-inspiring. She is possessed by madness. On the rock are golden objects that have been left by pilgrims, who stand in the water about her.*

TIYE: My name is detested. It smells like a carrion on a summer's day.

[TUTANKHAMUN *slides into the water.*]

TUTANKHAMUN: Mother. I dedicate my heart to you.

TIYE: There is no one who can be trusted. Come nearer, stranger. Learn there is no wrong that roams the earth greater than mine.

[TUTANKHAMUN *removes the cloak that hides the corselet of Tothmes and the royal ureus. The people recognise him and fall back.*]

37

TIYE: My son, Tutankhamun. Amon foretold your arrival. You shall be given the white crown and wear the red crown. The heretic shall be cast into oblivion.

66. THEBES

TUTANKHAMUN *stands in the ruins of the temple. Four* PRIESTS, *representing the cardinal points, pour water over him in a simple ceremony. He is attended by General* AY *and the soldiers.*

PRIEST: He has come, he has come,
> The beloved of Ra has come.
> I caused him to come, says Horus.
> I caused him to come, says Seth.
> Content is Amon, father of the gods.
> Content are all the gods in the sky,
> All the southern and northern gods,
> All the western and eastern gods.
> Beloved Tutankhamun, Horus has put
> his eye on your brow,
> In the name of great magic.
> King of Upper and Lower Egypt.

TIYE: O Serpent, grant Tutankhamun conquer the two lands through your power. Let the slaughter he makes be like the slaughter you make. Let him be feared like you are feared. Let him destroy the heretic.
> [*Over the speech of* TIYE *a great warcry is sounded, with trumpets and the clashing of arms.* TUTANKHAMUN *draws his dagger and holds it high in the air.*]

TUTANKHAMUN: It shall be.

67. BATTLE IN THE DESERT

Bodies lie in the sand. The two brothers face each other on opposing sand dunes, wounded, covered in dust and out of breath. TUTANKHAMUN *throws a water skin to* SMENK-HARE. *He drinks and throws it back. The sun beats down mercilessly. The two brothers fight each other to a standstill.*

They stop and rest again. Not a word is spoken. The sun has started to set. As it touches the desert, SMENKHARE *falters.* TUTANKHAMUN *kills him in a frenzy. His body is dismembered like the body of Osiris in the shadows.*

68. NIGHT TIME. DESERT

With flickering torches, Queen TIYE *and* AY *search through the bodies, until they come upon* TUTANKHAMUN *lying unconscious amid the remains of* SMENKHARE. *The old woman sits in the desert cradling him in her arms. She sings a wordless lullaby, in which all the sadness and joy of the moment are mingled.*

69. AKHETATEN. SUNSHADE TEMPLE

AKENATEN *sits in the Sunshade Temple. He is silent and alone. Queen* TIYE*'s lullaby steals into his mind with the sound of the battle. He holds a scarab beetle in his hands. He looks at it. Now he hears a different sound. The screams of Smenkhare.*

70. STREET

AKENATEN *runs through the streets of Akhetaten.*

71. THRONE ROOM

TUTANKHAMUN, *surrounded by* SOLDIERS, *accompanied by* AY *and* TIYE, *sits on the royal throne in splendour.* AKENATEN *appears in the doorway. There is a silence.* TIYE *is holding the head of* SMENKHARE *in her arms.* AKENATEN *is turned into a fury at the sight. With a scream of anguish, he launches himself at* TIYE *and stabs her to the heart. He grabs* SMENKHARE*'s head and kisses it. The soldiers fall back.*

TIYE: You shall have no soul. Nor spirit, nor body, nor shade. You shall have no house, no shelter, no tomb, no

light. Your name shall be erased. Burning be on you to eternity!

72. DESERT

In the desert AKENATEN *sits alone with the body of Smenkhare. He has placed the pieces together. He sits motionless, staring into the sun.*

AKENATEN: I inhale the sweet breeze that comes from your mouth and contemplate your beauty every day. My desire is to hear your voice, like the sigh of the north wind. Love will renew my limbs. Give me the hands that hold your soul. I will embrace you. Call me by name again and again, for ever, and never will you call without response.

[*He stares motionless into the sun. We see that he is blinded by the sun. Slowly, as he is blinded, the light goes out.*]

JUBILEE

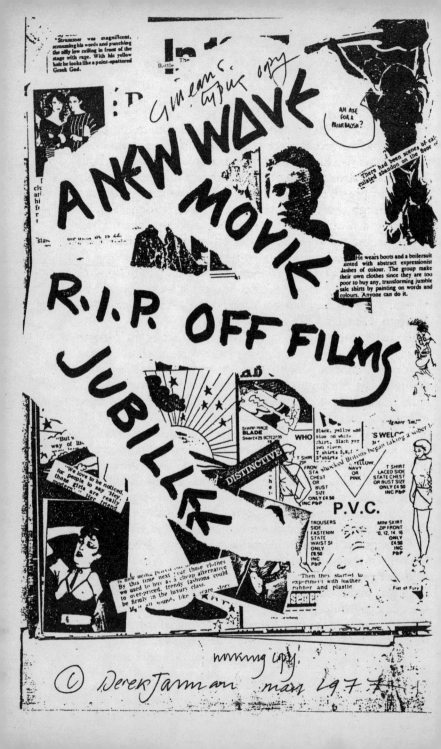

JUBILEE

I've put in the script for *Jubilee* to show one film in this book which was finished as a reference. Very little changed from the script as you have it here, just a couple of details. Adam, 'Kid', was murdered in a photo booth in a tube station – this proved impossible – I cut down the end as it went on too long, though there was one piece I liked, Jordan, 'Amyl', outfacing a rhino in the Longleat Safari Park. I wish I had kept that, but we were a long way off in a truck with keepers looking worried holding bull whips.

The film was cast with friends, none of them then known. The sources were fanzines and Frances Yates' *The Art of Memory* which had led me to read the renaissance texts: Agrippa, Giordano Bruno.

It always upset people. On the opening night Flower Power ladies danced in front of the screen, there was a continuous hubbub. The same anger that had crashed through the showing of *Sebastiane* in Locarno. Had I betrayed Punk as Vivienne Westwood's T-shirt would have us believe: 'Derek the Dull Little Middle-Class Wanker'? Or had Punk betrayed itself? How could you fight success?

In England at that time there was a political purity in artworks – woe betide if you didn't come from Barnsley – you were already lost. Provincial, parochial and still alive in the universities like Oxford. Even Tolstoy was second rate. Some aristo on a fallen estate, that's how I consoled myself in the face of so-called Social Realism, that was never real.

Throughout the shooting there was a long debate about the title of the film. *Jubilee* was changed to *'Honi Soit Qui Mal y Pense'* – evil to him who evil does – then 'High Fashion', an anarchic comedy of sex and violence. In the end we stuck to *Jubilee*; after all, 1977 was to be remembered as Jubilee year, and the film from the first stab of my pen to the final print took the whole of the year to make.

CAST

JOHN DEE, Court astrologer, alchemist and magician to Elizabeth I — Richard O'Brien

ELIZABETH I, the Virgin Queen, Astraea, paradigm of royalty — Jenny Runacre

BOD, Boadicea, Anybody, Queen of the new age. Antithesis of Elizabeth — Jenny Runacre

ARIEL, Angel, mercurial messenger, glitter punk, scintilla — David Horton

CRABS, Lovelorn, nymphomaniac, casualty of true romance — Little Nell

AMYL, Historian of the void — Jordan

MAD, Revolutionary and pyromaniac — Toyah

VIV, An artist, sympathetic, destroyed — Linda Spurrier

CHAOS, The silent French au pair — Hermine

SPHINX, Incestuous brothers — Karl Johnson

ANGEL, Incestuous brothers — Ian Charleson

KID, Musical simpleton — Adam Ant

BORGIA GINZ, Evil impresario — Orlando

MAX, Bingo playing mercenary — Neil Kennedy

1. THE GARDEN OF DR DEE'S HOUSE IN MORTLAKE. 1597

In the twilight Queen Elizabeth's dwarf SERVING WOMAN *walks through the avenue of ancient yews on the lawn of Dee's house. She is followed by huge spectral hunting dogs which tower over her.*

2. THE STATE ROOM OF DR DEE'S HOUSE

Queen ELIZABETH *nervously paces the room, her white dress frosted with jewels glittering in the shadows cast by the roaring log fire. Dr* DEE *is seated at the table concentrating on the shewstone with which he summons angels. The* SERVING WOMAN *enters the room and offers* ELIZABETH *a glass of mead, into which she drops a pearl.*

ELIZABETH: John Dee, some pretty distractions, which you call angels, call forth to forget our cares. Some aqua vitae to pass this hard night, for our pleasure, and this our gentlewoman.

JOHN DEE: Your Majesty as once a virgin fashioned the whole earth, so by a virgin it shall have rebirth, so says the old sage wisdom.

ELIZABETH: Dear our own Dr John, our triumphant antimony, our kingdom's eyes, this me pleaseth to see and have discourse with angels.

[ELIZABETH *sits at the table, John* DEE *takes his staff and pointing it to the four corners of the compass calls on the Lord.*]

JOHN DEE: Your Majesty, the spell we cast forth in the name of Christ Jesus and his Angelic hosts, calling forth a fiery spiritual creature our angel Ariel.

[*He concentrates on the shewstone.*]

JOHN DEE: Metratron! Angel commander of the ten hosts. I cast for Ariel pearl of fire, my only star. God's moonbeam, send forth my flower, my green herb.

The smoke and ashes of ages past which hangs like morning mists in veils across the universe parts in swirls and eddies, through them the shooting star. My angel flies with mirrored eyes leaving a sparkling phosphorescent trail across the universe,

down,

down,

he plummets towards earth, through the great vacuum, on the curve of infinity and like a fiery rose descends to Mortlake.

[*The room is irradiated by a burst of light as* ARIEL *materialises. Queen* ELIZABETH *jumps up frightened, shielding her eyes against the glare.*]

ARIEL: All hail, great master! Grave sir, hail! I come to answer thy best pleasure be it to fly, to swim, to dive into the fire, to ride on the curled clouds to thy strong bidding task, Ariel and all his quality.

ELIZABETH: This vision exceedeth by far all expectation. Such an abstract never before I spied.

JOHN DEE: An angel, your Majesty is the sun's true shadow – Spirit Ariel! Her Majesty seeks to have knowledge, to swim in those pure waters that are the essence that bind all creation.

ARIEL: By me this task shall be performed, for I am that noble and clarified spirit by which thy mayest turn all metals into the most pure gold. Sweet Majesty pluck up thy heart and be merry for I shall reveal to thee the shadow of this time.

3. POST MODERN

A GANG OF YOUTHS *wander through the fires which flicker in the ruined industrial landscape, aimlessly kicking empty beer cans. A Rolls Royce propelled by unseen hands glides down an empty street behind corrugated iron barriers.*

Under the graffitied wall of a derelict house on which are sprayed the words POST MODERN, *the* YOUTHS *loot from the* DEAD AND DYING, *a* SMARTLY DRESSED MIDDLE AGED WOMAN *and an* AFFLUENT HIPPY. *The Rolls Royce with its angel of death has passed, in the silent and empty street a* YOUNG WOMAN *with a pram is assaulted by a gang of* TRIBAL GIRLS *with garish make-up and safety pins through their noses. An* AGGRESSIVE LOOKING GIRL *with scarlet hair, dressed in paramilitary and carrying a machine gun marches the* GIRLS *off at gun point.*

MAD: All right, move – right up there. Quickly! Run, come on, run!

[*The street empties now. It is silent except for the distant gunfire and the crackle of the flames from the burning pram. There is nothing for our comfort in our back yard.*]

4. THE WORLD'S END

A hand spins a blue globe blotched with a black cancer. Written on the carefully deleted countries are sinister messages:

NEGATIVE WORLD STATUS
NO REASON FOR EXISTENCE
OBSOLETE

A hand turns the pages of a book with scrubbed-out images of sexual bondage which resemble the stockinged and balaclava'd features of bank robbers and terrorists.

5. THE H.Q.

A cavernous decaying room in which the discarded artefacts of our dying civilisation are assembled. Pell Mell. The walls are sprayed with graffiti: 'TRIUMPH OF THE WILL', 'ART DEGRADED, IMAGINATION DENIED, WAR GOVERNED THE NATIONS', *other slogans, and the sainted killers of our time, a TV, a mattress, a gilded throne, all lit by the exhausted light from one naked light bulb.* MAD *has assembled the* GIRLS *from the street and sat them down at*

machine gun point. A classroom where order is kept with the barrel of a gun. She slams the bolt of the gun. The GIRLS *giggle nervously.*

MAD: All right, girls. We are proud to welcome Miss Amyl Nitrate, England's glory who's going to tell us the exciting history of her misspent life.

[*She gestures to* AMYL NITRATE *who sits at a formal lecture table covered with a Union Jack, on which stand the book and the globe. Behind her the walls are daubed with slogans. She folds her hands and stares at her audience, a image of propriety in pink twin set and pearls and elegant futurist make-up.*]

MAD: The world is no longer interested in heroes. SO SAD. We now know too much about them, don't we? Do you remember any real heroes? No? I don't! Anyway, let me introduce you to Amyl Nitrate. SHE'S OUR HEROINE!

AMYL: Our school motto was 'Faites vos désirs réalités', make your dreams reality. Myself, I preferred the song, *Don't Dream it, Be it.* In those days desires weren't allowed to become reality, so fantasy was substituted for them.

Films, books, pictures. They called it art, but when your desires become reality, you don't need fantasy any longer, or art.

[*She pauses and pours herself a glass of water from a milk bottle.*]

AMYL: I always remembered our school motto. My heroine was Myra Hindley. Do you remember her? Myra's crimes were they said beyond belief. That was because no-one had any imagination then. They really didn't know how to make their desires reality. They were not artists like Myra. One can smile now at the naivety. When on my fifteenth birthday law and order were finally abolished, all those statistics that were a substitute for reality disappeared. The crime rate dropped to zero. Who believed in statistics then? Except for the vital ones. In any case, I started to dance. I wanted to defy gravity.

[*She slowly and delicately sprays herself with perfume*

48

and replaces the bottle in a musicial make-up box with a
ballerina who turns in time to the music.]

6. THE BONFIRE OF VANITY – A FLASHBACK
SEQUENCE

Deliberately scratchy and degraded, cut like a home movie
to romantic ballet music. AMYL *in a classic white tutu dances*
round a bonfire, the setting between iron sheds in a scarred
industrial landscape invaded by scrub. A BOY *with long*
golden hair circles around the fire fuelling it with books, one
of them, called My Life and Times, *blisters in the flames*
which consume a Union Jack. Masked figures representing
art, Michelangelo's David, and death watch impassively.
The BOY *who throws the books cuts his golden locks until he*
resembles a shorn penitent. The burning of the books,
Savonarola's bonfire of vanity. CONTRO I CAPELLI LUNGHI
against long hair, a new puritanism.

7. H.Q. LESSONS IN HISTORY

AMYL *selects books from the shelves of her library. She sits*
at her desk.

AMYL: I haven't danced for a long time. No-one's interested
in the ballet any more – but history still fascinates me – it's
so intangible. You can weave facts any way you like.
Good guys can swap places with bad guys. You might
think Richard III of England was bad, but you'd be wrong.
What separates Hitler from Napoleon or even Alexander?
The size of the destruction? Or was he closer to us in time?
Was Churchill a hero? Did he alter history for the better?
Now my friend Mad on the sofa is a pyromaniac, but she
thinks she's a revolutionary out to better the world. I'm
not so sure. The boys on the bed are Sphinx and Angel,
they're from Deptford and brothers. Their relationship is
quite peculiar, but they're nice enough. And over there at
the basin is Chaos, our French au pair. Life in England
these days is inflationary, but we're carrying on regardless,
coping with misgovernment and idiocy on every side.

[AMYL *picks up her perfume bottle and dabs her neck and hands.*]

AMYL: Carnation from Floris, not all the good things have disappeared.

[*During this speech* MAD, ANGEL, SPHINX *and* CHAOS *are presented in a series of vignettes.* MAD *sitting on a disembowelled sofa reading an eerie comic, flicking a lighter on and off with its pressure turned up so the flame is a foot high.* SPHINX *and* ANGEL *pallid and famished reading atrocities from the yellow press in bed and* CHAOS *a glamorous drudge doing the washing up. The sequence ends with details of the posters glued to the walls. A ripped and torn image of Queen Elizabeth II scrawled with the word* SUPERSTAR *in lipstick and an image of Hitler complete with moustache made of staples and the words* BRAVE NEW WORLD.]

8. THE QUEEN IS DEAD LONG LIVE THE QUEEN

BOD *the leader of the gang dressed in a man's dinner jacket pursues the second* QUEEN ELIZABETH *with scarf and hunting jacket through the wasteland. Her terrified quarry clutches a carrier bag. She corners her victim. The sound of distant gunfire. A* CHILD *picks up a diamond, holding it up to the light he squints through its facets. The sound of breaking glass.*

9. H.Q. HEALEY'S BUDGET STRATEGY IN RUINS

AMYL NITRATE's *Winston Churchill mug smashes to the floor.* MAD *stops reading.*

AMYL: Shit.

MAD: What's up, Amyl?

AMYL: I've broken my Winston Churchill mug.

MAD: Don't worry, we'll stick him together.

[*The two of them scrabble around on the floor picking up the pieces.* MAD *notices* AMYL's *history book on the desk and picks it up with a fiendish laugh.*]

MAD: Teach Yourself History by Amyl Nitrate.

[*She glowers at* AMYL *and makes off with the book.*]

MAD: Number one. The history of England. It all began with William the Conqueror, who screwed the Anglo Saxons into the ground, carving the land into theirs and ours. They lived in mansions and ate beef from fat tables, whilst the poor lived in houses minding the cows on a bowl of porridge, whilst they pushed them around with their arrogant foreign accents. There were two languages in the land.

ANGEL: What two languages?

SPHINX: Chinese and Liverpudlian. How do I know?

ANGEL: What about Norman?

SPHINX: Norman who?

MAD: There were two languages in the land and the seeds of war were sown. At first the two sides co-existed, meeting on the racetrack and the battlefield, where they fought the rest of the world, that's you, Chaos! who they despised more than each other. One day when there was no-one left to fight, it dawned on them that the real enemy was at home, and they should fight amongst themselves. Having grown greedy on the booty they had looted from the world they decided to fight with money, but by now this was made with paper and was pretty worthless, so when they discovered this they took to fighting with guns. The rest of the world sighed a sigh of relief to be rid of them and got on with their own business, and England sunk into the sea. Who you writing this crap for, Amyl?

AMYL: Myself, it's a hobby. When I'm not making history, I write it. I try to compress it. It would be great if all history could be written on a mandrax.

[MAD *flicks on her lighter with an evil grin.*]

MAD: This is how you compress it. You forget it.

[AMYL *seizes her book back and attacks* MAD *who collapses onto the bed with* SPHINX *and* ANGEL.]

AMYL: I'll compress you!

SPHINX: Fuck off, Mad.

MAD: Help me, Sphinx, Amyl's a raving lunatic. I'm a damsel in distress.

ANGEL: You clammy slag, you've sat on the K. Y. with your fat arse!

MAD: Fuck off.

[*The door bell sounds.* BOD *breaks into the room.*]

BOD: Shut your eyes. All of you!

[*She runs up the stairs and throws open the balcony windows revealing herself crowned with the Imperial State Crown.*]

BOD: Rata tat tat a tat!

SPHINX: Where did you get that from?

BOD: I captured it in Deptford. It's High Fashion.

10. WASTELAND

ELIZABETH, *John* DEE, ARIEL *and the* LADY IN WAITING *have materialised in the wasteland of Deptford at the scene of the murder.*

JOHN DEE: Now shall one King rise up against another, and there shall be bloodshed throughout the whole world. Fighting between the devil, his kingdom, and the kingdom of light.

[*The* SERVING LADY *stoops and steals a pair of sunglasses from the corpse. She puts them on and stares around her incongruously.*

The small BOY *who has stolen the diamond sits alone by a fiery maze he has constructed from petrol and sawdust. The* SERVING LADY *creeps up on him and surprises him. The frightened* BOY *gasps at this apparition from another world and runs off dropping the diamond, which the* SERVING LADY *picks up and pockets after examining it carefully.*]

11. KAYLAMITY KAFE

A smoky green light drains the colour from the tawdry formica café. A PALLID WAITRESS, *ash blonde, smears scarlet lipstick staring at her wounded reflection in a blistered mirror.* CRABS *relaxes with a cigarette. She has bought a meal for a* YOUNG MUSICIAN.

CRABS: What did you say your name was?

KID: Kid.

CRABS: Want some more eggs?

KID: No thanks.

CRABS: Cigarette? . . . What do you do?

KID: Nothing – I'm a musician.

[*She leans forward and removes the boy's glasses.*]

CRABS: You're gorgeous. I could get you a job with Borgia Ginz, he owns the media. My name's Crabs by the way. I'm an actress, did you ever see *War and Peace*?

[*The conversation is interrupted by the arrival of* BOD *and the rest of the gang.*]

BOD: Tea please.

[*She rattles the knives and forks in the tray.*]

CRABS: Where's Amyl?

MAD: Burning the midnight oil, working on her decline and fall.

KID: Who's that?

CRABS: That's Bod.

MAD: She's royalty.

KID: I don't like the way she looks, my dad has a suit like that.

CRABS: I think it's kinda nice. She liberated it from a Russian diplomat she fucked at the Dorchester. After he came she put on his clothes in the dark. She found a thousand pounds in his pocket. She wears it for luck now.

MAD: You're a sucker for sex, Crabs. Why don't you keep up with the times?
You're an antique like this place.

[MAD *crosses over to the counter and thumbs through the postcards on a stand.*]

VIV: What's the postcard, Mad?

MAD: It's New York. And you can forget it. It just had the bread to con the rest of the world. America's dead. It's never been alive.

[BOD *has stolen a box of Black Magic chocolates. She opens them, stabbing the contents with a fork. She prongs a chocolate and forces it into* CHAOS's *mouth.*]

53

BOD: Montelimar. It had better be.

MAD: Why don't you read the label, Bod?

[MAD *starts to chuck the postcards all over the Kafe.*]

MAD: All these ruins. All this concrete, brick and glass, and the people who made them are utterly forgotten. The prisons we live in today may have taken longer than a day to build but it doesn't take long to destroy them.

[*She throws the rest of the postcards across the room. The* WAITRESS *attacks her.*]

WAITRESS: You cow, get out of my place!

SPHINX: Come on, let's split before she burns the place down.

MAD: Nobody's going to help you, so help yourself.

[*She grabs the* WAITRESS'*s blonde wig, and* BOD, *seizing the ketchup bottle, comes into the fray, pouring it all over the* WAITRESS'*s face, like sodden chips.*]

MAD: If your house is ugly then burn it. If the streets you live in depress you then bulldoze them down. And if the cook can't cook then you kill her, all right?

[MAD *puts on the blonde wig.* BOD *carries on the assault.*]

MAD: For a moment I thought you would kill her.

BOD: Just a dress rehearsal.

12. THE ARTIST'S STUDIO. NOTHING IS OF NOTHING MADE

Viv's room, Spartan. Empty, painted black.

VIV: Oh, I was glad to get away. Mad's so crazy.

SPHINX: Not to worry.

VIV: Well, I know she's right. That's what upsets me.

SPHINX: Bit bare in here, isn't it?

ANGEL: Well, she's got a bed!

SPHINX: What do you do in here all day?

VIV: I'm a painter, an artist.

[SPHINX *looks around the empty room in disbelief. The only object is a radiator He taps it.*]

SPHINX: Very good! . . . didn't know there were artists any more.

VIV: There aren't – painting's extinct. It's just a habit. I started painting when I was eight copying dinosaurs from a picture book. It was prophetic.

SPHINX: I'm alive.

ANGEL: So am I.

VIV: Artists steal the world's energy.

SPHINX: Bet they never get caught.

VIV: Always! They become blood donors. Their life blood drips away till they're bled dry, and the people who control the world make it as inaccessible as possible by driving the artists into corners. Our only hope is to recreate ourselves as artists, or anarchists if you like and liberate the energy for all.

SPHINX: My brother's an artist. A piss artist.

13. H.Q. BOREDOM

The TV plays 'Love in a Void it's so Dumb'. BOD *is admiring her crown, humming 'Diamonds are a Girl's Best Friend'.* AMYL *is reading* Lenin, a romance. CRABS *and the* KID *are watching the TV from the bed.* MAD *knocks back a Special Brew. An atmosphere of disenchanted boredom. Inertia hangs over the room like a shroud.*

AMYL: What a fucking awful day.

BOD: Quite new wave, don't you think?

[*She admires the crown.*]

I'm going to convert it into a crash helmet. That would give it some use.

CRABS: Yeah, that would be distinctive. Why didn't you steal the pearls as well?

BOD: I never liked pearls or oysters.

AMYL: Pearls are for the pure.

CRABS: And the world's your oyster so swallow it.

[*She sinks her teeth into the* KID's *arse.* BOD *crosses over to the TV.*]

BOD: What's that?

MAD: *Top of the Pops.*

BOD: What, again!

MAD: They believe in overkill.

CRABS: He's cute. Who is he?

BOD: How should I know . . . Come on, you morons, what are we going to do this evening? The only thing that's open after eleven in this fucking country are the police cells.

MAD: Right on, Bod. If you're bored, join the National Front.

CRABS: Why don't you take up embroidery, doll?

BOD: There's so little electricity in this country, maybe it's fused.

[*The phone rings.*]

BOD: Real help at last . . . HELLO!

CRABS: Most people would hang up. She's hanging on for dear life.

MAD: Who is it?

BOD: Borgia Ginz. He wants me to meet his latest find.

KID: I thought you were going to introduce me to Borgia Ginz.

CRABS: I don't give away my connections that easily. You've got to convince me you're worth it first.

[*She pulls the clothes off* KID. BOD *leaves and* AMYL *seizing the Imperial Crown, inverts it.*]

AMYL: How the mighty are fallen. Well! She's in for a surprise.

14. RULE BRITANNIA

BORGIA GINZ, *the sinister impresario of mediocrity. He owns the media. King of Kapital and the Kathode sits in an empty opera house eating live goldfish from a bowl. The silence punctuated by his hysterical laughter.*

BORGIA: You wanna know my story, babe, it's easy. This is the generation who grew up and forgot to lead their lives. They were so busy watching my endless movie. It's power, babe, Power! I don't create it, I own it. I sucked, and sucked, and sucked. The media became their only reality and I owned their world of flickering shadows. BBC, TUC, ATV, ABC, ITV, CIA, CBA, NFT, MGM, KGB, C

of E. You name it, I bought them all and rearranged the alphabet. Without me they don't exist.

[*The curtains part to reveal* AMYL NITRATE, *a shell-shocked Britannia in a sea of dry ice.*]

BOD: It's Amyl Nitrate!

BORGIA: She's England's entry for the Eurovision Song Contest. She's my number one.

[AMYL *spits out 'Rule Brittania', goosestepping across the stage, a vision of disaster.*

On the soundtrack: Mayday, mayday, it's the people's death cry. Mayday, mayday, it's paradise, baby, the people's paradise. Hitler's hysterical speech jabbers through the football crowds chanting, 'England! England! England!', dive bombers, explosions.]

15. IDYLL

ELIZABETH *and John* DEE *walk through an English garden.*

DEE: To you, Elizabeth of England, is granted the greater vision. That man perceives but little and rarely beyond this labyrinth and the serpent of memory is the still point of the world, that gateway which man seeks. It is everywhere and nowhere. It is here and now, round it time runs in a circle. In you is the beginning and the end and the forgetfulness beyond. Every deed you accomplish accompanies you throughout time. He who sings with joy will be continuously greeted with joyfulness, but he who murders will swim in blood lapping against the bounds of time.

ARIEL: Consider the world's diversity and worship it, by denying its multiplicity you deny your own true nature. Equality prevails not for the gods, but for man. Men are weak and cannot endure their manifold nature.

16. SEX 'N' VIOLENCE

CRABS *and* HAPPY DAYS *are fucking in pink polythene sheets.* BOD *sits and watches, eating her breakfast cereal, naked except for the Imperial State Crown.* MAD *armed with a Polaroid camera snaps away.*

CRABS: He's great, isn't he? I picked him up at the Roebuck.

MAD: What's your name?

HAPPY DAYS: Happy Days.

MAD: Where ya from?

HAPPY DAYS: World's End.

BOD: Why encourage them, Crabs? You'll only get the clap.

CRABS: Tough shit, you virgin Queen. Where were you last night? Anyway, I like him. He's got a great arse.

MAD: Yeah, he's a real sex object, a real cute sex object.
[HAPPY DAYS *stops fucking her and smiles.*]
Hey! Back to work. No tea breaks.

BOD: For Christ's sake, Crabs, leave off, what do you see in these damned studs? Hey you, why don't you push off?

CRABS: Leave the guy alone, he's better than a vibrator, and bigger. Don't mind her, her parents were Christians. She was born with a hang-up.

HAPPY DAYS: I'm coming!

MAD: Another hit and run merchant. You hold it, mate, or it's curtains for you. Don't you spurt until she tells you. They all want to cream quick as a flasher's zipper, he's a lower form of life.

BOD: It's more than I can stomach, a blue movie for breakfast.

MAD: Oh, I like to watch.
[CRABS *handcuffs* HAPPY DAYS *while* MAD *puts a black leather mask on her, then between them they seize the polythene sheets and strangle the one-night stand.*]

HAPPY DAYS: Fucking hell.

MAD: Neat neat neat, that's it, perfect.
[*She seizes her polaroid and takes a rapid succession of Polaroids as* HAPPY DAYS *dies.*]

BOD: Do you think he's dead?

MAD: Dial 999.

17. IMPERIAL THEME TUNES

KID *climbs the steps of the Albert Memorial. He sits gazing towards the Albert Hall drinking from a milk bottle. Behind him a stony frieze of ash-white composers co-opted in death to support Empire and Mammon. Roll me over Beethoven – Mozart. Berlioz's* Requiem *on the sountrack.*

18. GOODBYE TO ALL THAT

Wrapped in its polythene shroud, MAD, CRABS *and* BOD *heave the body of* HAPPY DAYS *into a muddy backwater of the Thames. The body lies like a scar on the mud flat. The gang sit on the river wall.*

CRABS: It makes me rather sad.

BOD: Oh, cut it out, Crabs.

CRABS: For a moment I thought he might be the one.

BOD: Shit, your mind's blown, Crabs.

CRABS: What, are you all against me?

BOD: We're not. We're just saving you from yourself.

MAD: Yeah, you're just a faded collage of *Penthouse* and *True Romance.*

CRABS: Just for a moment I fell in love with him.

BOD: Love snuffed it with the Hippies.

MAD: Sex is for geriatrics. Mindless.

[*They look over the side of the dock at the body. The song 'My Love is Like a Red, Red Rose' steals into the scene.*]

19. RIGHT TIME WRONG MOMENT

ANGEL *and* SPHINX *lie in bed with* VIV.

SPHINX: It's your turn, Viv. Us boys are stepping back. We've been in the limelight for five thousand years.

ANGEL: Great, isn't it? He hands over to you just as time runs out, when there's no chance. That's what I call friendship.

VIV: Well the end is inevitable. It's either now or later. It's what makes the present so vital.

SPHINX: Take your partners for the last waltz.

[VIV *lights a cigarette.* SPHINX *stares into* ANGEL's *eyes.*]

ANGEL: I love you.

SPHINX: I love you, Angel.

VIV: And I love you both. You seem to have got things sorted out.

ANGEL: Why look for anything else. Time is so short. All that desperate search for one place that's better than the next.

SPHINX: My brother's great, isn't he?

VIV: Perfect.

[*She goes over to the blacked-out window and opens it. A shaft of sunlight falls across the room.*]

VIV: The sun's out. Let's go out.

20. FUTURE PROSPECTS

CRABS *and the* KID *sit on the railings outside Buckingham Palace*

CRABS: It's the biggest studio in the world, Kid, Borgia bought it from the liquidator.

KID: Christ, it's huge.

CRABS: Borgia does everything with style.
You didn't believe me, did you?

21. PARANOIA PARADISE

Inside Palace Recording Studios, BORGIA *sits in a recording booth with his slick henchman* SCHMITZER. MAD *is auditioning with her song 'Nine to Five,' prancing like a demented genie.* BORGIA's *jewelled fingers slide across the control desk. The telephone rings.* SCHMITZER *answers it.*

SCHMITZER: Sir, that was Wall Street, they say the dollar's crashing without your support.

BORGIA: I'm not interested in peanut economies, Schmitzer. Now, let's get down to the real business.

SCHMITZER: Well, sir, we've sold fifty million copies of 'Paranoia Paradise' in Moscow alone in the last three days. Lounge Lizard is number one.

BORGIA: As long as the music's loud enough we won't hear the world falling apart.

[*He collapses in fiendish laughter.*]

SCHMITZER: There was a message earlier from Madame
 Mao. She said she wanted to be in a film.
BORGIA: She won't be in this one, I can assure you.
 [CRABS *and the* KID *sneak into the room.*]
CRABS: I hope I'm not interrupting, Borgia. This is strictly
 business – I've been doing a little talent scouting. This is
 the Kid. He's pure sex, I'm going to be his manager.
BORGIA: Well what can I do for you? Or rather, what can
 you do for me?
 [*He eyes the boy malevolently.*]
KID: Hello, Mr Ginz.
CRABS: Oh! You see he's a natural. He's going to be the
 new Garbo.
SCHMITZER: Garbo was very profitable.
BORGIA: I'll take him into the theatre and audition him.
 Just for you, Crabs.
CRABS: I'll call Bod. She'll be so jealous.
KID: I don't care about the money. I just don't want to get
 ripped off.
CRABS: Sssh!
 [*She claps her hand on his mouth and laughs with
 embarrassment.*]

22. GATHER YE ROSES WHILE YE MAY

A rose hedge blooms in desolate suburbia. ANGEL *clambers
on* SPHINX's *shoulders to pick the full blown blooms which
fall to pieces in his hands. On a third attempt he picks a
flower and presents it to* VIV.
SPHINX: I know where there are some real flowers.
ANGEL: Where?
SPHINX: Max's.
ANGEL: It's a bit far, isn't it?
SPHINX: We can go by car.
They search in the bushes and find a brick which SPHINX
throws through the window of a car parked at the kerbside.

23. FAILED HOPES

MAX's *garden is entirely made with plastic flowers. The*

*brash mercenary in his Hawaiian shirt is scrubbing them
with warm water and detergent. He is interrupted by the
doorbell.*

SPHINX: Hi, Max. This is Viv. She's a friend.

MAX: Wipe your feet, son.

SPHINX: Praying for rain? Hello, Bod.

BOD: Hello.

[VIV *looks round the garden in disbelief.*]

VIV: What a crazy garden.

MAX: Yeah. It suffered from a bad case of weeds. I sprayed
it with poison. It looked kinda sad so I planted these
plastic petunias.

BOD: Max has been telling me of his adventures as a
mercenary since he gave up the army.

MAX: The army was a fucking con. It was their way of
solving the unemployment problem before they gave up
entirely. You're more likely to die of red tape than a bullet
in the guards. I ran a side line selling the boys to the local
punters in the pub. The army sees more action in bed these
days. Dammit! This carnation's got mildew.

[*He sprays the flower with an aerosol.*]

MAX: We never got a chance to kill anyone in the army, so I
killed the weeds in the garden of an evening instead.

VIV: Yeah. It must be frustrating in the army.

MAX: You're not kidding! To think the world's sitting on
enough megatons to blast the sunrise into the west and no-
one's prepared to press the fucking button. It's a bleeding
waste. Think what it all costs! I pay my taxes.

SPHINX: They're probably so bored they haven't got the
energy.

MAX: Yeah. War got so big it lost all contact with people.

SPHINX: Yeah. Well, the reaction's set in, it's moved back
onto the streets.

MAX: The politicians helped though. They demoralised
everyone so much talking about devalued money since it's
all most of us cared about. Their popularity died with the
pound. Funny when you try for one thing you end up with
another. Personally though, I prefer the world dead. It's

cleaner. My idea of a perfect garden is a remembrance poppy field. There's a caterpillar! My god, there's a fucking caterpillar in the tulips!

[*He squashes it and eats it.*]

VIV: Ugh!

MAX: What the hell, it's full of protein.

24. WHAT'S IN A NAME?

BORGIA *and his entourage stand watching as the* KID *performs* 'Plastic Surgery' *in the audition theatre. The song comes to an end.*

BORGIA: You're signed up! Now! What are we going to call you? SCUM. Ha ha ha ha! That's it, SCUM! That's commercial. It's all they deserve.

[SPHINX *comes over and puts his arm round* KID *who is disentangling himself from the electric leads.*]

SPHINX: Take my advice, stick away from her. Look, the music industry's dead. You're better off on the streets, it's not worth it. He'll steal your voice and sell it. He doesn't care if the mindless public hear your words or not. He just wants to package you, and when he's through with you, you'll be just another face on another album. Why don't you come along and sing to me?

25. BUILDING THE PAST PRESENT

High on the rooftops ANGEL, SPHINX *and the* KID *look out over the desolate city. Pools of water, a distant siren, grey tower blocks and the crack of gunfire scored with* BORGIA'*s demented laughter.*

ANGEL: Then the devil came unto him and took him to a very high place and showed him all the boroughs of London and the devil said, 'I'll give you all this if you go down on your knees', and he answered knowing full well that it was built by the Department of the Environment and was a rip off, 'Fuck off, Satan.' And an angel came and ministered unto him.

[*The* KID *smiles and sloshes his feet in the puddles.* SPHINX *points to a distant tower block.*]

SPHINX: That's where Angel and I were born; never lived below the fourteenth floor till I was old enough to run away. Never saw the ground before I was four, just locked alone with the telly all day. The first time I saw flowers I freaked. I was frightened of dandelions. My gran picked one and I had hysterics. Everything was regulated in that tower block, planned by the social planners to the lowest common denominator. Sight: concrete, sound: the telly, taste: plastic, touch: plastic, the seasons regulated by the thermostat. Once a year my mum and dad dusted down the plastic Christmas tree and exchanged pathetic presents. Didn't know I was dead till I was fifteen. Never experienced love or hate. My generation's the blank generation.

[*The* KID *who has been watching this soliloquy with amusement breaks out laughing.*]

26. H.Q. HOTELS ON THE OLD KENT ROAD

The gang sit around the Monopoly board lit by the flickering light of the TV.

AMYL: Home and dry. It's my lucky day.

CRABS: You threw a double.

AMYL: I've won a beauty contest. Collect ten pounds from each player, and quick. I'll trade Whitehall for Piccadilly.

BOD: Don't do it, Crabs.

AMYL: Oh shut up!

CRABS: I'll give you Piccadilly, two hundred pounds cash, a deal under the table and all of British Rail.

BOD: What's a nice girl like you doing trading Piccadilly? You'll be lost without it.

MAD: I'm spaced. Let's call a halt, Amyl will win in any case. Anyone who can afford to build hotels on the Old Kent Road is bound to.

BOD: I'm going to make some tea, go and get the BLACK BOOK. Amyl, let's plan the future.

[BOD *makes the tea while* AMYL *searches for the Black Book, a picture book of the success stories of the swinging 60s.* BOD *picks it up and throws it with relish so it demolishes the Monopoly board.*]

BOD: Goodbye, Baby and Amen.

[*She flicks over the pages. The photos are scrubbed out with bloody marks.*]

BOD: Couples! What could be better?

CRABS: Singles!

BOD: Must be someone pretty somewhere . . . what about meeting him on a dark night.

AMYL: Fuck, there's no-one left.

CRABS: SUCCESS!

[*Their attention turns to the television where the silent image of* LOUNGE LIZARD *performs.*]

BOD: Who's he?

AMYL: Lounge Lizard. Think he's still alive?

BOD: Never heard of him.

CRABS: He looks like death.

MAD: Kiss of death.

BOD: The world won't miss his missing chromosome.

CRABS: You're crazy, Bod – let's go!

[*The gang stumble out the door.* BOD *flicks her knife open over the image of* LOUNGE LIZARD *on the TV.*]

27. PARANOIA PARADISE

The record that sold millions mingles with the roar of the gang's bikes, headlights blazing.

28. PURE NOWHERE

LOUNGE LIZARD *in catatonic drag performs his own song to the television in an apartment where conspicuous spending has bought nothing.*

LOUNGE LIZARD: I'm on TV again! This is the hit that earned me millions.

Song: Late last night after I went to bed

I felt a demonic feeling in my head
Paranoia Paradise
Is surely going to be the death of me . . .
Now Eve didn't think that the devil was mad
To her he was an angel that just turned bad
No red is the word . . .
That well known communist
Part of God's heaven is what the devil had

[*He throws his champagne glass over his shoulder, it smashes against the wall.*]

LOUNGE LIZARD:
 I'm so rich, I'm so filthy rich
 I could eat my own glasses.

[*Still singing he crosses the room and sits at his drum kit.*]

LOUNGE LIZARD: A star shines forever.

BOD *materialises from behind the piano, tapping her fingers on the drum. She seizes* LOUNGE LIZARD, *whipping the microphone lead round his neck, ramming the mike into his mouth to record every last syllable of terror.*]

BOD: Good evening, punksters. This is Miss Slaughter bringing you the very latest in important world events. Tonight we have Lounge Lizard who's granted us an exclusive interview from the privacy of his own home.

[*She throws* LOUNGE *to the floor.* MAD *switches on the metronome which ticks his life away as* BOD *tightens the cord.*]

BOD: Now first of all, Lounge, tell me what it's like to be dead? Boring! Fucking great! I bet you're loving it. I'm so sorry. However we do allow you to take seven records with you of your own choice.

[LOUNGE LIZARD *expires in a froth of pink bubbles.* CRABS *smiles sitting on the sofa reading* Beauty in Vogue, *whilst* AMYL *hits a tambourine.*]

BOD: What a taste. What a buzz. Amyl, get us a Coke.

29. DARK PARABLES

ELIZABETH, DEE *and* ARIEL *materialise in the dead star's*

flat around the body.

ELIZABETH: A great chill embraceth this place. 'Tis a true marvel. What signifieth this death? A dark parable it is to my understanding.

DEE: Light and dark, living or dead, mankind is attracted to the polarities.

ARIEL: Seeing or not seeing.

ELIZABETH: My sweet angel, little I thought to be thus transported from my dear England.

ARIEL: Qui cunge in hoc speculum inspicit partes sapientiae totus mundi in illo videre et addiscere potest.

ELIZABETH: Spirit Ariel, we would have knowledge of God. Where is God? Is God dead?

ARIEL: Please your Majesty, gaze deep into the crystal.

ELIZABETH: We Elizabeth of England, a feather in the wind of time, pray for knowledge of God in the great whirlwind of shadows on the edge of the abyss.

30. THE TEMPLE OF HEAVENLY DELIGHT

ANGEL *stands on a soapbox outside Westminster Cathedral.*

ANGEL: Save your souls. Welcome to the palace of heavenly delight.

[*In the crypt* CHRIST *and the* TWELVE APOSTLES *perform a dance to a disco version of* Jerusalem.]

Song: And did those feet
 In ancient times
 Walk upon England's mountains green
 And was the holy lamb of God
 On England's pleasant pastures seen?
 And did the countenance divine
 Shine forth upon our clouded hills
 And was Jerusalem builded here, etc . . .

[*Outside a black Rolls Royce draws up.* BORGIA GINZ *climbs out dressed as a cardinal.*]

ANGEL: And now here's the man who made it all possible. Cardinal Borgia Ginz. The man who picked up the thirty pieces of silver and made the movie you saw on TV. This is

your last chance, folks, so come on in. Borgia Ginz is giving up the theatre and going into the car park business.

BORGIA: Without progress life would be unbearable. Progress has taken the place of heaven. Ha ha ha ha! It's like pornography, better than the real thing. They prefer the shadows, the light's too cruel for them. Ha ha ha ha! They're all working for me, and they follow blindly – I'm their life insurance.

[*Deep in the crypt the disco has turned into an orgy, the most enthusiastic and violent participants, the* POLICE. *The* TWELVE APOSTLES *fuck* CHRIST *to the tune of* 'Wargasm in Pornotopia'.]

31. THE ANTI-MATERIAL

Gangs of alienated kids roam the streets, destroying the last vestiges of an affluence that covered the abyss. A car is disembowelled while the conniving POLICE *watch with amusement. A* RICH BITCH *is wound to death in barbed wire in front of a huge billboard of Pisa. Hands clawing at her paste jewels.*

32. H.Q. ANOTHER HISTORY LESSON

BOD *is lying on the bed.* MAD *is cutting the word* LOVE *on her back. The* BOYS *watch the TV with* VIV, *while* AMYL *reads from her history book.*

AMYL: Hey Mad, do you want to hear my new chapter, 'Civilisation'?

MAD: What, are you going to serialise it? Hey hold it, everyone, another Mandrax history lesson from Amyl.

AMYL: Fuck you. Here goes in any case . . . On human rights: human beings have no rights, but some dumb fuck told them they had them. First, political rights. Freedom of speech and things like that. And if that wasn't enough they were told they had material rights too. They forgot about the political rights soon enough, but they got hooked on the material ones. One desolate suburban acre and a car. And then a TV, fridge and another car. That was by right,

mind you, and the habit demanded more and more. The day came when the expectations couldn't be fulfilled any longer, and everyone felt cheated. So here we are in the present, with civilisation destroyed by resentment, but since civilisation itself was always fucking awful for everyone, who gives a shit? We're better off without it.

[*There is a long silence as* MAD *finishes carving* LOVE.]

BOD: Go and find the salt, Mad.

MAD: Can't find the salt. Is it behind the HP?

BOD: It's on the next shelf.

[MAD *finds the salt and sprinkles it on* BOD's *back.* ANGEL *and* SPHINX *come over and watch curiously.*]

BOD: That live show was awful.

VIV: Where do they get those guys from?

BOD: They dope them. I saw them in the vestry, it showered Librium.

MAD: It was a real rip-off.

BOD: It's all nostalgia. It's the only way they can get through the day.

ANGEL: It's the entertainment business, isn't it? Easy come, easy go.

SPHINX: Yeah well, I'm going bingo. I promised Max.

BOD: I'm staying in. I've got better things to do.

MAD: I'm going to get zapped. I really like TV when I'm stoned.

SPHINX: Come on, Kid, come on, Angel, come on, Viv. We'll have some fun. See you.

33. BINGO

Malevolent MAX *plays bingo. His audience are* TWO OLD LADIES. *The gang don't join in, they play the slot machines. The prizes, as tacky as the interior, are held up by* MAX *with relish.*

MAX: Hello, hello, welcome to Max's bingo palace. It's a laugh a minute. OK, eyes down for a full house. Lots of lovely prizes tonight. First prize donated by General Idi Amin, one of the privates got the chop last week.

69

[*He holds up a large black dildo.*]

MAX: We're not prejudiced here, you know. Ha ha. Second prize, a tin of baked beans. Offer definitely not to be repeated. Ha ha. OK, now let's get the balls untwisted and away we go. The first one's a white 5 and 6, 56; and a white again, 4 and 9, 49; and a white 5 and 4, 54; and a red on its own, number 1, and a red legs 11 and a white 5 and 9, 59; and a blue 3 and 1, 31; and a white 4 and 4, 44; God rest Jayne Mansfield.

1ST LADY: They got Maureen.

2ND LADY: I know. She had the look. You can tell, you know. Innit a shame.

1ST LADY: Oh, don't be so sentimental, Joyce.

2ND LADY: She was so young.

1ST LADY: But what do you expect? She never carried a gun, not even a knife.

2ND LADY: I know. She couldn't get used to it.

1ST LADY: I told her last week in Sainsbury's, at least a hat pin, Maureen.

2ND LADY: They threw the toaster in the bath and she was electrocuted.

1ST LADY: Oh my God.

2ND LADY: What do you expect with millions unemployed . . . I won one of them inflatables last week for Fred. Funny three of us in bed.

1ST LADY: You should give it to Ted. He'll be lonely without Maureen.

2ND LADY: My God, I've won. House!

MAX: To the lovely lady in the white hat, three months supply of Jubilee knickers, red, white and blue.

[MAX *throws the knickers to the* LADY. *As he does so two* CYCLE COPS *break through the door. They ransack* MAX's *till at gunpoint.*]

2ND LADY: What the hell's going on?

COP: Special branch. Nobody move.

[*He sidles over to the gang.*]

SPHINX: Come on, give us a kiss.

[*Without warning the* COP *fires his gun.* SPHINX *and*

70

ANGEL *sink dead to the floor. In a split moment the* KID *runs for it and escapes into the night, the* COPS *in pursuit.*]

34. AN EMPTY STREET

Pursued along the dark streets by the COPS *on their cycles, the* KID *takes refuge in a builders' yard. Hiding in wooden packing cases, his presence is given away when he moves and dislodges an empty Coke can which clatters to the ground.*

35. H.Q.

MAD *and* AMYL *are fencing with the bravado of an old Fairbanks movie.* AMYL *is cornered against the motorbike.* BOD *looks on dispassionately, cleaning a machine gun.*

MAD: This will put an end to your history lessons. Historectomy, touché.

[*She skewers* AMYL. BOD *cocks her gun.*]

BOD: Want any help, Amyl?

AMYL: I've got through life with brains and a pair of fists.

MAD: Fists! I just have to look at them.

AMYL: OK. You're on, you rubber Medusa.

[BOD *chucks some boxing gloves in their direction.*]

BOD: On my right we have Miss Amyl Nitrate. On my left Mad Medusa, and may the best man win.

[*The two of them start to box.* AMYL *is winning, she draws blood.* VIV *enters and collapses on Bod's throne.*]

BOD: What are you doing on my chair?

VIV: At the bingo . . . they just killed the boys.

[*They turn and look at each other in dismay.*]

36. THE KID'S DEATH

The KID *has hidden in the builders' yard. The* COPS *are searching for him, one of them picks up a milk bottle. The* KID *makes a break to escape but runs into them. The* COP *smashes the bottle and attacks.*

COP: Mark your cards, Princess.

[*They beat* KID *to death.*]

71

37. H.Q. COCKTAILS

BOD *is making Molotov cocktails with old Special Brew cans.* VIV *is sitting quietly crying into her handkerchief.*

BOD: Here you are, Viv. A toast for Angel, and another one for Sphinx. Come on, don't cry, crying won't help anything, it's a negative reaction. Help me make these fire bombs instead. It'll make you feel better. We'll show those bastards, you wait and see.

[MAD *flicks on her lighter.*]

BOD: Fuck you, Mad, do you want to kill us?

[*She switches on the radio.* AMYL *is singing 'Rule Britannia'.*]

MAD: This will put us in the mood. Burn, burn oblivion R.I.P. We'll get those bastards, we'll corner them. It's party time, let's liberate the zoo.

38. AN EYE FOR AN EYE

AMYL *and* MAD *track down the cycle* COP *through the decaying warehouses. The distant sound of gunfire. As the* COP *takes a piss,* AMYL *blinds him with her perfume bottle.*

MAD: Where's the razor, where's the razor? I'm going to kill him! Crawl, crawl, crawl you bastard!

[*They attack the* COP, *disembowelling him. The murder is extremely violent. When it's all over,* MAD *breaks down and starts to cry at the futility of it all. A terrible desolation as her wailing echoes around the empty buildings.*]

39. A SNOW WHITE WASH

CRABS *sits reading a glossy magazine on the washing machine in the launderette. The 2nd cycle* COP *enters.*

CRABS: Say, would you mind if I put my stuff in with yours? I haven't got much and I'd hate to waste a machine.

COP: Make yourself at home.

CRABS: Thank you.

[*She throws in her wash as the* COP *takes off his jacket revealing the blood-stained shirt.*]

COP: Where did you get your t-shirt?

CRABS: I pinched it in Seditionaries. Say, do you always take your clothes off in the launderette too?

[*She notices the shirt as he takes it off.*]

CRABS: Très chic. Must have cost a bomb, did you get it in the King's Road? Say, what are you doing after the spin dry?

COP: Nothing.

[*She removes the rest of her clothes till she is stark naked.*]

CRABS: I just love a man without his uniform.

40. SUBURBAN BLISS

CRABS *and the* COP *make love.*

CRABS: Sure is the Special Branch.

[*Ouside* BOD *arrives on her motorbike.*]

CRABS: Lets get married.

COP: We could have kids.

CRABS: Lots of boys like you. I want to settle down. I think I've fallen in love.

[*The* COP *swallows.*]

COP: What do you do?

CRABS: I'm an actress in between jobs. Did you ever see Rock Follies?

COP: No.

[*The doorbell rings.*]

COP: Shit, I'll get it.

[*Outside* BOD *lights the fuse on a champagne bottle. As the* COP *opens the door she hurls it at him, engulfing the suburban garden in a huge fireball.*]

BOD: No Future.

41. WITHERED BLOOMS

ELIZABETH *and* DEE, *in an emblematic garden, tombs, ponds and a little temple. Somewhere apart* VIV *cries gently.*

ELIZABETH: Oh lila la la. The wheel turns in his hands, the roses of ecstasy burn, the ashes are upon his brow. The

waters of Lethe steal upon the golden eyed. He dances into silence.

[*The sound of cold wind and thunder.*]

ELIZABETH: Oh lila la la. Colour deserts the world.

ARIEL: I am the mirror, the fire that consumes all that is created. I bring the winter of thy flowers and the frost that secretly destroys the temple.

42. HOME SOUR HOME

A burst of thunder, the crackle of flames. The streets of London, decay, destruction. A STREET GANG *in the ashes.*

43. PRIVILEGE

The Rolls Royce drives through the dereliction, sinister and silent, following its angel.

44. H.Q. NO REGRETS

In the charred ruins of H.Q. CHAOS *balances on the washing line singing, 'Non rien de rien, non je ne regrette rien'. As she does so, she hangs up her clothes to dry.*

45. THE LAST FRONTIER

The Rolls Royce approaches a barbed wire frontier hung with the hammer and sickle. The sound of marching feet. A FRONTIER GUARD *commands the car to stop.*

CUSTOMS OFFICIAL: Halt halt. Blacks, homosexuals and jews are banned in Dorset. Passport. Hurry hurry hurry. Any seditious literature, records, tapes?

[CRABS *sits in the back of the car in furs and jewels. The* OFFICIAL *spots a record and grabs it.*]

CRABS: Hey, hold it. That's my Elvis album.

CUSTOMS OFFICIAL: That's on the blasphemous list. Right, on your way!

AMYL: My God, the English customs are deplorable. It used to be just the colour of your skin.

BORGIA: They have to be tough to keep the riff raff out of Dorset. It's the only safe place to live now.

AMYL: It's a tragedy that socialism and freedom weren't compatible.

[*The car rounds a corner to reveal a great stately home in rolling parkland.*]

CRABS: It's wonderful, Borgia. Is it all yours?

BORGIA: It used to belong to some aristocratic family. I requisitioned it.

AMYL: Ah well, carnation from Floris. Not all the good things have disappeared.

[*The car pulls up at the front door, a footman steps out to open the doors.*]

46. NOSTALGIA

In the great living room of the stately home CRABS, AMYL, MAD *and* BOD *sit on the sofa with* BORGIA, *entertained by a retired* HITLER *in a paint-splattered suit. They are watching the Jubilee on the TV.*

AMYL: Borgia darling, can I have a tank? It would be just perfect for a Saturday afternoon stroll down the Kings Road.

BORGIA: Of course you can, darling. You're my number one, I'll make millions out of you. Ha! ha! ha! ha!

CRABS: This is my first trip to the country, it's very exciting. All those trees, and the animals. I have a passion for fur.

BORGIA: They all sign up in the end one way or another. We lost Lounge Lizard, but gained the Daughters of God. Crabs, Amyl, Maddy!

[*The Jubilee coach rides by on the TV.*]

HITLER: The golden coach is so fantastic, an artist's dream. Though of course I was the greatest artist of this century, greater than Leonardo da Vinci.

[*The* GIRLS *laugh and toast him.* BOD *leaves the room.*]

47. DANCING LEDGE

ELIZABETH *and* DEE *walk arm in arm along the seashore.*

ELIZABETH: All my heart rejoiceth in the roar of the surf on the shingles. Marvellous sweet music it is to my ears. What joy there is in the embrace of water and earth.

DEE: Yea a great elixir is the seashore. Here one can dream of lands far distant and the earth's treasure.

ELIZABETH: The sea remindeth me of youth. Oh John Dee, do you remember those days? The whispered secrets at Oxford like this sweet sea breeze the codes and counter-codes, the secret language of flowers.

DEE: I signed myself with rosemary, true alexipharmic against your enemies.

ELIZABETH: And I with the celandine. True gold of the new spring of learning. You were my eyes then as now with your celestial geometry. You laid a path through treachery and opened my prison so my heart flew like a swallow.

DEE: Sweet majestie to me you are the celandine as then before balm against all melancholy.

[*At the sea's edge* ARIEL *sits with the* SERVING LADY. *He beckons her. She smiles and from her sleeve produces the missing diamond from the crown.*]

ARIEL: There and back.
 There and back.
 The waves break on the shores of England
 The white cliffs stand against the void
 We gaze seaward contemplating the night journey
 The sun sinks lower
 The moon waits to make her entrance
 In the south at Tillywhim a picture of wind on the sea
 In the west a vision of silver dew falling into a chalice
 Flowing on a sea of pure gold
 In the east a black hoarfrost
 The sun eclipsed by the wings of a phoenix
 In the north a howling chaos into which a black rain falls without ceasing
 Now is the time of departure
 The last streamer that ties us to what is known parts.
 We drift into a sea of storms.

[*On the clifftop* ELIZABETH *and* DEE *walk into the*

distance. As they do so the scene fades to black.]

ARIEL: And now Elizabeth and Dee go along the same great highway, and the light of the air about them seemed somewhat dark, like evening or twilight, and as they walked the phoenix spoke and cried with a loud voice: COME AWAY.

BOB-UP-A-DOWN

CRISTIN'S WEDDING DRESS:
WHITE FINE WOOL SEWN WITH
LITTLE SILVER COINS SHE WEARS
TOE Y FINGER RINGS & A HUGE
CROWN OF FLOWERS WITH TWO
LONG 'TRAINS' HELD BY
GARLANDED CHILDREN

Alternative hair style - a thick mummy binding of strip

CRISTIN-DAY DRESS: DRESS & OVER DRESS OF WOOL

Little 'loop' pig tails

GITHA. CLOTH LOOKS LIKE OILY SACKING

Huge broad brimmed hat

White calico & red cotton gauze mixed with little bells

dirty coarse white calico

ANGHARAD.

Village Woman in tweed cloth & straw hat.

Sheepskin

Coarse Woollen 'shirt'.

slip-on

SYMOND

Sheepskin 'Waistcoat'
BOB.

Bronze Badge

Decoration Stud Toggle

Fur-lined leather overjacket (very greasy)
Pedal Beads rolled into waist band

Rough Woollen cloak

thigh pads

leather baggy 'shoes'

FOR THE WEDDING.
HIS 'SHIRT' IS CLEAN WHITE
WOOL, PERHAPS EMBROIDERED.

BERNARD

RAUF & WAT

WAT'S costume little nose than a bag pulled in at the waist

Basket hat

leather needle

Work

BOB-UP-A-DOWN

I was always a Pre-Raphaelite: William Morris Tennyson. I loved Chaucer, and Piers the Ploughman, what a great film that would make,

> '. . . and he screamed for grace
> and I awoke . . .'

the unicorn tapestries, Ely, now what can beat Ely? My first grown-up book from a shop in Charing Cross Road: *The Cloister and the Hearth* – the exquisite bright painting irradiated with pure clear colour. At the risk of giving you a reading list, before I abandoned the 'sources' for something of my own, I took up with Hildegarde of Bingen, Marjorie Kempe, Richard Rolle and sailed into the cloudy unknown.

I spent the whole of the seventies reading. It was a marvellous adventure. I had so little work, and time on my hands – now I'm a dipper again, a jug-jug bird.

I worked on the script with Tim Sullivan who later went to Granada. It was good to be able to bounce ideas back and forth – I don't think Nico, who commissioned *Caravaggio* in the years before, particularly liked the divided attention and I think he was relieved when I started to write *Dancing Ledge*. It was a strange moment, the odd pop promo, autobiography, painting again, leather jackets sweaty with vaseline and come, and a medieval anchoress. I'm certain, though I like the story, circumstance liberated me from a worthy film. In any case, it was quite impossible. Should we make it at Dancing Ledge, or in the medieval barn at Avebury? There are no well designed medieval films with the exception of Dreyer's *Joan*.

81

In fact costume drama is rubbish and for an eye like mine, not alleviated by a good story – the Swedish film *My Sister My Love*, incest in the eighteenth century, is very well done – I believe the director Vilgot Sjoman made sex films, something a lot of very good directors who haven't had the luck to put their foot in the door have done.

A good casting for Bob: Nigel Terry, Vanessa Redgrave as the Anchoress, Tilda Swinton as Prophesy, and, of course, Orlando as the Priest.

1. EXT. SENTINEL OAK. DAY. TITLE SEQUENCE

Silhouetted against a pale midwinter sun, a gnarled oak stands, blasted by the sea gales at the edge of precipitous cliffs which plunge into a storm-tossed sea. Its dark and twisted branches rattle in the wind. A flock of crows wheel around, a black vortex of whirring wings punctuated by ominous insistent cawing. High in the branches of the tree a MAN *as dark as the crows sits motionless, a black hat pulled down over his dark features, sharp as a bird of prey. In the background there is the insistent cry of a young* BOY *shouting, which is nearly lost in the roar of the sea, the wind in the branches and the staccato chatter of the crows.*

2. EXT. HILL STREAM. DAY

WAT, *a tussle-haired boy dressed in skimpy rags with bare muddy feet, runs through a rapid and shallow stream which cascades down a steep hillside in the early morning mists. He is out of breath from running. He splashes the water everywhere, soaking himself. He shouts.*
WAT: Hollo! Hollo!

3. EXT. SHEEPFOLD. DAY

WAT *careens through a flock of sheep scattering them on all sides. He shouts at two craggy, weather-beaten* SHEPHERDS *who sit huddled together against the cold under blankets. They look up angrily from their frugal meal of bread and cheese as he runs past them. Stopping for a moment he laughs and then proudly flicks a silver coin in the air which catches the sunlight.*

4. BELFRY. DAY

The Belfry is a stark whitewashed room with no furniture. WAT *jumps up with as much effort as he can muster to catch the single bell rope which hangs almost beyond his reach. With one last effort he manages to catch it with one hand. He hangs suspended in the air and then throws his other hand up. Catching the bell rope he starts to swing in the air. The bell starts to ring.*

5. EXT. OLD STONE WALL. DAY

Two PEASANT GIRLS *dressed in heavy work clothing sit against an ancient lichen-covered stone wall, plucking chickens. A third girl,* PROPHESY, *seventeen years old with raven hair and green eyes, is just about to decapitate a chicken with a huge knife on a wooden block when the church bell starts to ring. She stops in mid air, and in the interruption the chicken escapes in a flurry of feathers. She looks up at the church tower.*

6. EXT. CHURCH TOWER. DAY

A beautiful but simple grey stone tower with the bell ringing.

7. EXT. PLOUGHED FIELD. DAY

Five young LABOURERS *wrapped against the winter cold with blankets draped over their heads and heavy leather pouches are broadcasting corn in a long line, working silently and methodically. Their work is interrupted by the chiming of the bell in the distance.* ROLLO, *a thickset youth with a red pugilistic face and flame red hair, looks up angrily and spits.*

8. EXT. PRIVY. DAY

In a privy, which is tacked onto the wall of the church, RAUF, *the blind, bald and fat village priest, sits asleep, his cassock hitched up about his ample middle. The squawking chicken comes flying in, landing on* RAUF's *lap. The priest's*

gentle day dream ends abruptly. He wakes up violently with a startled grunt.

9. EXT. LANDSCAPE. HILLSIDE. DAY

The cause of all this commotion in the little village is revealed. Four handsome PRINCES *on magnificent shire horses have come to seek advice from* ANGHARED, *the anchoress who lives on a hill above the village. They look almost otherworldly in the morning sunlight, their penitent's garb of sackcloth and ashes has an air of sophistication and elegance contrasted with the genuine rags of little* WAT.

Each of the PRINCES *wears a simple gold circlet round his head. They look solemn and noble on their great horses. They pass the* SHEPHERDS *in silence. The* SHEPHERDS *stop and stare. The* PRINCES *pay no attention to them.*

10. EXT. WOODLAND. DAY

PROPHESY *runs headlong through a dark wood, her heart pounding with excitement. The light falls on her in bright stripes through the trees. She almost stumbles, but saves herself. She is accompanied by the sound of a hurdy-gurdy which grows louder and louder, playing a haunting, slightly menacing tune.*

11. EXT. ROADSIDE. HEDGEROW. DAY

The young LABOURERS *have left their sowing in the fields to see the source of the disturbance. They stand at the roadside in a huddle and watch the* PRINCES *ride past in suspicious but inquisitive silence, which is reinforced by the hurdy-gurdy music.*

12. EXT. TREE. CAIRN. DAY

High in the oak tree, the coal black figure of BOB-UP-A-DOWN, *the charcoal burner, has sprung to life. He is playing the hurdy-gurdy, staring intently at the four* PRINCES *down*

below him as they dismount to make their offering to the
ANCHORESS, *immured in the grey stone cairn which
resembles a beehive. His clothes glitter like black hoarfrost,
tall, handsome with piercing black eyes and long jet-black
hair which is oiled and plaited. The* PRINCES *look up at him
but he ignores them and bends deeper over his whirring
instrument.*

13. EXT. CAIRN. DAY

Down below the PRINCES *have dismounted in front of the
cairn. A small opening like a wooden trap door receives the
offerings. The cairn itself is decorated with herbs and small
ties of different coloured materials like a jackdaw's nest. As
the* PRINCES *approach, the wooden trap door slides open to
reveal the* ANCHORESS *in the shadows. She glitters like a
tinsel tree. She is wearing countless offerings that have been
given to her in her crystalline grotto.*

14. EXT. ROCKS. CAIRN. DAY

PROPHESY, *out of breath from running, conceals herself in a
bush behind some rocks from where she can see both the
penitent* PRINCES *and* BOB *high in the gnarled oak.*

15. EXT. CAIRN. DAY

To the eerie will-o'-the-wisp of BOB-UP-A-DOWN'S
hurdy-gurdy, the four PRINCES *offer their crowns to the*
ANCHORESS. *One after the other they kneel and place the
simple gold circlets on the sill of her retreat.*

16. EXT. CAIRN. DAY

*The jewelled recluse glitters deep in the shadows behind the
golden crowns. The hurdy-gurdy music rises to an intensity.
There is the sound of swans flying through the air, a deep
drowsy sound.*

The ANCHORESS *starts to sing in a haunting voice in a half-forgotten tongue, the language of the Languedoc. Her voice has a sob of sadness and loss. The song is translated by* BOB-UP-A-DOWN's *whispered voice.*

BOB-UP-A-DOWN: I am maker unmade
 My blessing in joy
 My body in bliss abiding
 A bliss all protecting about me
 Dark princes of North, South, East and
 West
 You dance at the edge of time.

17. EXT. CAIRN. NIGHT

In the first verse of the song, time has miraculously passed, a mandragora sleep. The four PRINCES *are now kneeling in the configuration of a compass by the light of flares – praying. The flares glitter in the cold night wind which creeps into the song.*

 We dissolve through the flares to:

18. EXT. A GREAT METROPOLIS. SUNSET/NIGHT

An aerial panorama of a modern city is laid below us. As the sun slowly sets fiery in the west, the city itself is transformed to scarlet and seems to catch fire and burn.

BOB-UP-A-DOWN: Black clouds shroud your cities
 Dark night of the soul
 Now all shadows lie in the great
 shadow of God.

19. 'A GREAT SHOWER OF SPARKS'

A shower of incandescent sparks like the explosion of a volcano shimmers like stars on the former image, and dissolves to:

20. 'THE MOON IN THE NIGHT SKY'

Clouds scud across the moon which picks up the edges in silvery bars. The sound of honey bees 'melissa' buzzing, then the hurdy-gurdy stops, leaving us with a cold breeze which disappears in the enveloping silence.

21. INT. EMPTY WHITE CHAMBER. MOONLIGHT

PROPHESY *kneels in the moonlight which falls throughout the open window of her bare white room, her hair glittering like gold in the moonlight. She has cleared a circle in the snow that has fallen on the floor and laid out spring flowers: violets, snowdrops, celandine and sprigs of pussy willow. In the background is the rhythmic sound of* BOB *felling trees on the hillside.* PHOPHESY *holds a small bunch of the flowers in her hand and gazes mesmerised by those on the ground – her hand hovers above them – with a sudden movement she springs on a celandine, as if to catch it unawares. She holds it up in the moonlight. As she does so a tree crashes to the ground.*

22. EXT. WOODLAND CLEARING. NIGHT

In a clearing in the woods BOB *is cutting timber for the charcoal fires which smoulder all around him. The smoke drifts in the moonlight. Sweat glistens as it runs in rivulets down his blackened face.*

23. INT. EMPTY WHITE CHAMBER. NIGHT

PROPHESY *sits listening to the sound of* BOB'S *axe. She kisses the celandine and trails it across her cheek with her eyes closed, and sinks backwards into the straw.*

24. INT. BARN. EARLY MORNING

ROLLO *and the priest* RAUF *lie asleep in the corn.* RAUF *snores loudly with his eyes wide open. Young* WAT *creeps into the barn.* ROLLO *turns over in his sleep.* WAT *hesitates,*

then tiptoes over to the priest. He picks up a piece of straw and tickles RAUF's *nose.* RAUF *twitches slightly.* WAT *tickles him again and* RAUF *brushes the straw away like a fly. Now* WAT *puts the straw up* RAUF's *nostril.* RAUF *turns over with a grunt.* ROLLO *wakes up and seeing* WAT *lunges at him. The priest wakes up with a sneeze and* WAT *careers out of the door followed by* ROLLO.

25. EXT. BARN. MORNING

WAT *escapes round a corner of the stone barn and breathlessly comes to a halt. He creeps back.* ROLLO *bursts out of the door, stops for a moment and runs the other way.* WAT *giggles. A stealthy game of cat-and-mouse ensues around the barn.* ROLLO *finally catches him, and tripping him up grabs hold of his ankles, turning him neatly upside down. He shakes him violently.* WAT *screams, laughing hysterically. The silver coin drops out of his pocket and rolls on the ground. It glints in the dust.*

ROLLO *sees the coin and immediately drops* WAT *who hits his head on the ground and begins to cry.* ROLLO *picks up the coin and bites it. He puts it in his pocket with a triumphant smile.*

26. INT. COW BYRE. DAY

PROPHESY *is pouring milk into an earthenware jug from a wooden bucket. She is deep in her work, so that when* ROLLO *walks by she doesn't notice him. He stands at the door chewing a straw and watching her like a hawk. After a moment he breaks the silence and deliberately frightens the young girl by barking like a dog. Startled she turns round, spilling some of the milk.*
PROPHESY: Rollo.
[*She looks relieved and starts to laugh.*]

27. EXT. CAIRN. DAY

PROPHESY *approaches the cairn with the jug of milk. She puts the jug on the sill. She steps back and watches as the*

wooden shutter slides open and the jewelled hand of the
ANCHORESS *removes the jug, replacing it with an empty
one. The shutter closes.* PROPHESY *stands waiting as if she
was about to ask something, and then thinking better of it,
turns to walk off.*

28. EXT. WOODLAND CLEARING. DAY

PROPHESY *cautiously approaches* BOB's *clearing in the
forest and stops at its edge. The fires are smouldering gently.
It's very quiet.* PROPHESY *looks around her anxiously and
calls out quietly.*

PROPHESY: Bob?
[*She waits. There is no reply. She moves forward into the
clearing and moves cautiously towards the charcoal
burner's skin-covered hovel at the base of an oak tree. The
smoke drifts around her. She notices the fresh chip of
yellow wood on the ground. She whispers.*]
PROPHECY: Bob? Bob-Up-A-Down?
[*There is silence. She opens the flap of the hovel. She looks
round and then takes the celandine from under the shawl
and kissing it places it on the blade of* BOB's *axe.*]

29. EXT. TREETOP. DAY

Perched high in the branches of a tree unnoticed, BOB-UP-
A-DOWN *looks down at* PROPHESY *as she walks away
taking one last look.*

30. EXT. COTTAGE. DAY

The village GIRLS *crowd round the doorway of the small
cottage where* PROPHESY *lives with her grandmother,*
GYTHA, *the village goose-woman. The* GIRLS *are wrapped
in shawls, their hair decked with spring flowers. Their
excited whispering is mixed with cackling geese from the
interior. The smaller girls ride piggy back to get a better*

view. When PROPHESY *comes round the corner the girls are
unaware of her arrival.*

PROPHESY: Mary! Mary!

[*The* GIRLS *turn round surprised and cluster round*
PROPHESY.]

MARY: Prophesy!

[*She curtseys.*]

PROPHESY: What hailing is this?

MARY: Rollo has chosen thee for his.

[*One of the smaller* GIRLS *cuts a lock of* PROPHESY'*s hair
as a good luck charm.* PROPHESY *spins round and grabs
the hair back.*]

PROPHESY: Lay no hand on me!

[*The child is startled. A tear creeps into her eye.*]

MARY: Thou art full crabbed Prophesy.

[*She takes the child protectively.* PROPHESY *pushes
through them.*]

31. INT. COTTAGE. DAY

The GIRLS *crowd in the doorway and stare through the
window.* GYTHA, *bent double with age, leans heavily on a
stick. The geese cackle and peck at the straw strewn across
the floor. There is no furniture except for the stool on which*
RAUF *the priest sits. Smoke from the hearth drifts around
him. In the other corner of the room* ROLLO *stands with the
two* SHEPHERDS *who shift uneasily and tip their hats as*
PROPHESY *walks into the room.*

There is a moment's silence in which RAUF *clears his
throat.* PROPHESY *looks from one to the other.*

PROPHESY: Why gab ye at me?

RAUF: Rollo has chosen thee, Prophesy.

[ROLLO *steps forward.*]

ROLLO: Prophesy, thou hast thy sweetheart.

[PROPHESY *looks aghast from one to the other.* RAUF
breaks the silence by clearing his throat.]

RAUF: God save ye both. All joy and bliss shall then be
after.

91

32. INT. BELFRY. DAY

WAT *jumps up and down and eventually manages to catch the bell rope to pull the bell. A small* CHILD *grabs his legs and the two of them swing together from the rope. The bell starts to chime.*

33. INT. EMPTY WHITE CHAMBER. DAY

PROPHESY *hangs a wicker cage with two white doves in the window of her room. She stops for a moment to watch the birds, then turns away. In the distance the church bell is tolling. She kneels in the circle of flowers which have withered and picks several of them up to make a sad little posy.* GYTHA *shuffles in standing in the doorway.* PROPHESY *hardly notices her.* GYTHA *breaks the silence.*

GYTHA: What ails thee?

[PROPHESY *pays no attention, turning her back on her grandmother.*]

34. INT. CHAPEL. DAY

A minute village chapel which is filled to capacity by the village BOYS *who kneel between the worn stone arches to receive an unintelligible Latin prayer from* RAUF. *Each of the boys holds a fine ash crook which has been newly cut and* RAUF *passes down the line holding a wooden bowl of holy water which he sprinkles on the stones with the aid of some mistletoe. His prayers are drowned out by the sound of the bell tolling above them, echoing round the small cramped space.*

RAUF *blesses* ROLLO.

RAUF: My blessing have ye.
 Christ be with ye where ye wend
 All loyal ones that love his law
 Shall be blessed without end
 Laus tibi Domino cum gloria

BOYS: Amen.

35. INT. BELFRY. DAY

WAT *swinging from the bell rope fights off several ragged* CHILDREN *who are attempting to grab the rope from him. In the scrimmage the bell sounds erratically.*

36. EXT. CHURCH DOOR. DAY

The village GIRLS *stand outside the church door holding small posies of flowers like the ones* PROPHESY *has made for* BOB. *As the* BOYS *file out from* RAUF's *blessing they tie them onto the hats or behind the ears of the chosen one.*

GIRLS: Sweet St Lucy let me know
 Whose bed I shall make
 Whose child I shall bear
 Whose darling I shall be
 Whose arms I shall lie in.

37. EXT. HILLSIDE. DAY

The CHILDREN *are running along the edge of a dark wood which borders the meadow above the village. They are kicking a bladder ball. One of the children kicks it too hard and it flies into the shadows of the hedgerow where it is caught by* BOB-UP-A-DOWN *who is standing concealed in the darkness. He throws the ball back at the kids who stop and stare at him. A dark figure, he stands as black as the shadows around him, carrying game from a yoke on his shoulders: pheasants, hares and rabbits.*

38. EXT. HEDGEROW. DAY

Led by RAUF, *the boys of the village are beating the village boundary with the staves, a rhythmic sinister sound. They tap the ground on either side of them in unison, beating the bushes.*

BOYS: Out! Out! Haro! Haro Lurdans, have at ye. Out! Out! Haro! Haro! Out on thee, Lucifer. Ye are lost.

39. EXT. HILLSIDE ABOVE THE VILLAGE. DAY

BOB, *surrounded by the curious* CHILDREN *who mill around him, walks down into the village from the rolling hillside above the barn which nestles into the valley. He plays his hurdy-gurdy which mingles with the church bells.*

40. EXT. ROOF OF TITHE BARN. DAY

Two WOMEN *surrounded by reeds are perched precariously on the roof of the barn repairing the thatch. They stop their work to watch* BOB *and the* CHILDREN *come singing down the hill.*

41. HEDGEROW. DAY

ROLLO *beats the bounds with the other* YOUNG MEN *of the village. They stop for a second as they hear the sound of* BOB'S'S *hurdy-gurdy.*

42. INT. VILLAGE. DAY

GYTHA *kneading dough for bread, her hands covered in white flour, frosting her wrinkled face, stops work as she hears the sound of* BOB's *hurdy-gurdy. The geese start to cackle in alarm as if surprised by a fox.*

43. INT. WHITE ROOM. DAY

PROPHESY *runs to the window, concealing herself in the shadows, she watches* BOB *pass by. The white doves flutter in their cages, the* CHILDREN *circle about* BOB *like sparrows attacking a crow.*

CHILDREN: Bob-Up-A-Down! Bob-Up-A-Down!
 [*Their cries mingle with the sound of the hurdy-gurdy and the church bell.*]

44. INT. BELFRY. DAY

WAT *is hanging upside down from the bell pull. The sound of the hurdy-gurdy and the bell and the excited shouting of the* CHILDREN *reaches a crescendo.*

94

45. INT. TITHE BARN. NIGHT

The whole village is gathered in the title barn, lit by flares. Bales of rushes have been cleared to form a circular dance floor in the centre. Around this circle the VILLAGE ELDERS *sit, their wrinkled faces like stone idols in the flickering light. The* CHILDREN *sit on rafters and in the bales of straw. High above them is* BOB-UP-A-DOWN. *Into the circle step the village* MAIDENS, *who, with* PROPHESY, *perform a slow reel, their elders watching them with the concentration of country people at cattle fair.*

The GIRLS *circle the floor slowly. Then their place is taken by the* BOYS *carrying their ash staves. No-one talks, there is an air of extreme concentration. At the end of the reel the boys present their chosen ones with small silver pennies.* ROLLO *presents* PROPHESY *with the silver penny he stole from* WAT. PROPHESY *takes it unwillingly. As she does so the music comes to a stop.* BOB *takes the celandine flower from his cap and throws it down to* PROPHESY. *The silence is broken by a great shout from* ROLLO.

ROLLO: Out, Lurdan, Out!

[*His friends take up the cry. They seize their ash staves and rattle them ominously.*]

ROLLO AND BOYS: Out! Out! Haro!

[*The villagers leave the barn,* PROPHESY *is grabbed by the two* SHEPHERDS *and carried out forcibly. She screams.*]

PROPHESY: Bob! Bob!

46. EXT. BARN. NIGHT

The OLD MEN *of the village bar the barn door which closes with a resounding crash.*

47. INT. BARN. NIGHT

The village LADS *glare at* BOB *high in the rafters.* BOB *turns the hurdy once or twice. It lets out a wild and sinister note.*

BOB: Busk to my bidding thou boy,

dance on in the devil's way.

ROLLO: Thou shalt bleed, Bob. Thy bones shall be brittled.

BOB: Chatter away.

[BOB *leaps down amongst the* BOYS. *Seizing an ash stave, he clears a space as it whirs through the air.*]

[*The* BOYS *back away in fear.* BOB *confronts* ROLLO. *He removes his clothes till he is stripped to the waist.* ROLLO *does likewise and a violent boxing match takes place.* ROLLO *is no match for* BOB *and is felled.* BOB *glowers at the* BOYS. *Seizing the stave he turns in a circle pointing at all of them.*]

BOB: Out, Lurdans, out, Haro!

[*He laughs.*]

[BOB *puts on his clothes and picks up his hurdy-gurdy and crashes the door with the stave. The door opens slowly. The village* MEN *stare at him. He pulls his hat over his eyes and walks through them.*]

48. EXT. SEASHORE. NIGHT

PROPHESY, *her dress wrapped round her by the wind, walks through the rock pools. The wind whistles in the dark, whipping up the foam on the breakers as they rush across the rocks.* PROPHESY *is crying, her face glistens in the moonlight. Unseen by her,* WAT *has also stolen away from the party. He follows her at a distance. He slips on some seaweed and cuts his knee on a rock. He lets out a cry.* PROPHESY, *startled, turns, and seeing him runs back.*

PROPHESY: Wat? Wat?

[*She stoops down, and noticing his cut knee tears a strip off her dress, and dipping it in the sea dabs the wound clean and binds it. She kisses him on the forehead.*]

49. EXT. BACK OF BARN. NIGHT

A group of DRUNKS *are urinating against the back of the barn.* ROLLO *sits on the bank, sharpening the ash staves.*

ROLLO: Thou shalt bleed, Bob. Thy bones shall be brittled.

50. EXT. SEASHORE. NIGHT

PROPHESY *sits on a rock at the sea's edge. The surf surges round her, little flecks of foam are blown on her by the wind. Now she seems unaware of* WAT, *who sits uncomfortably next to her.*

WAT: What ails thee, Prophesy?

[*She does not answer but buries her face between her knees, then almost to herself she says:*]

PROPHESY: Full wild in woe am I, Wat.

51. EXT. WOODLAND. NIGHT

Torch light flickers through the darkness as ROLLO *and his* DRUNKEN COMPANIONS *invade* BOB-UP-A-DOWN's *wood. In the darkness one of the boys trips up and starts to laugh.* ROLLO *spins round and slaps him across the face.*

ROLLO: Stay thy jangles.

1ST BOY: Jessie thou art a Jay.

2ND BOY: He patters like a pie.

[*The* BOYS *enter the clearing where* BOB's *charcoal fires smoulder in the moonlight. Around the fires are wooden frames with animal skins stretched out to dry. One of the* BOYS *starts to set light to them with his torch. The others shin up the ropes which hang from* BOB's *tree house.* ROLLO *reaches the top first. He opens the flap of leather which forms the entrance. There is no-one inside. One of the other* BOYS *misses his footing and falls to the ground cursing.* ROLLO *starts to demolish the tree house. Suddenly there are three quick reports of an axe hitting wood and a creaking noise as a large tree crashes down on one of the boys who is demolishing the frames with the drying skins. The* BOY *screams as he is pinned to the earth by the branches, the flames from his torch and the burning skins set fire to the tree.*]

1ST BOY: Jessie! Rollo!

[ROLLO, *thoroughly scared, jumps from the tree.*]

ROLLO: Lift there!

97

[*The* BOYS *lift the tree away and pull out their badly burnt comrade. In the background there is the sound of an axe. Another tree begins to fall and crashes down in the clearing, narrowly missing the frightened group, who panic and run for it helter skelter through the wood.*]

52. EXT. SEASHORE. DAWN

BOB *and* WAT *are walking along the seashore.* WAT *leading* BOB *by the hand.* BOB *is singing.*

BOB:This day day dawes,
 This gentil day day dawes,
 and I must home gone,
 This day day dawes
 This gentil day day dawes
 and we must home gone.

 In a glorious garden green
 Saw I sitting a comely queen
 Among the flowers that fresh been
 She gathered a flower and sat between
 and ever she sang . . .

 In that garden be flowers of hue
 The gelofir gent that she well knew
 The flower de luce she did on rue
 and said the yellow celandine is most true
 This garden to rule by right wis law
 The yellow celandine me thought I saw
 and ever she sang.

[*The two of them come across* PROPHESY *who has fallen asleep at the sea's edge.* BOB *falls silent, her pale face is still in the dawn light, with a faint trace of a smile on her lips.* BOB *bends down and strokes her forehead. Her eyes open for a moment and then close again.* BOB *gently picks her up in his arms.*]

53. EXT. HOUSE. DAWN

WAT *quietly opens the door of* PROPHESY'*s home, screwing his eyes up in an effort to make no noise.* BOB *follows*

carrying PROPHESY *asleep in his arms. They tiptoe through the room past* GYTHA *who is sleeping in* RAUF *the priest's arms.*

54. INT. PROPHESY'S ROOM. DAWN

WAT *sits down by the doorway as* BOB *gently lowers* PROPHESY *onto the straw and covers her with a blanket. He pauses and leaves the room.* WAT *remains staring at* PROPHESY *until he too falls asleep.*

55. EXT. ANCHORESS'S CAIRN. DAWN

BOB-UP-A-DOWN *pulls his black coat firmly round his shoulders. He sits beneath the sill of the* ANCHORESS's cairn. She glitters in the shadows as she pulls open the small wooden window. There is the drowsy sound of swans flying through the air and the ANCHORESS *starts to sing.*

ANCHORESS: I am maker unmade
My blessing in joy
My body in bliss abiding
A bliss all protecting about me.
[*We dissolve through the face of the* ANCHORESS *to . . .*]

56. EXT. A WALL OF ROSES. DAWN

In glittering sunlight PROPHESY *stands against a wall of pink roses. She attempts to pick one. The full-blown flower falls to pieces in her hands. She smiles and tries again. Each flower she picks crumbles in her hands. She catches her finger on a thorn. A small drop of blood appears.*

ANCHORESS: She is the Rose of the blood red field.
The rose of Jericho that grows in Bethle'm
Towards paradise the Red Stream flows
The sun is 'clipsed and the realm dark

57. INT. PROPHESY'S ROOM. DAY

PROPHESY *lies asleep.* WAT *is also fast asleep, huddled against the wall, his mouth wide open. Daylight filters*

through a crack in the shutters. For a moment there is silence, then we hear a scraping sound from the ceiling. A couple of bits of thatch drift down to the floor from somewhere above WAT's head. Suddenly a gap appears in the thatch and a CHILD's face with a wicked grin appears.

The CHILD whispers to an accomplice and produces a frog on the end of a string which he lowers towards the unsuspecting WAT. Two hands appear on the window ledge and a small face appears straining to look in. The frog dangles ominously over WAT's mouth and lands on him. WAT wakes up with a start, and seeing the CHILD at the window charges headlong towards him, trampling over PROPHESY in the process. He jumps out the window.

58. EXT. PROPHESY'S HOUSE. DAY

WAT lands in the group of CHILDREN outside the window, pulling them down into a mass of flailing arms and legs.

59. INT. GYTHA'S ROOM. DAY

The noise wakes GYTHA and RAUF. RAUF pulls himself together, brushing the straw from him and yells at the CHILDREN.

RAUF: Wat, away with thee. Let us alone.

[There is dead silence and then the giggling starts again.]

60. INT. BARN. DAY

The village GIRLS are sweeping up the remains of the party with large besoms. One of them disturbs a DRUNK who is lying beneath a pile of hay. The CHILDREN come careening into the barn chased by WAT. They go flying through the straw which the GIRLS have tidied up, kicking it everywhere. Before they can be stopped they are out the other door.

61. INT. SMITHY. DAY

ROLLO *and his* FRIENDS *lie asleep in the lean-to shack which houses the village forge. They are curled up against the furnace for warmth.*

WAT *and the* CHILDREN *creep in. They pick up horseshoes and pieces of metal and on a signal start to bang them in a deafening rhythm.*

CHILDREN: For her love I carke and carp
For her love I droup ne dare
For her love my blisse is bare
For her love in sleep I slake
For her love all night I wake

62. INT. PROPHESY'S ROOM. DAY

PROPHESY *stands at her window in the weak winter sunlight, meticulously tying her hair in a scarf. Down below her the gang of* CHILDREN *run past and up the hill. She waves and smiles as they disappear round a corner. She finishes tying her scarf and turns back out of the sunlight. She is brought to an abrupt halt by* GYTHA *who is standing in the shadows.*

GYTHA: Rollo is thy betrothed. To be mother and wife is no small thing.

[PROHESY *turns away.* GYTHA *continues with exasperation.*]

GYTHA: Love of our Lord, child. All this is ordained in wedding weeds. Thou shalt be wed. No mischiefs shall this mar. Mark thy grandmother, Prophesy. These words are not wrought to waste away in the wind. Think on the maiden Mary, the lily equalling, because of her clean life, was wed in bliss.

[GYTHA *kisses her.*]

GYTHA: Now dread thou nought, girl, heed my words, and blest be thou.

63. INT. FORGE. DAY

The furnace has been kindled. One of the MEN *stands by the*

fire operating a huge bellows. His legs are bound to protect them from the heat with coarse blackened cloth. Each time he pushes the bellows a flurry of bright red embers fly from the fire and fall about his feet. Another MAN *holds a glowing metal ring in the fire. His arms glisten with sweat and dirt, his blackened face staring at the flames.*

ROLLO *is rigorously beating a metal hoop over an anvil. He is stripped to the waist, his hair tied up in a cloth band. His muscles flex as he beats the glowing metal.* PROPHESY *stands in the shaft of light which falls through the door. Behind her the door slams shut in the wind. No-one speaks to her or looks at her and* ROLLO *steadfastly ignores her as he works. He plunges the glowing iron into the water. It hisses and a cloud of steam rises.* PROPHESY *flinches.* ROLLO *smiles and hangs the hoop from the rafters.*

He turns and takes the tongs from the man who bends over the furnace. He puts the metal on the anvil and beats it rhythmically. When he has finished, he plunges it in the water and lifts it in the light. We see that he has been forging a wedding ring.

ROLLO: This work is well.

[*He takes* PROPHESY's *hand and tries to fit the ring. He smiles at her.*]

ROLLO: This boring I must amend.

[*He takes the ring back and places it on the anvil and beats it violently.* PROPHESY *smiles.*]

PROPHESY: This work is unmeet.

ROLLO: Peace now, Prophesy, have done, this work shall not fail if four bulls were bound.

[*The* BOYS *laugh.*]

[ROLLO *pushes the ring onto* PROPHESY's *finger with difficulty. She smiles at him with defiance and pulls it off, replacing it on the anvil.*]

PROPHESY: This travail is in vain, Rollo.

ROLLO: Be still, thou mayest nothing amend.

[PROPHESY *turns on her heels and walks out of the door.*]

64. EXT. FORGE. DAY

PROPHESY *plunges her hands into the rain butt outside the door. As the dirt comes off, a small trickle of blood flows from her wedding finger.* ROLLO *stands at the door watching her. She takes off her scarf and immersing it in the cold water she presses it to her face. Then she ties the wet scarf back round her hair and turns away defiantly.* ROLLO *stares after her.*

65. EXT. LANE. DAY

PROPHESY *runs down a lane bounded by stone walls. As she turns a corner she runs into* GYTHA *with her flock of geese. The geese fly up.* PROPHESY *pays no attention to them and carries on.* GYTHA *shouts after her in alarm.*
GYTHA: Prophesy!
[PROPHESY *pays no attention.*]

66. EXT. FIELD. DAY

A line of GIRLS *are kneeling in a ploughed field planting bean seeds with wooden dibbers in their hands. They stop their work as* PROPHESY *runs past.*

67. EXT. BOB'S TREE HOUSE. DAY

BOB *is sitting in his eyrie with* WAT *beside him. He is skinning a rabbit with a sharp knife. His work is interrupted by the distant figure of* PROPHESY *running up the hill to the* ANCHORESS's *Cairn. He stops and watches.*

68. EXT. ANCHORESS'S CAIRN. DAY

PROPHESY *collapses out of breath and sobbing at the foot of the stone cairn. The trap door opens slowly and the* ANCHORESS *appears glittering in the dark. She places a jewelled hand on* PROPHESY's *head to comfort her, and produces two amulets on the end of simple twine thongs.*
ANCHORESS: Prophesy, dread thee not, this token shall thee free. Hold to hope in thy plight, all loyal ones that

103

hold my law shall be blessed without end, of women thou
bearest the flower, now thou shall dwell in bliss that shall
ever endure and here I give my blessing.
[*The* ANCHORESS *withdraws her hand, the door closes.*
PROPHESY *stares at the glistening charm.*]

69. EXT. HEDGEROW. DAY

As PROPHESY *walks back down the hill she is intercepted by*
BOB *who steps out of a hawthorn bush.* PROPHESY's *heart
misses a beat. On tip-toe she places the amulet around his
neck.*
PROPHESY: Thou art my life and my liking. This is the
blessing which brings succour. With this token the
marriage will never be joined. Thou shalt dwell with me in
bliss that shall ever endure.
[BOB *takes* PROPHESY *in his arms and kisses her.*]

70. INT. PROPHESY'S ROOM. DAY

PROPHESY *walks into her room closing the door behind her.
She kneels down and, rummaging through the folds of her
gown, produces the second amulet which she holds up to the
light. Suddenly the bolt on the door closes with a loud bang.*
PROPHESY *runs to the door but it will not open. She bangs
at the door and tries to open it but it is firmly locked.*

71. INT. HOUSE. DAY

On the other side of the door RAUF *listens to* PROPHESY's
banging. He turns and moves away with a satisfied look.

72. EXT. WOODLAND. DAY

In his blindness RAUF *walks cautiously through the wood,
feeling his way with a large stick. He calls out.*
RAUF: Bob! Bob-Up-A-Down!
[*But there is no answer, just the silence of the wood and
the rattling of his stick. Hearing the priest,* BOB *cautions*
WAT *to silence.* WAT *slips down the tree and tiptoes*

towards RAUF. *He stops in front of the blind priest, and circles round him silently with a broad grin.*

BOB *remains motionless in the tree top, chewing a leaf, watching the comedy below him.*]

RAUF: Bob! Bob-Up-A-Down!

[WAT *circles round him getting steadily closer.* RAUF *reaches the bottom of the tree and calls after* BOB *again. There is silence. A twig cracks and* RAUF, *sensing he is being watched, calls out again.*]

RAUF: Bob-Up-A-Down, for all thy tricks Prophesy will marry Rollo. Let her be. I bid you bide here and look ye stir no strife but stand stone still.

[*The silence continues.*]

RAUF: Do you hear me?

[BOB *leans out of the tree directly above the priest. He spits out the chewed leaf which lands on* RAUF's *bald head with a resounding splat.* RAUF *startled, turns and trips over. He picks himself up and curses* BOB.]

RAUF: God's cursed light on you.
 No fruit to thee shall there be found
 of wickedness since thou art, son,
 in bitter bale now thou art bound.
 An outcast shalt thou be for this affray.

73. INT. PROPHESY'S ROOM. DAY

PROPHESY *has fallen asleep in her room. She clutches the amulet in her hand. Her sleep is interrupted by the drawing of the bolts on her door.* RAUF *walks in. He circles the room, prodding with his stick till he captures* PROPHESY *who has shrunk into a corner. She struggles with him.* GYTHA *appears at the door and* PROPHESY *gives up her struggle. She clenches the amulet firmly in her fist.*

74. INT. FORGE. DAY

ROLLO *is hard at work in the forge. The iron hoops that he has been working on hang from the rafters. His face is covered in grime and sweat trickles in rivulets down his face.*

His assistants are binding the hoops with straw and pitch.
The furnace grows in the shadows. The work is interrupted
by RAUF *who enters pulling* PROPHESY *in behind him,*
closely followed by GYTHA.

RAUF *motions* ROLLO *over to* PROPHESY.

RAUF: Now God all hope is in, save thee and guide thee.
Rollo I give thee Prophesy to wife. The ring.

[ROLLO, *who is startled by the turn of events, fumbles*
around to find the ring. RAUF *lets go of* PROPHESY'*s*
clenched fist. Her wrist is white and red from the force of
his grip.

RAUF: The ring is thy binding.
Take Prophesy to thy keeping.
In nomine Domini et filius.

[ROLLO *takes* PROPHESY'*s hand and forces it open. The*
crystal amulet falls to the ground. PROPHESY *lets out a*
cry and stoops to pick it up, but she is restrained by RAUF
who forcibly slips the ring on her wedding finger.]

RAUF: Now gracious God, guide thee for the best.

[GYTHA *crosses herself.*]

GYTHA: With all my heart entire
Thy blessing so I beseech thee
Thou grant us all now here.

75. EXT. WALLED LANE. DAY

Four BOYS *roll a wooden barrel down the dry stone walled*
lane. The rumbling is deafening as it bounces unevenly off
the stones on the ground, accelerating so that the boys have
to run to keep up with it.

76. INT. PROPHESY'S ROOM

PROPHESY *stands in the middle of her room motionless, a*
completely vacant expression on her face. GYTHA *stands*
behind her, pulling the ties on her clothes. PROPHESY'*s*
body sways limply every time GYTHA *undoes a knot. Her*

dress falls to the floor in a circle around her. She stands naked.

77. INT. GYTHA'S ROOM. DAY

The BOYS *pass buckets of steaming water which are poured into the barrel which stands in the middle of the room. The room is full of steam.* GYTHA *waits like an apparition in the steam. The boys pour in the last bucket and leave.* GYTHA *closes the door.* PROPHESY *comes in naked and shivering as if she has lost all her powers of resistance.* GYTHA *bathes her, gently singing a lullaby.*

GYTHA: When nettles in winter bear roses red
 and thorns bear figs naturally
 and brooms bear apples in every meed
 and laurels bear cherries in the crops so high
 and oaks bear dates so plenteously
 when wives to their husbands do no offence
 then put in a woman your confidence.

78. INT. FORGE. EVENING

ROLLO *is sitting in the corner with* RAUF *drinking ale from a large mug. He is drunk.* RAUF *turns the Anchoress's charm in his fingers. He seems troubled by it. Around them Rollo's* FRIENDS *carry on working on the hoops, covering them with straw and pitch from a large bubbling vat. The church bell begins to toll.*

79. INT. BELFRY. EVENING

A CHILD *is ringing the bell, a triumphant smile on his sinister face.*

80. EXT. VILLAGE STREET. EVENING

PROPHESY, *dressed like a sacrificial offering in a white shift, is led through the village to Rollo's forge by* GYTHA. *The* VILLAGERS *stare curiously.*

81. EXT. HILLSIDE. EVENING

WAT *is running as fast as he can down the hill to the village. The sound of the bell ringing in his ears.*

82. EXT. FORGE. EVENING

Rollo's forge is surrounded by circles of fire as the BOYS *roll the flaming hoops around the building. The flames roar in the cold night air as the hoops spin like catherine wheels. Blue smoke trails in the darkness.*

BOYS: Blessed be that lady bright
That bears a child of great might
Withouten Peine as it was light
Maid mother Mary!

83. EXT. WOODLAND. NIGHT

BOB-UP-A-DOWN, *perched in the very highest branches of a tree, watches the distant hoops of fire. The church bell which has been ringing in the darkness suddenly stops.* BOB *bristles like an animal sensing danger. He shins down the tree and seizes his axe.*

84. INT. ROLLO'S ROOM ABOVE THE FORGE. NIGHT

A small attic room above the forge lit by the flickering flames from a fire which burns in the grate. The sound of BOB *chopping down the tree in the wood.*
ROLLO *is drinking, an earthenware pitcher at his side.* PROPHESY *sits by the hearth, shivering under a blanket.* ROLLO *belches and starts to undress. He pulls off his shirt revealing the stolen amulet swinging from his neck.* PROPHESY *catches sight of the amulet glittering in the firelight.*

85. EXT. WOODLAND. NIGHT

BOB *stripped to the waist is frenziedly chopping down the*

young saplings in his clearing. Sweat pours off his brow as the woodchips fly.

86. INT. ROLLO'S ROOM. NIGHT

ROLLO *stands in front of* PROPHESY. *He holds the amulet in front of him and chuckling wickedly swings it from side to side like a pendulum. Then, staring at* PROPHESY, *deliberately throws it in the fire.* ROLLO *pulls the rug from* PROPHESY*'s shoulders. She sits naked and defenceless. She pushes him away and as she does so her wedding ring falls off her finger into the fire.*

ROLLO *dives into the fire to retrieve the ring, and in his drunkenness trips on the hearth falling headlong into the flames. He screams, and staggers out of the fire with his pitch-covered clothes burning fiercely.* PROPHESY *recoils in horror as he throws himself against the walls of the room, desperately trying to put out the flames. He rushes from the room.*

87. EXT. FORGE. NIGHT

ROLLO *is writhing around on the ground in a ball of fire. The men stand around, paralysed with fear.*

88. EXT. CAIRN. NIGHT

BOB *piles brushwood around the* ANCHORESS*'s cairn in a frenzy, transforming it into a funeral pyre. He plunges a torch into the straw at the base of the pyre. He walks around the cairn lighting it at various points. He stands back and watches silhouetted against the bright orange flames as they roar into the night sky. He rips the amulet from his neck and throws it into the fire. The* ANCHORESS *sings in the flames.*

ANCHORESS: Ah loved be thou lord of all heaven and earth
who with thine angels would us call
out of our graves
men see the world but vanity
yet think they not they shall die.

89. EXT. ASHES OF CAIRN. DAWN

RAUF *leads the* VILLAGERS *up the hill to the ruins of the cairn. It has been reduced to a pile of white ash. The villagers stand and watch as* RAUF *wades into the ashes and kneels in prayer. Nothing is left of the cairn or the Anchoress. There is silence except for* RAUF'S *muttered prayers. Suddenly the calm is shattered by* BOB-UP-A-DOWN *who emerges from the ground ash white in front of* RAUF. *He lunges forward and stabs the priest in the heart with his hunting knife.* BOB *wipes his knife on the priest's cassock and turns to face the* VILLAGERS *who run in fear.*

90. EXT. BOB'S CAMP. DAY

The MEN *of the village enter* BOB'S *camp cautiously, hunters looking for their quarry. The men divide up and disperse into different parts of the wood.*

91. EXT. WOODLAND. DAY

One of the young MEN *stalks through the forest, his hunting knife at the ready. The hurdy-gurdy begins to play in the bushes next to him. He spins round to face his unseen enemy. As he does so he steps into a trap which snaps savagely around his ankle. He lets out a horrified scream.*

92. EXT. WOODLAND. DAY

Two MEN *stop in their tracks as they hear the scream in the distance. They look at each other anxiously. The silence is shattered by a second scream.*

93. EXT. WOODLAND. DAY

The young MAN *in the trap falls limply to the ground, blood pouring from his mouth. The ashen figure of* BOB *stands holding a knife.*

94. EXT. WOODLAND. DAY

A MAN *with a burnt arm treads nervously through the brushwood. He parts some branches and lets out a cry. One of the* MEN *we have just seen hangs upside down from a rope, blood drips from his nose and his mouth opens and closes silently. The hurdy-gurdy begins to play behind him. He turns terrified and starts to run in panic. Each tree seems to have a hidden danger behind it.*
The ghostly figure of BOB *steps in his way. Unable to stop, he runs straight into his arms.* BOB *clasps him in an embrace. Without any emotion,* BOB *takes his hunting knife and forces it through his ribs.*

95. EXT. BOB'S CAMP. DUSK

BOB *has gathered the corpses of the dead men of the village and has laid them like vermin in a line in the clearing. He lies on the ground amongst them simulating death, his eyes open, staring at the sun which shines through the trees as it sinks over the horizon.*

96. EXT. ANCHORESS'S CAIRN DUSK

The WOMEN *are praying at the remains of the* ANCHOR-ESS*'s cairn in the fading light.* BOB *emerges from the woodland. They watch him as he passes by them.*

97. INT. FORGE. DUSK

BOB *walks through the empty forge looking for* PROPHESY. *The huge fire is no longer burning. He climbs the stairs to* ROLLO*'s room.*

98. INT. ROLLO'S ROOM. DUSK

BOB *stands in the doorway. The room is empty. The fire in the grate just a pile of blackened ashes.*

99. INT. PROPHESY'S ROOM. DUSK

BOB *enters* PROPHESY*'s empty room. He walks across to*

the window, on the sill lies the withered celandine. He picks it up. It crumbles in his hand.

100. INT. BELFRY. DUSK

BOB *opens the door of the belfry and walks in. He stops for a second and looks up. Straight ahead of him* WAT*'s small body hangs limply from the bellrope. He stares at the corpse. He cuts* WAT *down, the body falls over his shoulder.*

101. EXT. SEASHORE. DUSK

BOB *walks along the craggy shore carrying* WAT*'s small corpse in his arms. In the distance* PROPHESY *sits, staring out to sea.* BOB *approaches her and whispers her name.*

BOB: Prophesy?

[*She turns her face away.*]

BOB: Prophesy?

[*He places* WAT*'s corpse next to him on the shingle and sits watching* PROPHESY. *Without warning a hail of stones falls all around him, bouncing and thudding off the rocks.* BOB *stands up as the stones begin to find their target. He raises his arms to protect himself. He staggers backwards towards the sea, his face and hands now bleeding.*

The women of the village are moving down on him, pelting him with rocks. He wades into the sea, the stones splashing around him.

PROPHESY *watched without a flicker of emotion as he begins to lose his footing and, finally knocked unconscious, his battered and bleeding body sinks beneath the waves.*]

102. EXT. SEASHORE. DAWN

The sun rises over the sea. PROPHESY *sits on her rock looking vacantly out to sea as the women build a cairn around her. The first layers of stone are already in place.*

They pass the stones in a human chain. PROPHESY *begins to sing with the voice of the old anchoress. As she starts to sing everything slows up, the waves freeze, the wind dies, then the women passing the stones. The film ends on a freeze frame of* PROPHESY's *face accompanied by her song.*

Song: Prophesy
 Farewell this world
 I take my leave forever

B Movie:

Little

England/A Time

Of Hope

B MOVIE

B Movie was a chance to snap out of the worthy *Bob-Up-A-Down*. Julian Sands, the handsome young actor, was writing a play on John Donne, and was undecided which way his life would take him – writer, film-maker, director. He had appeared briefly in the *Broken English* video, but with a skull's mask, a year or so before. He was great fun to work with.

This was to be a light hearted 'Carry On' of *Jubilee*. Where do these things come from? The Villian, Borgia Ginz was a good start. Mrs T. had gone mad in the ideological jumble sale, flogging the silver, then the china, and the table itself. The worst had come to roost like vultures in the great hall at Westminster, picking through the tatters of the past, threadbare flags in a cathedral. Janet Street-Porter, an old friend, would have made an excellent Veronica. Adam is of course Adam Ant, whose career had blossomed from the Megalovision camper. England is sold off, a Disney theme park. Revolution triumphs.

I would love to have made this film, but it is too late now. The vultures swooped and took the Iron Lady to the Other Place. Everyone has their can openers at the ready. This is the role of the Late Windsors, and their Castle. When will the little recipe from *Exit* be brought up by the butler?

1. INT. WESTMINSTER HALL CATAFALQUE.
TV SEQUENCE

In the glittering candlelight, frozen in a cube of ice, the body of LORD PROTECTOR GINZ, *dictator of all England, lies in state on a huge pile of red and white roses. At the four corners of the bier* OFFICERS *of the Household Guard stand vigil. The* PEOPLE OF ENGLAND, *having queued all night, pass by in silence to pay their last respects to the sound of a muffled drum roll.*

ANNOUNCER: And now, in this beautiful and historic hall in Westminster, resting place of so many Kings and Queens, deep in the night, the people of England file past the catafalque with its emotive red and white roses on which lies the body of Lord Protector Ginz, dictator of all England.

[*The drum roll has ushered in the first movement of Beethoven's 5th Symphony.*

At the four corners of the bier stand OFFICERS *of the Household Guard in their scarlet and gold uniforms, with black armbands, the traditional symbol of mourning.*

We cut to the MOURNERS *and notice they are chained to each other like convicts.* GUARDS *stand in the shadows with machine guns.*]

For two days now the never ending stream of mourners has filed past the bier to catch a final glimpse of the leader they loved so dearly. How moved the Protector would have been by this display of loyalty and indeed if his dreams are fulfilled he will no doubt comment on this from beyond the grave.

All day heads of state have been flying into London for tomorrow's service which will be conducted by the Archbishop of Canterbury in the refrigerated vaults of the Churchill centre for suspended animation where the Lord

119

Protector Ginz will be the first Head of State. His last words were: 'I will succeed beyond Lenin's wildest dreams'.

2. EXT. SOTHEBY'S SALEROOM. DAY

ADAM, *a young busker, stands at the door of Sotheby's auction room playing his guitar. The song is drowned out by the sound of cars arriving for an auction. Rolls Royces and Cadillacs deliver Arabs, Japanese, Africans, Russians, etc . . . who push past the young singer ignoring him. A* JAPANESE BUSINESSMAN *in a very grey suit stops to pose his* WIFE *with* ADAM *to take a photo. He gives him 50p with Borgia's head engraved on it as a tip.*

JAPANESE: Ah ta ta pa attatta pa aah

JAPANESE WIFE: Photo suchi mi ha

[*The photo is taken.*]

JAPANESE WIFE: Yama ha Tokio

[*They turn to enter the auction room.*]

ADAM: [*Under his breath*] Hiroshima

3. INT. SOTHEBY'S AUCTION ROOM. DAY

Hanging on the walls at the back of the auction room behind the auctioneer's podium is a large map of England. The podium is decorated with limply hanging bunting. There is a babble of voices from the crowd. The AUCTIONEER *takes his place on the podium.*

AUCTIONEER: Good morning, ladies and gentlemen. Under the terms of Lord Protector Ginz's will, all lots today will be sold for cash. You will find the conditions of this sale printed in the forewords of your catalogues. As you know we have a special affection for England, having sold so much of its contents in the past for Protector Ginz, so it is with special pleasure that I commence today's historic sale.

Lot one. Protector Ginz's country estate, the former county of Dorset. This picturesque country estate has been

entirely relandscaped to remove all evidence of former industry and settlement. What am I bid? 30 billion, 100 billion, 200 billion, 250 billion, 300 billion. 300 billion. Any advance on 300 billion? You're out on the left, sir, 300 billion in the centre of the room. Is there any advance? [*He brings the hammer down.*]
Sold to C.T. Slicker. Congratulations.
[*A line of* FLUNKIES *wheel barrows of cash down the aisle. The* AUDIENCE *clap. Dissolve:*]

AUCTIONEER: Lot 131, the conurbations of Liverpool, Manchester and Birmingham. All properties maintained in an excellent state of preservation by the National Trust. Monuments to the industrial past, these cities were left to the Trust in lieu of death duties by their former inhabitants. Included in this lot is the extermination camp at Windscale. Still in working order, this has obvious tourist potential. What am I bid? 200 billion, 275 billion, 500 billion. Any advance on 500 billion? Sold to C.T. Slicker.
[*Dissolve: The auction room is nearly empty. Just* C.T. SLICKER *and his* AIDES *remain. The* AUCTIONEER *looks exhausted.*]

AUCTIONEER: And finally, ladies and gentlemen, lot 400, the last of England and today's sale. The Isle of Dogs, Alcatraz has nothing on it.
[*There is a long silence,* C.T. SLICKER *turns out his pockets. They are empty. He looks embarrassed, his aides are now penniless.*]
What? No takers? Gentlemen, I assure you the lot has no reserve.
[*Young* ADAM *walks in and wanders up to the podium and bids the 50p that the Japanese businessman gave him.*]

ADAM: 50p
[*He puts the money on the auctioneer's desk.*]

AUCTIONEER: Going, going, gone.
[*The* AUCTIONEER *brings down his hammer with a crash, hitting* ADAM'S *hand.*]

C.T. SLICKER: Damn.

4: EXT. BATTLE OF BRITAIN ESTATE, E200.
NIGHT

A concrete jungle with a forest of dead trees and seas of mud fringed with debris. Under the one working street lamp stands a group of BEDRAGGLED WHORES, *behind them a huge regulation board which is headed: 'Battle of Britain Estate' listing a never ending series of 'don't's. The chief of the girls is* MONIQUE *who is dressed in scanty army surplus with a tatty feather boa.* ADAM *approaches, singing of his new found wealth.*

ADAM'S TYCOON SONG: Do wop a do wopa do wop wop
 Do wop a do wopa do wop bop
 Wop bopa lu bopa lu bam boom
 Wham bam a bama I'm a Tycoon
[*As* ADAM *passes by the girls,* MONIQUE *lifts up her dress revealing all.* ADAM *stops and grabs her.*]

MONIQUE: 'Ere, we can't do it here, Adam.

ADAM: Why not?

MONIQUE: [*Pointing to the regulation board*] Says so.

ADAM: Where?

MONIQUE: Housing act, section, one, clause three.

ADAM: Let's fuck, Monique.
[*He picks up a bottle and throws it at the light, plunging everything into darkness.* ADAM *starts to sing as they make love in the dark. The* GIRLS *giggle.*]

ADAM: Wop bopa lu bop . . .

5. EXT. COUNCIL HOUSE, BATTLE OF BRITAIN
ESTATE, E200. NIGHT

'The Blue Hawaii'. Under the illuminated sign, MONIQUE *kisses* ADAM *goodnight.*

ADAM: Thanks a million. See you, darling.

6. INT. BLUE HAWAII. NIGHT

Adam's parents live in a flat entirely decorated with rock 'n' roll memorabilia. On one wall is a shrine with scarlet votive lights dedicated to the memory of Protector Ginz. Adam's

122

parents, whose names are MARY LOU *and* KING ROCKER,
*are in their late 60s. He is a teddy boy and she is a Marilyn
Monroe lookalike.* ADAM *walks in the door and interrupts
their jiving to an old 50s classic, they are celebrating their
silver wedding anniversary.*

KING ROCKER: Where you been?

ADAM: West End . . . Happy anniversary.
[*He hands them an envelope proudly.*]

KING ROCKER: What's this then? . . . You open it, Mary
Lou.

MARY LOU: All right, King Rocker.
[ADAM *pours himself a drink and sits down. He puts his
leg up on the shrine.*]

KING ROCKER: Take your feet off the bleeding shrine!
[ADAM *rearranges himself.*]

ADAM: Open it, Mum.
[*She opens the envelope, takes out a card and reads.*]

MARY LOU: THE ISLE OF DOGS.
[*She looks questioningly at* ADAM, *turns it over, it is
blank on the other side.*]
What's this?

ADAM: It's your present. It cost.

KING ROCKER: What do you mean you bought it?

ADAM: I bought it, didn't I, up the West End. Don't you like
it?

MARY LOU: Course we do, don't we, King Rocker. Lovely
present, just what we always wanted.

KING ROCKER: Do you mean you actually bought it, paid
for it!

ADAM: Yeah, Sotheby's . . . Bargain.

KING ROCKER: I see . . . Well, s'pose it's the thought that
counts.

MARY LOU: That was very nice, Adam. Now let's have
some cake.
[*She cuts the cake.* KING ROCKER *picks up a cracker and
pulls it with* ADAM. *A gold paper crown falls out.*]

ADAM: Here, dad, let's crown you.

KING ROCKER: Oh hell.

ADAM: Kneel down, dad.

KING ROCKER: All right then.

[ADAM *takes the crown and crowns him.*]

ADAM: I crown you King Rocker the First of the Isle of Dogs!

[ADAM *collapses on the sofa and starts to sing 'God Save the King'.*]

7. INT. 'THE KRIEG', A NIGHTCLUB, WHERE IT'S AT. MIDNIGHT

MONIQUE *and her* GIRLS *prop up the bar. Some* BOYS *play pool, the majority of the club are watching Adam's band, who perform a rock version of 'God Save the King'. Behind the band the only decoration is a large sign painted on a backdrop, 'The Krieg'.* ADAM *and the* BAND *finish the set. In a corner a character stands dressed in eighteenth-century footman's outfit. As the band leaves the stage he walks over to* ADAM.

FOOTMAN: [*In a fey voice*] I've a job for you.

ADAM: What sort of job?

FOOTMAN: Coronation ball in Dorset. Tomorrow.

[*He gives him a gold coin.*]

ADAM: You're on. Better get moving.

Bye, Monique.

MONIQUE: Why, where are you going? We've got a date, haven't we?

ADAM: It'll have to wait.

8. EXT. LANDSCAPE DORSET. CUSTOMS POST. DAY

ADAM *in the back of an armoured car accompanied by the* FOOTMAN *passes through the barriers of the Dorset customs post.*

CUSTOMS LADY: Blacks, homosexuals and Jews are banned in Dorset. Hurry, hurry, hurry!

9. EXT. CROQUET LAWN, H.Q. KINGDOM OF DORSET. DAY

A game of croquet is in progress. The participants are C.T.
SLICKER, *his daughter* VERONICA *and a group of* GENERALS
surrounded by FOOTMEN *in eighteenth-century dress.*

VERONICA: Your turn, daddy.

C.T. SLICKER: Thank you, Veronica.

[*He hits the ball and turns to a general.*]

C.T. SLICKER: Good show, what, eh Genocide? Ha ha ha.

[GENOCIDE *clicks to attention.*]

GENOCIDE: Absolutely, sir. [*Aside to himself*] For an amateur.

VERONICA: [*Hisses*] I heard that, Genocide.

[VERONICA *hits the ball. The* COURTIERS *applaud her.
At this moment the armoured car arrives with* ADAM,
interrupting the game. One of the COURTIERS *whispers
into* SLICKER's *ear.*]

SLICKER: 'Scuse me, Veronica darling. It's that musician
chappie who bought the Isle of Dogs. We're going to do a
deal. Ha ha ha ha.

[*He walks across to the armoured car and looks through
the window, smiling.*]

SLICKER: Do you want to play?

ADAM: No thanks, mate.

[*He turns to the* FOOTMAN]

SLICKER: Gieves, show him to his quarters. Ha ha ha ha.

[*As the car pulls away* SLICKER *returns to the croquet.*
VERONICA *looks at* ADAM *long and lovingly, her buck
teeth and brace crease into an awful smile.*]

10. INT. DUNGEON CORRIDOR. DORSET H.Q. DAY

ADAM *is ushered along the corridor by a mad crippled*
HOUSEMAID *carrying keys and a candle accompanied by
one* FOOTMAN.

ADAM: Bit dark, isn't it?

[*The* HOUSEMAID *doesn't answer. In the distance they*

hear a scream. The candle gutters. ADAM *looks slightly taken aback. A bat flies past.*]

ADAM: Nice effects.

[*They come to a door and the* FOOTMAN *opens it.*]

HOUSEMAID: Your room, sir.

[*The* FOOTMAN *pushes* ADAM *in and slams it shut behind him.*]

11. INT. CELL. PITCH DARKNESS

ADAM *looks around the room which is completely black except for one small candle. The key turns in the lock.*

ADAM: Hey! Wait a minute!

[*He rattles the door. It doesn't open. There's a chuckle in the dark.* ADAM *turns and sees a* PRISONER *who wears painter's overalls, sitting by the candle in the dark.*]

ADAM: What are you doing here?

RED FLAG: Name's Red Flag. I'm a trade unionist.

ADAM: Aren't they extinct? A trade unionist. Pleased to meet you. I'm Adam, a musician.

[*He holds out his hand.* RED FLAG *takes it.*]

RED FLAG: Welcome, comrade.

[*They sit down*]

ADAM: Why have they put me here?

RED FLAG: You're a hostage for the Isle of Dogs.

[ADAM *looks amazed.*]

RED FLAG: Join the resistance.

12. INT. DORSET HQ. DINING ROOM. NIGHT

C.T. SLICKER *and* VERONICA *at either end of a huge table eat soup in silence by candlelight. They stare at each other angrily.*

VERONICA: Oh daddy, please let him play at the Coronation Ball, oh do.

[SLICKER *spills his soup down his front in agitation.*]

SLICKER: Damn damn damn!

[*He looks at* VERONICA *who has a tear in her eye. She dabs it with a napkin.*]

VERONICA: Oh daddy please.

SLICKER: Oh all right, dammit.

[VERONICA *gets up and throws her arms around him.*]

VERONICA: Oh daddy thank you.

13. INT. DUNGEON. DORSET H.Q. NIGHT

RED FLAG *is teaching* ADAM *'The Internationale'. They are interrupted by a knock on the door.*

VERONICA: I say, yoo hoo!

ADAM: Bleeding room service. What do you want?

VERONICA: Daddy's relented. You can play at the Coronation Ball.

ADAM: Thanks a million. I can't wait.

VERONICA: Oh goodee. [*Whispered.*] Come here. We could elope.

ADAM: Elope! Where to?

VERONICA: The Kings Road.

ADAM: Not a chance.

VERONICA: Anywhere then.

ADAM: Now you're talking. What about my mate?

VERONICA: A threesome! Oh! Anything you like, darling.

14. INT. THE THRONE ROOM. DORSET H.Q. DAY

The Coronation of C.T. SLICKER *as King Charles the Last of England. The* ARCHBISHOP OF CANTERBURY *puts the crown on* C.T. SLICKER's *head.*

ARCHBISHOP: I crown you Charles King of all England, except the Isle of Dogs.

[*The* CHOIR *burst into Handel's 'Zadok the Priest', the* COURTIERS *form a guard of honour. They are all dressed in eighteenth-century costume.*]

15. INT. THE BALLROOM. DORSET H.Q. NIGHT

The COURTIERS *are dancing to the sound of a jukebox which beats out disco. A* FOOTMAN *feeds it with gold sovereigns. In the background a shifty looking* VERONICA

pours a sleeping drug into the wine decanters. A footman steps forward and announces ADAM, *another serves the poisoned drink.*

FOOTMAN: Your Majesty King Charles, your Royal Highness, My Lords and Ladies, ADAM.

[*The curtains on the stage part revealing* ADAM *and* RED FLAG *standing handcuffed and chained. They start the set with 'Jailhouse Rock.'*]

VERONICA: Goodee!

[*The music blasts out as one by one the drugged* COURTIERS *faint until* VERONICA *and* CHARLES *who sits on a throne in the front are the only ones left. The sound of the music drowns out the sound of the fainting courtiers. The song finishes.*]

KING CHARLES: Not bad.

[*He takes a glass to toast them, swigs a large mouthful and keels over.*]

VERONICA: NOW!!!

16. EXT. DORSET H.Q. NIGHT

VERONICA, RED FLAG *and* ADAM *pile into the armoured car and drive off.*

17. EXT. THE ISLE OF DOGS. NIGHT

A small group of caravans packed in an urban wasteland. One of them still has its lights on with a flag flying alongside it with a picture of Elvis on it. The camera zooms in through the window and we find KING ROCKER *and* MARY LOU *in an interior decked out like the Villa Blue Hawaii, with rock mementoes.* KING ROCKER *sits on a throne.* MARY LOU *is weeping, holding a picture of* ADAM.

MARY LOU: My poor baby.

KING ROCKER: Oh shut up.

MARY LOU: How can you be so heartless?

KING ROCKER: It's easy.

128

MARY LOU: [*Breaking down*] Oh, King Rocker.

KING ROCKER: Oh forget it.

[*He switches on the TV.* MARY LOU *has hysterics.*]

KING ROCKER: He's old enough to look after himself.

MARY LOU: How can you forget him after he gave us all this?

[*The TV flickers on and* KING ROCKER *turns the volume on full to drown out* MARY LOU *wailing. On the television we hear the honeyed voice of the announcer from the Churchill Institute of Suspended Animation.* WE CUT INTO THE TV.]

18. INT. BURIAL VAULT. CHURCHILL CENTRE

On a white mortuary slab the body of BORGIA GINZ *in its ice cube is connected by a thousand multicoloured wires and electrodes to a computer operated by the* ARCHBISHOP OF CANTERBURY *wearing his mitre and polar thermals to protect him from the cold.*

ANNOUNCER: [*Voice over*] Here at the nucleus of the Churchill Centre of Suspended Animation. Forged in the white heat of the technological revolution, we are waiting with the Archbishop of Canterbury, for mankind's first contact from beyond the grave.

[*The electrodes begin to activate. The computer screen flickers.*]

ANNOUNCER: It's happening. Something is definitely coming through. You can feel the excitement down here. This really is an historic moment. Science's greatest triumph besides which the space programme pales into insignificance. Now we'll join the Archbishop.

ARCHBISHOP: It looks as if we are to receive a revelation.

19. INT. CARAVAN. ISLE OF DOGS. NIGHT

MARY LOU and KING ROCKER *glued to the TV.* MARY LOU *wipes her tears away.*

KING ROCKER: Fuckin' Hell!

20. INT. CHURCHILL INSTITUTE. NIGHT

Close-up of computer screen.

ANNOUNCER: [*Voice over*] It's happening. We're witnessing history. He's definitely coming through. Lord Protector Ginz said he'd do it, and he's done it.

[*The screen illuminates and the following words print out:*]

... TO BE OR NOT TO BE, THAT IS THE ANSWER ...

[*An awful buzzing sound and it phases out.*]

ANNOUNCER: [*Voice over*] We've lost him, but how about that, how about that. One small step for man one giant leap for mankind.

21. INT. CARAVAN. ISLE OF DOGS. NIGHT

KING ROCKER *and* MARY LOU *are fucking. On the stereo is a 50s classic: 'Goodness Gracious Great Balls of Fire'.*

22. EXT. CUSTOMS POST. DORSET BORDER. DAWN

The armoured car draws up to a halt. ADAM *and* RED FLAG *get out carrying a trunk.*

23. INT. CUSTOMS POST. DORSET

ADAM and RED FLAG *walk through the 'Nothing to Declare' gate wheeling the trunk. They are half way through when the* CUSTOMS OFFICIAL, *a 20 stone giantess with a deep voice calls them back.*

CUSTOMS LADY: Just a minute, you two. What's in that?

ADAM: What?

CUSTOMS LADY: The trunk.

ADAM: [*Innocently*] Oh, the trunk.

[*He laughs.*]

A princess. Do we have to declare her?

CUSTOMS LADY: A princess. Well well well. Let's have a little look.

ADAM: Lost the keys.
[*He looks to* RED FLAG.]
Have you got the key?
RED FLAG: No, I ain't got it. Thought you had it.
[ADAM *looks in his pockets.*]
ADAM: We must have lost it.
The CUSTOMS LADY'*s suspicions are all aroused.*]
CUSTOMS LADY: Well, I'll have to open it myself, won't I?
[*Suddenly she sits on the trunk with all her bulk. The trunks caves in. There is an awful scream from* VERONICA *who is bound and gagged inside. The boys run for their lives. The* CUSTOMS LADY *draws a gun. She misses the fugitives but hits the* BARRIER GUARD *who falls on the lever, opening the gate.* ADAM *and* RED FLAG *escape.*]

24. INT. 'THE KRIEG'. EARLY MORNING

The club is almost empty. The BARMAN *is cleaning the glasses. A* COUPLE *are playing a desultry game of pool.* MONIQUE *is sitting on a stool against the bar looking very sad. The barman is trying to cheer her up.*
BARMAN: Cheer up, luv. I'll put on his song.
MONIQUE: Thanks, Lucky.
[*He crosses over and puts a coin in the juke box.* ADAM'S *voice floods into the room.*]
MONIQUE: Do you think he's still alive?
BARMAN: Sure he is, he's a survivor.
[*He pours her a drink.*]
MONIQUE: What did he have to buy that island for?
BARMAN: Destiny, I suppose. Cheer up, luv.
[MONIQUE *listens to the song in silence.*]
MONIQUE: It's the West End. That's what did it.

25. INT. DORSET H.Q. WAR ROOM. DAY

Surrounded by patriotic memorabilia, flags, guns, suits of armour, portraits of famous generals and battlescenes, KING

CHARLES THE LAST *pores over a map.* VERONICA *now dressed as a general and holding a machine gun converses with general* GENOCIDE *and a group of* AIDES. *In the corner, tied and bound, lies the* CUSTOMS LADY.

CHARLES: Well, Genocide, a couple of tanks should do the trick. Ha ha ha ha.

VERONICA: I want him alive.

[*The* CUSTOMS LADY *is crying in the corner.*]

CUSTOMS LADY: What's going to happen to me? I was only trying to help.

VERONICA: What's going to happen to you?

[*She levels her machine gun and blasts her out of existence.*]

CHARLES: Good shot, dear. Wha ha ha ha.

26. INT. THE CARAVAN. ISLE OF DOGS. EVENING

KING ROCKER *and* MARY LOU *are glued to the TV. Full volume.* MONIQUE *washing up. We cut to the TV.*

27. INT. CHURCHILL CENTRE. EVENING

Close-up of computer screen.
. . . I AM BECAUSE I AM . . .
 [*It phases out.*]

28. INT. CARAVAN. ISLE OF DOGS. EVENING

KING ROCKER *and* MARY LOU *applaud the TV.* MONIQUE *washing up.* ADAM *and* RED FLAG *arrive during the applause.* MONIQUE *screams and drops a pile of plates with a smash on the floor.*

MONIQUE: Adam!

[*She throws her arms around him and kisses him.*]

KING ROCKER: Haven't you got any feelings? Your mum's been sick to death. When I was your age I had a bit more respect.

132

MARY LOU: Where have you been?

ADAM: I'm sorry, mum, I've been inside.

KING ROCKER: You what?

MARY LOU: My God, what will the neighbours think?

ADAM: Listen, we're in schtook. This nutter has crowned himself the King of England and his army is coming up from Dorset to do us in.

KING ROCKER: What are you talking about?

ADAM: There's no room for two Kings.

KING ROCKER: Right mess you've got us into with your bleeding present. Stuck in this fucking caravan in the middle of bleeding nowhere playing at royalty.

MARY LOU: I was happy in E200.

MONIQUE: Oh come on, you two, he meant well, and anyway he's home safe.

KING ROCKER: Well I'm abdicating.

ADAM: It's too late, he's on his way, anyhow if you think you've got problems you should see his sabre-toothed daughter.

MONIQUE: [*Bursts into tears*] I was right. There is another woman.

[RED FLAG *steps forward to* ADAM's *defense.*]

RED FLAG: Don't worry, luv, he's for your eyes only.

MONIQUE: [*Through her tears*] Who are you?

RED FLAG: I'm Red Flag.

ADAM: He helped me escape.

MARY LOU: [*To Monique*] Come on, we'll make a cup of tea.

29. INTERLUDE MONTAGE WITH VOICE OVER

The cryogenic computer screen. With the ANNOUNCER's *voice repeating the words which are coming through.*

ANNOUNCER: [*Voice over*] '. . . This land of such dear souls this dear, dear land, dear for the reputation through the world is now leased out . . .'

[*The* ANNOUNCER's *voice carries on over the subse-*

*quent images which resemble an old newsreel and show
the fragments of old footage from the 70s and early 80s.*]

ANNOUNCER: [*Voice over*] I die pronouncing it like to a
tenement or a pelting farm. England bound in with the
triumphant sea, whose rocky shore beats back the envious
siege of watery Neptune, is now bound in with shame,
with inky blots and rotten parchment bonds; that England
that was wont to conquer others, hath made a shameful
conquest of itself. Ah would the scandal vanish with my
life, how happy then were my ensuing death.

30. EXT. A DERELICT LANDSCAPE. NIGHT

*In the flickering shadows of a camp fire with their tank in the
background,* KING CHARLES *the Last,* VERONICA *and
General* GENOCIDE *are holding a council of war.* CHARLES
the Last sits drunkenly on his throne. On camp stools
GENOCIDE *and* VERONICA *pore over a folding table whose
top is a map of England showing the progress of their
campaign with black flags.*

KING CHARLES: What have we bagged today, Genocide?
Wha ha ha ha What!

GENOCIDE: Swindon and Slough, your Majesty.

VERONICA: [*Banging the table*] That's not enough, Geno-
cide!

GENOCIDE: Princess! We had stiff resistance in Salisbury
and there were all those listed buildings.

VERONICA: What!

GENOCIDE: The Cathedral after all was painted by
Constable.

VERONICA: Dynamite it.

CHARLES: Is that really necessary, Veronica?

VERONICA: Shut up, daddy.

CHARLES: Just like your mother.

[*He shrugs his shoulders and shuts his eyes.* VERONICA
leans conspiratorially towards GENOCIDE *in a whisper.*]

VERONICA: Poor daddy, the excitement's proving too

much for him, unlike you Genocide, he doesn't understand modern warfare.

31. EXT. AN IDYLLIC ENGLISH VILLAGE. DAY

A panoramic shot of rural paradise with magnified birdsong and the sound of a cuckoo.

32. EXT. IDYLLIC ENGLISH VILLAGE. COUNTRY COTTAGE GARDEN. DAY

A lush green lawn. Beautiful flowerbeds and a greenhouse at the bottom of the garden. A water sprinkler turns in the sunlight. DAD *is mowing the lawn. The two* CHILDREN *are playing hopscotch. The* BABY *snoozes in its pram.* MOTHER *comes through the french windows carrying a tea tray.*

MUM: Tea time!

[*The kids run over as she puts it down on a garden table.*]

MUM: Come on, Jack, it'll get cold.

JACK: Coming, darling.

[*They sit down for the family picnic on the lawn. Suddenly* KING CHARLES*'s tank comes crashing through the greenhouse and up the crazy paving path, crushing gnomes and roses.*

Before the family can react the tank opens fire. Bullets riddle tea cups and blast the family into oblivion. The water sprinkler slowly fades as the hose is severed by a bullet.]

33. EXT. A RUINED LANDSCAPE. ISLE OF DOGS. NIGHT

The forces of KING ROCKER, ADAM, RED FLAG, MONIQUE *and her* GIRL FRIENDS *dressed in army surplus are sitting round a bonfire.*

ADAM: Is everything planned for tomorrow?

RED FLAG: Yeah, we'll give them a run for their money.

ADAM: Are you OK?

RED FLAG: Just waiting for the war to end all wars.
ADAM: Get some rest, tomorrow's the big one.
RED FLAG: Goodnight Adam, goodnight Monique.
 [MONIQUE *gives him a kiss. He leaves.*]
ADAM: It'll be all right, luv, you wait and see.
MONIQUE: I know everything will be fine, but if it isn't, Adam, I want you to know I love you.
ADAM: Me too Monique. I'm crazy about you.
MONIQUE: Oh Adam, I won't let you down.
 [*She kisses him.*]

34. EXT. DESOLATE WASTELAND. NIGHT

By the light of a bonfire KING ROCKER *and* MARY LOU *back to back in sleeping bags.* KING ROCKER *rolls over and nudges her. She wakes up.*
MARY LOU: What is it?
KING ROCKER: I just want you to know you were great to dance with.

35. EXT. DESOLATE WASTELAND. NIGHT

A panorama of glittering bonfires. In the foreground ADAM *serenades* MONIQUE *and his forces with the song, 'You'll Never Walk Alone'.*

36. EXT. WINDSOR CASTLE. NIGHT

A shot of the battlements of Windsor Castle in the darkness. Ominous music.

37. INT. WINDSOR CASTLE. NIGHT

The bedroom of Princess VERONICA. VERONICA *is in bed with General* GENOCIDE *in a vast four poster. She is reading a large copy of* Mein Kampf *and he a copy of the boy's book* Valiant. VERONICA *shuts her book and turns to* GENOCIDE.

VERONICA: Ich liebe dich.
[*She kisses him on the cheek.*]
Time for daddy's medicine.
[*She gets up, throws her black feathered negligee over her shoulders, goes to a medicine cabinet and takes out a bottle labelled 'poison'. She pours it into a silver chalice.*]

38. INT. KING CHARLES THE LAST'S BEDCHAMBER. NIGHT

KING CHARLES *the Last sleeps fitfully in a gilded Royal bed. He mutters to himself in his sleep recalling the Kings of England and their dates.*
CHARLES: William the First 1066–1087, William the Second 1087–. . .
[*The door creaks open and* VERONICA *appears like a black crow.* CHARLES *wakes with a grunt.*]
VERONICA: Time for the monkey glands, daddy.
CHARLES: Not bloody likely.
[VERONICA *advances with the chalice.*]
VERONICA: You want to have a long reign, don't you, daddy?
[CHARLES *smiles in agreement.* VERONICA *hands him the chalice.*]
VERONICA: I'll hold your nose for you.
[*She pinches his nose. He gulps it down.*]
CHARLES: Good god, what was that stuff, Veronica?
VERONICA: Just a little recipe from EXIT.
CHARLES: EXIT!
[*He starts to splutter and turn green. She seizes the crown and crowns herself.*]
VERONICA: Goodnight, King Charles the Last.

39. EXT. DESOLATE WASTELAND. MORNING.

In the debris of the industrial past KING ROCKER *slicks back his hair in front of a washstand mirror.* MARY LOU *is ironing his battledress trousers.* MONIQUE *and the* GIRLS *are doing P.E. to the sound of a whistle.* ADAM *and* RED FLAG *are*

*working out a new song. Over the rubble, bringing a
breathless message, comes* LUCKY *the barman.*

LUCKY: Crawley and Richmond have fallen, sir.
 [*He salutes*]

KING ROCKER: Call it off.

MARY LOU: Come on, King Rocker, you beat the Brighton
 Mods single handed with a couple of deckchairs.
 [KING ROCKER *flexes his muscles.*]

KING ROCKER: That's right, so I did.

MARY LOU: Well then
 [*She gives him a kiss.*]

KING ROCKER: Yeah all right, Mary Lou. Boys and Girls,
 take your positions!

ADAM: Well done, dad.
 [ADAM *blows a jaunty alarum on a bugle. The forces of*
 KING ROCKER *form themselves for battle.*]

40. EXT. RUBBLE STREWN BATTLE GROUND.
ISLE OF DOGS. DAY

VERONICA's *tank rumbles through the smoke of the
battlefield, shells and bombs exploding around it.*
Several Dorset INFANTRYMEN *scatter in the debris to take
up battle positions.* VERONICA *is in the parapet of the tank
wearing her crown conducting the battle through a loud-
hailer.*

VERONICA: Plebs! Scum! Parasites! Unemployed scroun-
 gers! Surrender before I wipe you off the face of England.
 [*A chorus of voices from the rubble.*]

VOICES: Never!
 [VERONICA *fires blindly into the rubble.*]

41. EXT. DIFFERENT PART OF BATTLEFIELD.
DAY

The tank rumbles forward. KING ROCKER *advances from
out of the rubble using a deckchair as a shield.* VERONICA
*screams with hysterical laughter through her loudhailer and
opens fire.*

KING ROCKER *falls to the ground. He's hit.* MARY LOU *runs out of the smoke to rescue him. She drags him to safety.*
MARY LOU: Oh my baby. My brave baby.

42. EXT. DIFFERENT PART OF BATTLEFIELD. DAY

ADAM *advances with his* MATES *in the thunder of battle. They are singing a marching song.* RED FLAG *lobs a hand grenade at the tank. It explodes harmlessly. The tank thunders on.* VERONICA *screams with laughter, gunning down two of Adam's gang.*
ADAM: Reform.
 [*They scatter.*]

43. INT. CARAVAN. ISLE OF DOGS. DAY

MARY LOU *is nursing* KING ROCKER'S *leg. Suddenly through the window she sees the tank advancing. She drops* KING ROCKER'S *bandaged leg.*
KING ROCKER: Ohhhh Ohhhh Ouch!!

44. EXT. CARAVAN. ISLE OF DOGS. DAY

VERONICA'S *tank bears down on* KING ROCKER'S *caravan, destroying everything in its path.*
The tank blasts other caravans which explode in a ball of flame.

45. EXT. RUINED CARAVAN. ISLE OF DOGS. DAY

The forces of KING ROCKER *have reformed.*
RED FLAG: Look!
 [VERONICA'S *tank is sitting on top of a crushed caravan. The Dorset* FORCES *gathered round it.*]
ADAM: Mum! Dad!

139

[*Through the smoke* MARY LOU *and* KING ROCKER *appear hobbling to safety.*]

KING ROCKER: We've lost.

MONIQUE: No we haven't. Girls, Operation Mantrap!

[MONIQUE'S GIRLS *begin to loosen their clothing.*]

KING ROCKER: [*Forgetting his injuries.*] Cor! Good god!

MARY LOU: Think modern, King Rocker.

[MARY LOU *strips off and joins the* GIRLS *who advance on the tank, seductively throwing off their bras, stockings and unpinning their hair as they go.* ADAM *accompanies them on his guitar.* KING ROCKER *looks on with his mouth wide open. He starts to loosen his tie.*]

46. INT. VERONICA'S TANK. DAY.

View of battlefield through General GENOCIDE'S *sights. The swirling smoke of the battle suddenly clears to reveal* MONIQUE'S *naked* GIRLS *advancing suggestively.* GENOCIDE *grabs his binoculars and desperately fiddles with the focus to get a better view.* VERONICA'S SOLDIERS *gape in amazement.*

VERONICA: Perverts.

[*She commands her* SOLDIERS *to shoot the advancing* GIRLS.]

VERONICA: Shoot them!

47. EXT. BATTLEFIELD. DAY.

VERONICA'S SOLDIERS *begin to strip off and run to embrace* MONIQUE'S GIRLS.

48. INT. TANK. DAY

General GENOCIDE *is salivating at the sight of the* BOYS *and* GIRLS *embracing. He unbuttons his tunic and begins to masturbate.*

VERONICA: Traitors, deserters, think of England!

49. EXT. BATTLEFIELD. DAY

The SOLDIERS *team up with* MONIQUE'S GIRLS *in the smouldering ruins. They sing to the sound of* ADAM's *guitar.*

50. INT. TANK. DAY

General GENOCIDE *has an orgasm, keels over and dies.*

51. EXT. BATTLEFIELD. DAY

The tank is surrounded by the forces of KING ROCKER. RED FLAG *pulls* VERONICA *out of the tank. Her crown falls off and disappears under a bramble bush.*
KING ROCKER: A horse, a horse, a kingdom for my horse.
MARY LOU: Don't be silly, dear.
 [KING ROCKER *grabs the crown.*]

52. EXT. DESTROYED CARAVAN. ISLE OF DOGS. DAY

The forces of KING ROCKER *are drinking tea, celebrating the victory.* VERONICA *is tied up on a ruined sofa.* KING ROCKER *is trying to tune into the salvaged TV.*

53. INT. BURIAL VAULT. CHURCHILL CENTRE FOR SUSPENDED ANIMATION. DAY

BORGIA GINZ *in his ice cube.*
ANNOUNCER: [*Voice over*] Strange events at the Churchill Centre today. Lord Protector Ginz has repeatedly trans-mitted the same message. I quote: 'Never before in the history of human conflict has so much been owed by so many to so few.'

54. INT. VILLA BLUE HAWAII, BATTLE OF BRITAIN ESTATE, E200

The party has moved on and is rowdier and more enthusias-tic. VERONICA *lies naked, bound on the sofa whilst* ADAM

141

plays the guitar and they sing, 'There's No Place Like Home'. KING ROCKER *sits in splendour on his throne wearing his crown, his leg bandaged, looking a proper war hero. As the song stops there are shouts of 'Speech!'.*

VOICES: Speech, speech, King Rocker!

[KING ROCKER *looks embarrassed.*]

KING ROCKER: Right, well, first I'd like to offer a vote of thanks to our heroes.

[*Everyone cheers.*]

Mary Lou and I, in view of the fact we really prefer our home comforts in Villa Blue Hawaii, have decided to abdicate, and doing so declare England a Republic.

[*Everyone cheers.*]

VERONICA: What about me? What's going to happen to me?

RED FLAG: Death or banishment, babe? It's up to you.

VERONICA: Banishment.

55. INT. SOTHEBY'S. DAY.

The interior of the sales room is entirely filled with Texans wearing wide-brimmed ten-gallon hats. The AUCTIONEER *steps out on to his podium.*

AUCTIONEER: Good afternoon, gentlemen. I trust you are all familiar with the conditions of the sale. It is with great sadness that we commence this afternoon, the final sale at Sotheby's, but with great pleasure that we offer as the only lot of this final sale, VERONICA!! who comes complete with a one way ticket to anywhere in the world. Gentlemen, I give you . . . VERONICA!!

[*The scarlet satin curtains part to the sound of a brass band playing 'A Long Way To Tipperary'.* VERONICA *is revealed wearing a voluminous scarlet Dior ball gown, tied to a stake like a diva taking a last curtain call, clutching her one way ticket to anywhere.*]

AUCTIONEER: Gentlemen, over the years I have been fortunate enough to sell England down the river, and this exceptional lot has to go the same way. What am I bid?

142

56. INT. VILLA BLUE HAWAII. E200. DAY

MARY LOU *and* KING ROCKER *are watching the Sotheby's auction on the TV as the bidding ends.*
MARY LOU: All's well that ends well.
 [*She changes the channel, cut to:*]

57. THE CHURCHILL CENTRE FOR SUSPENDED ANIMATION. EVENING

Inside the burial chamber there is total panic, a warning siren wails, lights flash.
ANNOUNCER: My God, something is wrong, something is terribly terribly wrong. The breakthrough has broken down.
 [*We cut to a close up of Borgia's ice cube, the wires are fusing and steam is pouring out. In the ice cube* BORGIA GINZ *seems to be resuscitating with the sound of hysterical spasmodic laughter. The* ARCHBISHOP *has become tangled with the shorting wires as minor explosions destroy the machinery. The* ARCHBISHOP *shouts the last rites in the chaos.*]
ARCHBISHOP: Dust to dust and ashes to ashes.
 [*There is an almighty explosion.* BORGIA *gurgles into silence. The computer collapses, burying the* ARCHBISHOP *and the ice melts, reducing everything to a sticky mess.*]

58. INT. ALBERT HALL ROCK CONCERT. NIGHT

ADAM *performs 'The Internationale' in a rock version in front of an ecstatic audience who wave red flags and join in the chorus.*

59. EXT. DOORSTEP VILLA BLUE HAWAII. NIGHT

MARY LOU *kisses* KING ROCKER *goodbye. She hands him a thermos of tea and sandwiches to take in a spanking new taxi.*

MARY LOU: Your first job in forty years.
[*She kisses him.*]

60. INT. DRESSING ROOM, ALBERT HALL.
NIGHT

MONIQUE *watches* ADAM *as he takes a shower.*
MONIQUE: You were wonderful.
ADAM: Come in here, darling.
[*She giggles and goes in fully clothed. He puts his arms around her.*]
I've been thinking. We deserve a holiday.
MONIQUE: Oh Adam.

61. EXT. SKYWAY HOTEL. DAY

A Texan MILLIONAIRE *stands with a pile of luggage on which* VERONICA *sits. He waves down a taxi which pulls up. The window goes down.* KING ROCKER *leans out.*
KING ROCKER: Where to, Guv?
TEXAN: The airport.
[*He climbs into the back of the taxi puffing his huge cigar.* VERONICA *loads the bags.* KING ROCKER *chuckles to himself.*]

62. EXT. WHITE CLIFFS OF DOVER. SUNNY DAY

ADAM *and* MONIQUE *stand arm in arm staring out to sea.* ADAM *delves in a carrier bag and produces the crown of England. For a brief moment they both look at it then he hurls it into the sea.*
He and MONIQUE *kiss and the camera pulls away and away and away.* RED FLAG *is the pilot of the helicopter which films this ravishing aerial shot.*

NEUTRON

SEQ20. (cont'd). ÆON UPSIDE DOWN

SEQ20 (cont'd) TOPAZ CHASES THE OLD MEN

SEQ21. BOMB.

SEQ22. SUPERMARKET.

NEUTRON

Lee Drysdale brought a darker cinematic side to this collaboration, a Jungian Yin and Yang. He was dead good on the drugs and violence, sort of in love with the Krays. Lee had more cinematic knowledge than anyone except Terence Davies. The Revelation of St John a good basis for this paper chase of horror casting. Bowie, Steven Berkoff, who I was helping adapt a play at that time, and Tilda. I hope that doesn't sound a throwaway 'and Tilda'. Tilda is what we call an 'old soul', sort of eternal She, sparkling like the evening star in the quirky skies of my films.

I visited all the great rusting power stations and factories. Chicago would have been the best location. Now it's Siberia, one of those decaying complexes, a nuclear base.

And what was I doing in 1983? Well, writing seventeen versions of this script, flying down to Bowie in Geneva. He was to be Aeon, though he wanted to play the tougher role of Topaz. Later he played me *Ashes to Ashes* in a darkened room.

Talk of the film daily with Michael Relph at Boyd's Co. Nothing happened. I was certain someone would want it. It was four years since I last worked. David liked it, I think, though he thought of me as a black magician – he said so when we came out of a screening of *Jubilee*, so maybe it was cursed. Too much God Slot.

1. THE GREAT JUNKED MACHINE/TITLE SEQUENCE

Superimposition of a blank white paper falling through space, past mountains of disused machinery, through cavernous halls, floating down, down. The sound of a single piano note and the distant half-distinct sound of two-way radios.

RADIO SIGNALS: 2000 calling I know your works repeat I know your works. Do you hear me? [*Interference*]. I know your works repeat you have the name of being alive but you are dead. Over. Do you hear me? You have the name of being alive but you are dead.

[*A hand catches the paper and places it in a typewriter . . . There is a brief silence then the words:*

'Who if I cried would hear me
Among the angelic orders'

are typed aggressively over and over. There is the sound of a crash as the typist hits the keys so hard they tangle and jam.]

2. INT. LIVING ROOM. AEON'S COUNTRY HOUSE. DAWN

SOHPIA, *in her late twenties, with her haunted but beautiful face, dressed in white, slowly pours a glass of red wine till it reaches the brim of the glass. She picks it up and moves cautiously and silently through the living room as the dawn light filters through the windows that open onto the garden. The slightest vibration threatens to break the surface tension – a gust of wind which picks up the curtains, or one of the party-goers stirring in their sleep. Huddled on the floor and on the sofas are young* MEN, *some of whom are in uniform, with* GIRLS *in expensive dresses with pallid exhausted faces.*

149

One of them, awake, thumbs through a coffee table book which illustrates the life of AEON, *the celebrity to whom this house with beautiful furniture and paintings belongs. A* BODYGUARD *stands at the door.* SOPHIA *smiles at him as she passes by.*

3. INT. GALLERY. AEON'S COUNTRY HOUSE. DAWN.

AEON *stands with his back to the camera, silhouetted against the window in the long gallery looking at the garden below. He is lit by the bluish flicker of an empty television screen. He is good looking, in his mid-30s and immaculately dressed.*

4. EXT. GARDEN. AEON'S COUNTRY HOUSE. DAWN

Down below two of the REVELLERS *have slipped out of their clothes and are making love in the lilypond. In the pale blue light of dawn they seem an Adam and Eve in the Garden of Eden. The beautiful romantic garden with the countryside beyond, a paradise. The sun comes up on a perfect summer morning, sending great streaks of pink and orange across the pale blue sky as the stars fade.*

5. INT. GALLERY. DAWN

SOPHIA *tip-toes into the gallery, carrying her wine glass. A slight movement betrays her existence.* AEON *turns round. She crosses the room. She smiles and offers him the wine.* AEON *kisses her. The force of the contact spills the wine over his perfect white shirt. They laugh at the accident.*

6. EXT. FILLING STATION. MOTORWAY. MORNING

AEON *is caught in a traffic jam alongside a petrol station on the motorway. The station is besieged by cars filled with anxious irritated occupants. The petrol pumps are protected*

by an armed GUARD *with a sub-machine gun. As* AEON *sits in his limousine he notices a young man in the uniform of a conscript pull a gun. The young man (*TOPAZ*) shoots the* GUARD, *but one of the bullets, going wild, shatters the driving mirror of* AEON's *car. As* AEON *pulls away, their eyes meet – briefly.*

7. INT. AEON'S TOWN HOUSE. MIDDAY

AEON *walks through the living room of his town house. It is shrouded with white dust sheets, which hang like a pall over the furniture, giving the room a ghostly air, reinforced by the half-light which filters through the windows, which are being blanked out by two workmen who are painting them white. In the twilight* AEON *almost misses the* HOUSE-KEEPER, *who is taking down the pictures which are stashed against the sofa. He is obviously in a hurry.*

AEON: Good morning, Annie.

HOUSEKEEPER: Good morning, sir. I'm just finishing the paintings. The van's here at one.

AEON: Thanks, Annie.

8. INT. BEDROOM. AEON'S TOWN HOUSE. MID-DAY

AEON *showers. Half way through the water mysteriously stops and turns to a trickle.* aeon *looks irritated, dries himself.*

On the bed a black suit and fresh shirt are laid out. AEON *contemplates the exact order.*

Dressed, he stares in the mirror which he has to unveil. ANNIE *has covered it with Sellotape, making it difficult to see his face.*

9. INT. CHAPEL. MID-AFTERNOON

The Committal Service is read briefly and without emotion by the PARSON. AEON *is the only mourner at his father's funeral. He stands alone next to the coffin. The parson's*

voice flickers for a moment, as there is a distant burst of machine gun fire and the wail of a siren. AEON *stares at the ceiling. A bird flies trapped in the rafters and crashes with a thud against the gaudy stained glass window. The siren wails insistently.* AEON *closes his eyes.*

10. INT. DERELICT OFFICE OF DESERTED FACTORY. EARLY MORNING

The camera pulls back slowly revealing the back of a seated typist: AEON, *and the ruined office in which he sits. The future world we have entered is in sharp contrast to the world we have left behind.*

Now AEON *has short, ill-cut hair, is wearing a dirty track suit over which is worn a shabby black overcoat with bulging pockets. He looks old beyond his age, unshaven and pale, with a scar on his cheek. He sits huddled over the typewriter like a tramp.*

The office is in total disarray. Holes gape in the ceiling, windows are smashed, furniture and files scattered and overturned. AEON *spins his chair round and stands up. He shuffles across the room coughing. He rubs his dirty tear-stained face and sits at a table looking at the decaying table top and the rusting typewriter and its yellowing paper. At the end of the table water drips through the ceiling into a puddle. He looks at his face distorted in the oily water.* AEON *fumbles in his pockets and pulls out a packet of cigarettes. He lays out the contents and slowly and deliberately cuts one in half. In another pocket his finds a lighter. He presses it and the lighter fails to ignite. He curses, gets up slowly, retrieves his typing paper, thrusting it into his pocket. He walks over to the window.*

11. EXT. RUINED COURTYARD OF DESERTED FACTORY. EARLY MORNING

Aeon's POV.
AEON *stares down into a ruined courtyard strewn with industrial debris. It is lit by an eerie sodium light which*

drains the colour from every surface, the greyness intensified by the fine ash which has drifted down covering everything in a deathly pall. In the middle of the yard is a bright bonfire around which ragged destitute CHILDREN *lie asleep in each other's arms in a bivouac constructed of old furniture. Some of the children are wearing drab ill-fitting adult clothing hitched up with belts and braces, others are naked. At first sight they seem quite normal but closer inspection reveals that they have yellow nostrils, fangs, strange eyes etc. They behave like wild cats, an unexpected mixture of fear and ferociousness.*

The smoke from the bonfire hangs suspended in blue wreaths in the still morning air. One of the elder boys sits playing a single note on a ruined piano, every now and then passing his hand over the strings with a strange, ghostly sound, disturbing a wild feral child who snores softly, and growls in his sleep.

12. INT. DERELICT OFFICE OF DESERTED FACTORY. EARLY MORNING

AEON *steps back from the window picking up a sharpened iron bar which leans against the wall. Then suddenly and very violently he walks along the floor smashing the window panes, showering glass into the courtyard far below.*

13. EXT. THE CHILDREN'S BIVOUAC. DESERTED FACTORY COURTYARD. EARLY MORNING

As the glass cascades into the courtyard the startled children wake up and fall into a defensive huddle around the LEADER. *High above a series of piercing whistles from* AEON *echo around the building. The* CHILDREN *stare upwards.* AEON *emerges from behind them taking them by surprise. He advances on them with his iron bar. The* CHILDREN *scatter into the debris, their eyes glowing in the shadows.* AEON *takes out his piece of typing paper, looks at it for a moment,*

153

plunges it in the fire and quickly lights his cigarette, then blowing out the flame stuffs it back in his pocket. Suddenly the LEADER *of the children steps out of the shadows, and hurls a stone at point-blank range at* AEON. *It hits him sharply on the side of the head. His cigarette drops to the ground.* AEON *retrieves it in a hail of stones. He quickly backs away, and the* CHILDREN *re-group to capture their fire.*

14. INT. DERELICT OFFICE OF DESERTED FACTORY. EARLY MORNING

AEON *stands gazing down at the* CHILDREN *below through the shattered windows. He wipes the blood off his forehead. It is only a small cut. He smokes his cigarette pensively and coughs.*

15. EXT. GARDEN. COUNTRY HOUSE. AFTERNOON.

AEON *sits under a huge cedar tree in the sunlight. He is typing out a manuscript. In the background the sound of lawn-mowers and an indolent tennis game. Suddenly, through the flower beds a gang of* CHILDREN *appear trampling an enormous clump of scarlet poppies.* AEON *looks up his, his concentration broken as the noisy children disappear into the shrubbery, and silence returns.*

16. INT. TOPAZ' HIDEOUT. DERELICT PORN SHOP.

A shuttered room barricaded with sand bags, the walls of which are plastered with old pornographic images. There is no furniture except a table piled high with magazines, writing materials and books, several clocks all of which are set at different times, and a bizarre collection of swords, axes and knives. In the corner is a chaotic jumbled bed on which TOPAZ *lies staring at the ceiling playing a mournful little tune on a harmonica. He is in his late twenties, dark and hollow-eyed, with prominent cheek bones and a deep scar*

154

which crosses his forehead and obliterates one of his eyebrows. He has short clipped black hair. He is wearing a scruffy assortment of clothes and his khaki army jacket. His oil light gutters and blows out. He curses, stops playing the harmonica, gets up and stumbles about in the dark. He finds two fire sticks under a pile of books. He starts to rub them together until they start to smoulder. In the far distance the sound of breaking windows and the CHILDREN shouting.

17. EXT. THE CHILDREN'S BIVOUAC. DESERTED FACTORY COURTYARD. HIDE AND SEEK

The wild CHILDREN stand around the bonfire. One of them, an ALBINO, with his eyes closed, beats on an oil drum with a piece of metal which echoes round the courtyard. The metal crashes onto the drum. Suddenly there is an explosion. A scarlet flare hangs motionless above the courtyard. We hear the sound of the RADIO static.

RADIO: [Static] repeat. I will come like a thief. Over. Are you receiving me, 2000? Over. You will not know at what hour I will come upon you.

[The ALBINO CHILD opens his eyes to discover an ominous paramilitary OUTRIDER, whose camouflaged uniform blends into the rusting machinery. His face is blacked up so that it shines like bronze. He carries a machine gun. The CHILD runs for his life diving into the shadows in a hail of bullets. The OUTRIDER stamps out the fire.]

RADIO: Repeat [Static] I will come like a thief, you will not know at what hour I will come upon you.

18. INT. STAIRCASE DERELICT FACTORY

AEON runs as fast as possible down an endless metal fire escape. At the bottom he loses his footing and stumbles. He is in a long gallery of rusting machinery and huge metal pipes. He peers through the grid of the metal staircase. Two FEMALE MEDICAL ORDERLIES, masked and wearing long

*white surgical coats, push an operating trolley onto which
an* OLD MAN *is strapped and gagged so that he is immobile
except for his head which tosses back and forth violently.*

The ORDERLIES *are accompanied by a paramilitary*
OUTRIDER. *They pass by* AEON *without seeing him and
disappear round the corner. When they have gone* AEON
*waits for a moment and then cautiously makes his way
down the gallery.*

*This sequence is accompanied by the sound of a two-way
radio conversation which is indistinct and half-heard. The
crackling air waves carry quotations from the Apocalypse,
which comes from the* OUTRIDER'S *radio:*

RADIO: 2000, you are reading. Blessed are those who fear
for the time is near. Over. Loud and clear. [*Static*] I am
Alpha and Omega. [*Static*] 16.30 Sector 16. The words of
the first and last. [*Static*] The words of the first [*Static*].

19. INT. TOPAZ' HIDEOUT. DERELICT PORN
SHOP

In the distance we hear the OUTRIDER's *radio.*
RADIO: And last message 13 [*Interference*].
[3 *short signals*]. He who conquers shall not be hurt by the
second death. [*Incoherent*] Repeat. 2000 he who conquers
shall not be [*Static*] hurt by the second death. Come up
and I will show you [*Incoherent*] who was is and is to
come [*Static*] Over.
[TOPAZ *has re-lit his oil lamp and sits hunched up playing
his harmonica. The bright scarlet light of another flare
floods through his shuttered windows. He rummages
beneath his bed and takes out a sabre, runs his fingers
along the edge.*]

20. EXT. RAILWAY VIADUCT

TOPAZ *edges cautiously along the ruined arches of a railway
viaduct. In his hand he carries the sabre at the ready. He hugs
the side of the building, now he's there, now he isn't. His feet
seem to echo like thunder, his breath comes in gasps.*

Suddenly round the corner comes an ambulance, its red light flashing and siren blaring. TOPAZ *freezes into the shadows as it passes by.*

21. EXT. ALLEYWAY. RUINED CHURCH

AEON *edges along the shadowy buttresses of a ruined church from which emerges a ghostly muttering. In the background the sound of the ambulance passing by. He turns the corner of the building to find himself face to face with a group of* ACOLYTES *who kneel around a make-shift altar on which a flame burns in a crimson jar. They mutter 'Miserere' and pass rosary beads through their bony fingers. They are dressed in the ragged remains of dinner suits and evening dress, a precarious decorum.*

AEON'*s cough breaks the silence.*

The ACOLYTE LEADER, *tall, hard-faced, with steel-rimmed spectacles, carrying a crozier turns to face the intruder.*

AEON *stares around wildly and starts to back away. The* ACOLYTES *advance on him in silence. The* LEADER *trips him with his crozier.* AEON *falls to the floor. The* ACOLYTES *kick him with their gnarled bare feet. One of them fetches a rope. They bind his feet together and drag him along the ground. He grabs wildly at pipes and railings, anything to save himself. The rope is thrown over a lamp-post and* AEON *is hoisted up by the heels. He dangles helplessly a few inches above the ground. The* LEADER *kneels down and pushes his face into* AEON'*s, staring at him with his hard, cold eyes. He jabs his finger into* AEON'*s eye, swinging the rope like a pendulum so hard that* AEON'*s head crashes against the ground.*

TOPAZ *steps out of the shadows.*

AEON'*s inverted POV of* TOPAZ *watching.*

TOPAZ *advances on the* ACOLYTES *brandishing his sabre. They back away in fear as the sword cuts through the air.*

TOPAZ *slashes the rope.* AEON *crashes to the ground and lies there unconscious.*

157

22. INT. AEON'S COUNTRY HOUSE. NIGHT

AEON *and* SOPHIA *contemplate suicide. He holds a gun to her forehead and she to his. She then takes it aside and smiles. They embrace.*

23. EXT. DERELICT SUPERMARKET. DAY

TOPAZ *stands in the shadow of a ruined shop front as a group of* OUTRIDERS *fan out across the street with flame throwers.*

RADIO: [*Static*] message to all sectors – repeat – all sectors – I who sit on the throne will come to dwell among you [*Interference*]. There will be no more hunger, no more thirst [*Static*] I will feed you [*Static*] I will lead you to fountains of living water [*Static*] I will wipe away all tears [*Static*] fountains of living water [*Static*] all tears [*Static*] I who sit on the throne [*Static*].

24. INT. DERELICT SUPERMARKET. DAY

TOPAZ *wakes* AEON *who has been sleeping. They methodically search through the remains of the small supermarket. Absolutely everything edible has either been pilfered or has decayed beyond hope. Freezers full of empty cans, rotten meat, smashed jars. Empty packets litter the floor that have been used to light fires to cook meals. Discarded money from the tills lies abandoned and half-burnt in the debris. The only thing intact in the room is some packets of salt, and bottles of cleaning agents.*

AEON: There's nothing over this side.

TOPAZ: Some salt, fuck all here.

[*He tosses a packet of soap over to* AEON.]
 You ought to get yourself cleaned up, you look disgusting.

[AEON *catches the soap and pockets it. There is a sound of scuffling feet.* TOPAZ *and* AEON *freeze.* TOPAZ *mouths silently 'Stay put, they're upstairs.' He grasps his sabre tightly.*]

25. INT. DERELICT SUPERMARKET. STAIRCASE. DAY

TOPAZ *cautiously climbs the staircase at the back of the shop.*

26. INT. DERELICT SUPERMARKET. BEDROOM. DAY

At the top of the stairs he finds an empty bedroom. On the bed is the corpse of a woman who is clutching the rotting remains of a large alsatian. The dog is stretched out across her body. The remains of his tongue licking her empty eye sockets in his death agony. The whole body is crawling with maggots. The silence of the room is broken by the sound of a cough which comes from a large Victorian wardrobe.

TOPAZ *pulls out a hunting knife from his rucksack and opens the door to reveal a* CHILD *standing dressed in nothing but glistening jewels. The* CHILD *opens his hand and timidly offers its contents of crawling pallid maggots to* TOPAZ, *then he darts past* TOPAZ *as quick as lightning.*

27. INT. DERELICT SUPERMARKET. STAIRCASE. DAY

AEON *is standing at the bottom of the staircase as the* CHILD *hurtles past him almost knocking him over dropping the maggots on the stairs.* AEON *stares at the maggots.*

28. INT. DINING ROOM. DERELICT HOTEL. NIGHT

TOPAZ *and* AEON *sit at opposite ends of a long refectory table. They sit eating hungrily in the flickering light of a single candle that glows in a silver candelabra placed in the middle of the table.* AEON *stares at* TOPAZ *and then returns to the meal. He looks up again as if to speak, to see* TOPAZ, *mouth full, glaring back.*

TOPAZ: What are you staring at?

AEON: I've this feeling I've met you.

[TOPAZ *does not reply.*]

AEON: It doesn't matter. Forget it.

[*There is a long silence. They continue eating.*]

TOPAZ: Met me? No-one's met me.

AEON: I'm sure I know you.

TOPAZ: I know; in the good old days when all was fair in love and war, when the poor were shot, and the rich went sailing. Well that's changed.

[*Pulls out a filthy rag from his pocket*]

For the tears, my friend.

[TOPAZ *goes back to his food, looking up after a long pause.*]

TOPAZ: How can we forget who you were? You watched while they put the world in khaki.

AEON: That's not true.

TOPAZ: Some of us picked up guns and turned on them. We knew who the enemy was. While you sang about the end of the world we fought to save it.

[AEON slumps back in his chair and begins drumming his fingers on the table.]

29. INT. VIDEO EDITING SUITE. NIGHT

AEON *watches as his face flickers on a dozen screens, and the sound of his drumming fingers becomes the rhythm of a song, which shows the world's leaders, and marching feet, missiles, tanks, interspersed with dancers who dance at the edge of time to* AEON's *immaculate performance.*

30. EXT. DESERTED STREET. LATE NIGHT

AEON *at the wheel of his car, exhausted. He goes through some red lights. He notices an oncoming car too late, there is a wild screeching of brakes as he misses the car. For a moment, he slumps against the wheel exhausted and angry with himself, then he opens the car door and walks over to the other car which has come to a stop on the kerb.* SOPHIA

is at the wheel. She looks shaken and rather angry. They stand staring at each other for a moment. AEON *taps on the window. She ignores him then slowly winds it down.* AEON *catches his breath. She is very beautiful. She stares at him angrily and says nothing.*

AEON: I'm very sorry. Really very sorry.

31. EXT. AEON'S GARDEN. LATE NIGHT

SOPHIA *and* AEON *make love in the lily pond of his garden exactly as we have seen the couple earlier. We now realise that his reverie at the open window was for his own love affair with* SOPHIA. *The love scene is cut with an image of* SOPHIA *dancing.*

32. INT. CORRIDOR. DERELICT HOTEL. NIGHT

A long corridor strewn with hastily packed and abandoned suitcases and overturned furniture in disarray – in the middle of the gallery SOPHIA *dances in a torn white dress abandoned and desolate. C.U.s of* SOPHIA *cut with the love scene with* AEON.

33. INT. HALLWAY. DERELICT HOTEL. NIGHT

SOPHIA *dances in a glittering revolving door, half-mirage, half-reality.*

TOPAZ *and* AEON *pursue her but when they push through the doors, she has disappeared. They confront an empty street, with an abandoned baby, which crawls through the litter.*

34. EXT. CITY STREET. NIGHT

ORDERLIES *with flaming torches and scarlet flags form a processional route.* OUTRIDERS *on menacing black motorcycles slowly come into view accompanying several black armoured vehicles with blacked-out windows. Radio waves*

break through the low rumble of the procession accompanied by a strange musical white noise – the Muzak *of the* Spheres.

RADIO: [*Interference.*] Do not fear what you are about to suffer. Are you hearing me – repeat – [*Static*] I will come like a thief and you will not know at what hour [*Static*] repeat – you will not know at what hour I will come upon you. Message indistinct 13 sector here is a call for the endurance of the saints. Over. Repeat, here is a code message judgements – repeat – code judgements. It is done, Amen [*Static*] Amen [*Static*]

[*As the last of the vehicles passes the* ORDERLIES *fall into rank and follow on, leaving the highway completely empty. Silence.*]

35. EXT. TUNNEL. RAILWAY VIADUCT. NIGHT

A group of OUTRIDERS *on a huge earth remover advance by torchlight through dark tunnels. Their scarlet headlights picking out the sombre dead world.*

36. EXT. COURTYARD. NIGHT

A black ambulance with a scarlet cross and scarlet headlights, its scarlet warning light turning in the darkness, illuminating the pallid faces of the ACOLYTES *as they are rounded up at gunpoint by* ORDERLIES *and* OUTRIDERS

37. INT. TOPAZ' BUNKER. NIGHT

The OUTRIDERS *destroy* TOPAZ's *room, tearing the place apart with the utmost violence and setting it alight with flame throwers. One of them picks up pornography and pockets it.*

RADIO: Blessed are the dead who die. [*Static*] Repeat – twice blessed are the dead who die in the Lord [*Static*] Hello 2000. Their deeds follow them. Can you hear me. Clearly [*Static*] their deeds follow them. [*Static*] They may

rest from their labours [*Static*] They may rest from their labours for their deeds follow them.

38. INT. DERELICT FACTORY. CATACOMBS. NIGHT

AEON *and* TOPAZ *sit by the dying embers of a fire. In the shadows a group of ragged refugees shuffle by. Their tired strained faces with expressions of bewilderment and anguish reveal their confusion. Men and women who wear the vestiges of once elegant clothing, covered by overcoats, sacks and blankets to protect themselves from the cold. They carry the remains of treasured possessions in an odd assortment of battered suitcases.*

TOPAZ *whittles at a stick nervously with his knife.* AEON *is typing.*

TOPAZ *gets up and starts to shadow-box, violent manic movements.*

TOPAZ: [*Shouting at them*] The careful ones dug deep on their mortgages. They emerged to laugh at the dead. Bastards!
[*He shouts these last words at the refugees.*]
[*Dulled by the enormity of the situation they fail to react.* TOPAZ *pees on the fire.*]

AEON: Hard times.

TOPAZ: What do you know of hard times? This is a doddle.
[*There is a long silence broken by the sound of the wind and shuffling of feet.*]
 Waiting for the archaeologists.
[TOPAZ *carries on boxing. He pretends to knock himself out.* AEON *carries on typing, talking to himself.*]
 AEON: There was a lull which seemed an eternity. Such total silence. Then the church bells started to ring as the fiery glow sucked up the city like a passionate kiss.

39. EXT. THE BOMB AND THE CITY. DAY

In an intense white light an image of a great metropolis glimmers briefly and turns to ashes.

40. EXT. CITY STREET. DAY/NIGHT

In a storm of ashes PEOPLE *run wild, some are looting, the others move from side to side of the street like a tidal wave.*

AEON: [*Voice over*] People were running and screaming like some January sale gone mad. Carrying looted clothes, electrical goods and TV sets.

[*Armoured trucks with* SOLDIERS *appear. They pour out into the crowd.*]

AEON: [*Voice over*] Some soldiers arrived out of nowhere. Those whose arms were empty threw up their hands. They shot the others just like that, Bang, Bang, Bang, then loaded the booty on to their trucks and drove away. Once the danger had gone the survivors fought over the bodies tearing at the jewellery and wallets.

[*A lion is running wild in the crowd.*]

AEON: [*Voice over*] A lion had escaped and lumbered out of the pools of steaming water in the shadows of the underground.

41. INT. DERELICT CATACOMBS. NIGHT

A CHILD, *naked and emaciated, has crawled into the light of the fire. He sits staring with yellow eyes and sharpened wolfish fangs, bared behind thin lips.* AEON *stops his typing and looks at the* CHILD *who eyes him suspiciously.*

AEON: Come here.

[*He motions to him to come nearer. The* CHILD *doesn't move but shifts slightly.*]

AEON: [*To* TOPAZ] He's cold.

[TOPAZ *takes off his jacket.*]

TOPAZ: Here.

[*He holds it for the* CHILD, *who remains motionless.*

The CHILD *growls like a dog. Without warning he launches himself at* TOPAZ *and bites his hand to the bone.* TOPAZ *gasps and lets the jacket fall to the ground. The* CHILD *disappears into the shadows with a wolf-like cry.*

TOPAZ *stand ashen, quickly puts his hand to his mouth, draws the blood from the wound and spits it out. Suddenly the whole scene is illuminated by the flash of a scarlet flare.* RADIO SIGNALS *crackle through the air.*]

RADIO: [*Static*] Blessed are the dead who die [*Static*] repeat – twice blessed are the dead who die in the Lord. [*Static*] Over. Blessed indeed! [*Interference*] Hello 2000. Their deeds follow them. Can you hear me? Clearly. Their deeds follow them [*Static*] they may rest from their labours [*Static*] repeat. Blessed are the dead who die in the Lord. They may rest [*Static*] they may rest from their labours for their deeds follow them.

42. INT. DERELICT FACTORY. CATACOMBS. NIGHT

AEON *and* TOPAZ *run through the catacombs. The* CHILD *disappears into the shadows.*

TOPAZ: [*Under his breath*] This way.

43. INT. DERELICT FACTORY. CATACOMBS NIGHT

TWO OUTRIDERS *discover the remains of the fire, they split off in different directions.*

44. INT. DERELICT FACTORY. CATACOMBS. NIGHT

One of the OUTRIDERS *discovers a trail of blood from* TOPAZ's *wounded hand. He scouts it like a bloodhound after the kill.*

45. INT. DERELICT FACTORY. CATACOMBS. NIGHT

AEON *and* TOPAZ *press themselves against a wall, panting and out of breath, their faces glistening with sweat. In the gloom they become aware that they have stumbled into the*

den of the wild CHILDREN. *The* OUTRIDER, *his radio blaring, lumbers heavily after them. The* CHILDREN *turn silently and ambush him, tearing him to pieces with their bare teeth and hands.* TOPAZ *and* AEON *use the distraction to escape.*

46. EXT. CITY STREET. NIGHT

TOPAZ *clambers out of the manhole. A few yards away an ambulance is parked, its red light revolving.*

47. INT. AMBULANCE CAB. NIGHT

The DRIVER *slumps in the cab asleep.*

48. EXT. AMBULANCE. NIGHT

TOPAZ *creeps along the side of the ambulance, his knife drawn. He opens the door and in one motion stabs the* DRIVER *in the neck and pulls him out of the cab. He climbs in and* AEON *joins him.*

49. INT. AMBULANCE. NIGHT

TOPAZ *and* AEON's *point of view.* TWO OUTRIDERS *on bikes turn into the street, their headlights blazing.* TOPAZ *starts the engine but it stalls. The* OUTRIDERS *close in. On the third attempt the engine starts.* TOPAZ *reverses the ambulance into the* OUTRIDERS *sending them spinning in all directions.*

50. INT. AMBULANCE. CLOSE UP. NIGHT

TOPAZ *changes into forward gear and speeds off laughing.*

51. EXT. BEACH. SUNNY DAY

AEON *and* SOPHIA *on two horses ride along the sea's edge on a perfect morning. A slight breeze whips the foam off the surf across the beach. The horses plunge into the waves, as they do so a jet passes low over them with a thunderous noise. The horses rear in fright – the idyll is broken.*

52. EXT. DESOLATE RUINED LANDSCAPE.
NIGHT

*The ambulance is travelling through a landscape of ashes,
dead trees and mined buildings.* TOPAZ *at the wheel talking
grimly to himself.*

TOPAZ: You can imagine it, those bastards in the bunkers
. . . Hey Joe! The computer's fucking around with the
oblivion digits again . . . SCRAMBLE!! Oh fuck! Just
another dress rehearsal. The civilisation's burnt out
already. What mother-fucker will be able to tell the
difference when the big ones come? . . . How's it going?
. . . The White House just confirmed it. This is what we've
been waiting for all these years. We're going in. What a
relief. Thank God, they're coming thick and fast . . . After,
the children built a house with the bones.
'Daddy, daddy, look what Jimmy's done.'
'Fucking marvellous.' No hay fever, no flowers, no grass.
All the mirrors melted. No shadows.

[TOPAZ *drives off the road into the parking bay of a
building.*]

53. INT. PARKING BAY. NIGHT

AEON *and* TOPAZ *clamber out of the ambulance.*

TOPAZ: Have you ever been tempted to leave all this
behind? Turn yourself in?

AEON: I never thought of it.

TOPAZ: All the comforts you've left behind! Champagne!
Coke! [*He turns with a wide grin*] – Sailing!
Enemy number one. [*He points to himself and then to*
AEON] Number two collaborating with the enemy, sen-
tence – eternity and a day.

54. INT. FACTORY LAVATORY. DAY

AEON *stares at himself in a mirror. Behind him smashed
basins and mirrors litter the floor. In one corner a sinister
and large pile of bones. The room resembles a stone age lair.*

AEON *idly turns on a tap. After a series of rumbling noises and splutterings, rusty water spurts out onto the floor.* AEON *looks around and finds an old galvanised bucket which he fills. He peers at himself in the shattered mirror. In the corner he sees the reflection of* TOPAZ. *He then slowly peels off layer after layer of clothes. He takes a T-shirt and tears it in half. He picks the bucket up and leaves the bathroom.*

55. INT. VERY LARGE EMPTY OFFICE. DAY

TOPAZ *sits warming himself by a fire in the empty room.* AEON *places the galvanised bucket on the fire to warm the water. He shivers slightly in the cold and throws his overcoat round his naked shoulders, crouching near to the fire. He watches in a detached manner as* TOPAZ *jacks off.* AEON *quietly bites his finger nails and then gets up and leaves the room with the pail of hot water.*

56. INT. LAVATORY. DAY

AEON *stands the galvanised bucket in the broken basin in front of the cracked mirror. He carefully unwraps soap from a handkerchief in his pocket, takes out an old cut-throat razor from another, and starts to shave. He stares at himself thoughtfully in the mirror, and beats out a tattoo with his fingertips on the bucket. He carries on a dialogue with his reflection.*

AEON: Now I remember! That's it! The week our world ended.

57. EXT. FILLING STATION. MOTORWAY. MORNING

The wing mirror on AEON's *limo is shattered in slow motion by* TOPAZ' *stray bullet. He turns round and their eyes meet. A fleeting moment.*

58. INT. BEDROOM. AEON'S TOWN HOUSE. AFTERNOON

AEON *has dressed in the black suit. He adjusts his black tie in the mirror.*

59. INT. LIMOUSINE. STREET. DAY

AEON *sits alone, immaculately dressed. The car passes through the deserted city with empty banks and businesses guarded by troops. On a corner, beside an armoured car* TWO YOUNG SOLDIERS *are boxing, stripped to the waist, a group stands round cheering them on. The stereo plays reinforcing the divorce of the car from the world through which it passes.*

60. EXT. CEMETERY. LATE AFTERNOON

The cemetery is empty, AEON *stares at the newly dug grave, and adjusts a wreath on which is written:*
TO OUR BELOVED FATHER
There is the distant wail of a siren, some dogs barking, then silence. Suddenly he's aware of TOPAZ *who is running on all fours through the graveyard, dishevelled and out of breath. The sound of voices and barking dogs draws closer.* AEON *hides* TOPAZ *under the pile of wreaths. The* SOLDIERS *who are chasing* TOPAZ *barely stop as* AEON *falsely indicates the direction the fugitive has taken. One of the* YOUNGEST SOLDIERS *asks* AEON *for his autograph.*

SOLDIER: Could I have your autograph?
[AEON *signs the butt of his rifle – he has no paper. The soldier moves off.* TOPAZ *emerges from the flowers. From his jacket he takes a half bottle of Scotch. He sits down against the tomb and drinks – his eyes never leaving* AEON*'s.*]
TOPAZ: To those in the shelters.
[*He offers the bottle to* AEON *who refuses.*]
TOPAZ: To the new world.
[*He drinks again.* TOPAZ *lies on the grave amongst the flowers and smiles at* AEON.]

169

TOPAZ: Take this. You'll be needing it.
[*He gives* AEON *a gun and two bullets. He gets up and runs away through the graveyard. He turns for a moment and looks back.* AEON *looks after him, giving a thumbs-up sign.*]

61. INT. HUGE DERELICT HALL. NIGHT

A searchlight like a lighthouse sweeps around the perimeter of a vast and ruined hall, the floor of which is pitted with granitic and dungeon-like vaults, whose broken arches resemble the gigantic excavated ruins of a past civilisation. From these pits smoke drifts into the air, from small bonfires which flicker in the ruins. Around the fires small groups of REFUGEES *huddle as they are methodically stripped by* ORDERLIES *who burn their clothes. High above them on the gantries,* OUTRIDERS *stand covering them with their machine guns.*

Some of the exhausted and frightened REFUGEES *sleep in the shadows as their comrades are searched. In the middle of the hall* AEON *stands with a group of* REFUGEES. *A group of* ORDERLIES *sit nearby playing dice for any articles of value taken from the* REFUGEES.

An ORDERLY *is seated at a desk.*

ORDERLY: Next.
[AEON *steps forward, his rusty typewriter in hand, he places it on the desk. The* ORDERLY *removes the paper from the typewriter and starts to read it as* AEON *empties the contents of his pockets onto the table.*]

ORDERLY: Consider: The Hero continues, even his fall was a pretext for further existence, an ultimate birth.
[*The* ORDERLY *leans back in his chair and fixes* AEON *with a steely gaze.*]

AEON: I came voluntarily.

62. INT. HUGE DERELICT HALL. NIGHT

AEON *is stripped and searched, his clothes are burnt and a*

*Geiger counter is passed over his body, it clicks ominously.
As this continues the loudspeaker system blares on:*

LOUDSPEAKER: 2000 [*Interference*] behold I am alive
[*Static*] behold I am alive for ever more [*Static*] over, do
you hear me? [*Interference*] I have the keys of death.

63. INT. BUNKER, LIFT. NIGHT

*A huge service lift descends into the bowels of the earth past
floor after floor, the passengers have fleeting glimpses of the
world they are entering. There are about fifteen refugees in
the lift which include the* DOORMAN, *a* MIDDLE-AGED
WOMAN, *a* YOUNG BOY, *an* OLD MAN *and an* ACOLYTE. *As
the lift travels down, the music which is the theme of the
underworld they are entering, gets louder and louder. The
music seeps into every corner of this subterranean labyrinth
from hidden speakers, like the muzak of large public spaces.
It is elusive, now high, now low.*

*The lift is lit by a revolving scarlet ambulance light which
goes on and off periodically illuminating the drawn haggard
faces of the refugees within.*

They stand shivering and naked. The OLD MAN *bites his
nails nervously, the* ACOLYTE *sits stony-faced. The* YOUNG
BOY *who is standing next to* AEON *sobs gently to himself.
The* OLD MAN *leans over unsympathetically.*

OLD MAN: Keep him quiet, will you.

[AEON *puts his arm around the* YOUNG BOY *who throws
his arms around him in desperation.*]

DOORMAN: Why are you here? Why did you turn yourself
in?

AEON: Where else was there to go? What about you?

[*There is a pause.*]

DOORMAN: I knew you as soon as I saw you. You're
young. You could've escaped, you've got legs.

MIDDLE-AGED WOMAN: Please stop quarrelling, that's
not going to help any of us.

[*She turns to the* ACOLYTE.]

Father, why don't you lead us in prayer?

ACOLYTE: [*Without looking up*] Fuck the lot of you, you've had this coming for years.
[*There is a stunned silence. As the lift travels down, we see* OUTRIDERS *standing guard on all floors and finally a group of* BALD-HEADED MEN *dressed in elegant dinner jackets; they seem to be sharing a private joke.*]

64. INT. BUNKER, CORRIDOR. NIGHT

The lift door opens into a long corridor off which are numerous doorways. As they open, Muzak gathers in intensity. The REFUGEES *are marched down the corridor and put into separate cells by a group of* OUTRIDERS.
AEON *is shown into one of the cells.*

65. INT. BUNKER, CELL. NIGHT

AEON *finds himself in a tiled cell which is illuminated by blinding white lights. The cell is completely bare except for* TWO OUTRIDERS *who stand at opposite ends holding coiled fire hoses.*

The OUTRIDERS *turn on the hoses which hit* AEON *with a violence that knocks him off his feet, flat onto the floor. He struggles to regain his footing but the force of the water knocks him into a corner. Eventually the* OUTRIDERS *turn off the water and leave the exhausted victim gasping for breath.*

The door opens and TWO ORDERLIES *enter. One carries an aluminium tray with food, the other a white towel.*
ORDERLY: You'll be out of here as soon as you've finished your meal and dried yourself.

66. INT. BUNKER, CORRIDOR. NIGHT

AEON *is led naked down a corridor accompanied by a group of* ORDERLIES. *The music which has accompanied all the*

sequences in the bunker gathers in intensity. At the end of the corridor huge metal doors slide apart.

67. INT. BUNKER, HALL OF JUDGEMENTS. NIGHT

A vast cavernous hall lit by columns of shimmering white light, at the end of which TWELVE MEN *sit behind a long refectory table in the position of* The Last Supper. *The table, covered by a white cloth, is decorated by sprays of laurel leaves and set with a glittering gold and crystal service. A man stands in the centre with his back to* AEON. *He is dressed in an exquisite formal black suit, the twelve are similarly dressed, they resemble a gang of gangster businessmen.* AEON *and the* ORDERLIES *stop in front of the table; there is a pause. The man turns without saying a word to face* AEON. *To* AEON's *horror he sees that it is* TOPAZ. *He is now exquisitely polished and manicured. High above, the sound of the Muzak shimmers.*

LOUDSPEAKERS: Grace to you and peace from him who is and was and who is to come! Behold I am alive for evermore and I have the keys of death. I know your works, Aeon, your toil and patient endurance. I am the Alpha and Omega who is and was and is to come.

[*The twelve are finishing the sumptuous banquet laid on the table before them, lighting cigars and supping the blood-red wine from a ruby decanter that is passed along the line. They pause and turn in* AEON's *direction.*]

TOPAZ: Aeon, you are numbered amongst the angels.

[*The group of* ORDERLIES *move forward. One of the twelve looks up.*]

DISCIPLE: These are they who have come out of great tribulation.

DISCIPLE II: Therefore are they before the throne, and serve him day and night.

DISCIPLE III: He who sits upon the throne will shelter them. They shall hunger no more, neither shall they thirst . . .

173

[TOPAZ *smiles, the sound of the music mounts higher and higher.*]

ALL DISCIPLES: Just are thou in these thy judgements.

[TOPAZ *smiles with great satisfaction, slowly turning his palms round to reveal the stigmata.*]

TOPAZ: It is done. I am the Alpha and Omega. The beginning and the end.

68. INT. AUDITORIUM. NIGHT

AEON *receives public recognition for his work at a glittering reception. He walks back from the stage clutching his 'Oscar' to be greeted by* SOPHIA *who gives him a kiss as he sits down. The applause is thunderous, all eyes are on him. He smiles and bows his head in recognition. He sits in his chair and looks at the bronze statuette in his lap. Its design is vulgar, rather hollow. A shadow crosses his face. He quickly recovers and smiles again.*

69. INT. AEON'S CELL. NIGHT

A sparsely furnished monastic cell with marble walls, containing a mirror, a simple bedstead, and a portrait of TOPAZ *with red votive lights. In a corner is a TV monitor which plays continuously.*

AEON *stands in front of the mirror camouflaging his face, he is dressed in the fatigues of an* OUTRIDER. *He looks at himself for a second, then crosses to the bed and straps a radio around his waist.*

RADIO: [*Static*] Holy, Holy, Holy is the Lord God Almighty [*Static*] to the Angel of the Church whose feet are like burnished bronze. [*Interference*] I know your works, your love and faith and patient endurance, and that your latter works exceed the first. [*Static*] He who conquers and who keeps my works until the end, I will give him power over the nations.

[AEON *crosses to the portrait, kneels down and flicks a switch. The lights below the portrait come on, as the rest*

of the lights in the room fade. He picks up a little red book at his bedstead.]

RADIO: [*Static*] I warn everyone who hears the words of prophecy of this book, if anyone adds to them I will add to him the plagues described in the book.

[AEON *kisses the book and puts it down, he lies down on the bed and starts to watch the television.*

The television relays the illusion of a perfect and visionary idyll of Life on Earth *constructed around the central image of* TOPAZ.]

70. TELEVISED IDYLL

The TV monitor fills the screen with a succession of images of the idyllic life: white beaches, palm trees in the sunlight, a yacht skimming across the deep blue waves, bronzed and healthy swimmers.

Suddenly the screen goes blank, an alarm siren sounds.

VOICE FROM TV: Here is a call for the endurance of the saints who keep His commands. The Nations raged but my wrath came and the time for the dead to be judged. For rewarding my servants and for destroying the destroyers of the earth.

71. INT. SUBTERRANEAN PARKING AREA.

AEON *scrambles with the other* ORDERLIES *to go on a mission. The underground parking area is a mass of whirling lights and men running to action stations.* AEON *takes his place in the transport. The loudspeakers and alarms sound.*

72. EXT. THE CHILDREN'S BIVOUAC. DESERTED FACTORY COURTYARD. NIGHT

A pitched battle rages in the derelict courtyard between the mutant CHILDREN *and* OUTRIDERS. *The* CHILDREN *defend themselves to the death against their adversaries.* AEON, *stands by a waiting ambulance and watches impassively.*

LOUDSPEAKERS: Come gather for the great supper of God to eat the flesh of kings, the flesh of captains, the flesh of horses and their riders, the flesh of all men both free and slave, both small and great.

73. INT. AEON'S DERELICT COUNTRY HOUSE. NIGHT

AEON *walks back through the dark and empty rooms in which we first discovered him; there is no sign of life, complete silence, even his footsteps make no sound. He trips on a book and looking down discovers the coffee table book of his life.*

A hand comes out of the shadows holding a gun which is pointed at AEON, *it follows him across the room. He is unaware that he is not alone. He crosses over to the window. He fumbles in his pockets and brings out a packet of cigarettes, he puts a cigarette in his mouth, he lights it.*

He turns back into his room for one last look – sitting at the desk with the gun levelled at him is SOPHIA.

He stares at her in disbelief.

SOPHIA: Aeon.

[*She lowers the gun to the table.*]

74. EXT. STREET. DAY

AEON *hands* SOPHIA *the gun he received from* TOPAZ. *Grey ashes rain down, lit by the flicker of huge fires.* AEON *and* SOPHIA *are parted in the panicking crowd. They stare at each other helplessly as they are swept apart.* AEON *fights his way through the mob but the tide of humanity carries him on.* SOPHIA *clings to a lamp post as the panicked horde sweeps by. There are screams and the deafening thunder of collapsing masonry and crackle of fire.*

75. EXT. WASTELAND. DAY

SOPHIA, *alone now, stands in a burnt field, grey ash covers everything. A solitary tree is burning like a torch as if it had suffered from internal combustion. There is a total silence*

except for the crackling sound as the great tree is consumed in the flames.

76. EXT. OUTSIDE AEON'S COUNTRY HOUSE. NIGHT

There is absolute stillness. The curtains flap listlessly from the open windows. There is no sign of life.

SOPHIA *walks through the open french windows holding the gun ready. Absolute silence. She sits on the sofa and spins the revolver. It clicks and fails to detonate.*

77. INT. AEON'S DERELICT COUNTRY HOUSE. NIGHT

AEON *and* SOPHIA *embrace. He pulls her tattered dress from her shoulder. She wipes the camouflage from his face with her hand. He kisses her breast then her shoulder and hand. There are tears in his eyes. He catches sight of the gold wrist watch as he takes her hand.*

AEON: Is that the real time?

SOPHIA: It's never stopped. 3:18 . . . December the 24th. It's Christmas Eve.

AEON: You must come with me.

SOPHIA: *[Smiles]* I have no choice, have I?
 [She turns looking at AEON *and says:]*
 Take the gun.
 [He looks at her for a second as if to hesitate and then takes it. It is the gun TOPAZ *gave him in the graveyard. He hides it in his uniform.]*

78. INT. HUGE DERELICT HALL. ANTE-CHAMBER. NIGHT

The ORDERLIES *are, as in the earlier scene, stripping and searching the captives, and burning their clothes.* SOPHIA *stands in a queue of captives in front of an* ORDERLY *at a desk.*

ORDERLY: Next.
[SOPHIA *steps forward.* AEON *is standing to the side, watching. An* ORDERLY *steps forward and strips* SOPHIA, *her white dress is burnt on the bonfire, she stands naked. A second* ORDERLY *steps forward and subjects her to a body search with a Geiger counter, passing it through her legs. As it travels over her mouth it lets out a high-pitched whine. He prises open her mouth and extracts a gold wedding ring.*]
SOPHIA: My ring!
The ORDERLY *stares at her for a second, and unexpectedly slaps her viciously around the face. She looks in* AEON's *direction, and he turns away.*]

79. INT. BUNKER, ENTRANCE LIFT. NIGHT

SOPHIA *and a small group of* REFUGEES *are pushed into the service lift by the* OUTRIDERS. AEON, *who has run up to the lift, is just in time to see it disappearing.*

80. INT. BUNKER, LIFT. NIGHT

As the lift descends, the Muzak of the Spheres *becomes louder and louder.* SOPHIA *and the other occupants stand mute with apprehension.*

81. INT. BUNKER, CORRIDORS. NIGHT

AEON *rushes down the stairs and along the corridors to catch up with the lift, but on each floor he just misses it. As he descends his path is impeded by* PARTY-GOERS *who are dressed in exquisite evening dress. Gradually he is brought to a halt by the crowd.*

82. INT. BUNKER, WAITING ROOM. NIGHT

As the lift doors open the REFUGEES *are ushered out into a clinical marble waiting room by bald-headed* ATTENDANTS *with numbers branded on their heads. They wear prison*

uniforms and carry mops and buckets. The REFUGEES *sit on the waiting room chairs. The doors open and a smiling clinical* RECEPTIONIST *steps out.*

RECEPTIONIST: Next please.

[SOPHIA *gets up and walks through the doors. At that moment* AEON *comes rushing down the staircase, he is just in time to see the doors closing on* SOPHIA. *The* REFUGEES *shift around uneasily.* AEON *runs to the door and bangs on it. The* RECEPTIONIST *opens the door and he pushes past her.*]

83. INT. BUNKER, SLAUGHTERHOUSE. NIGHT

A clinical white room is lit by white fluorescent tubes. In the corner is a switchboard with dials operated by a DOCTOR *in a white coat. A* SECOND DOCTOR *holds a stun gun attached to a thick electrical cable. A* THIRD DOCTOR *holds* SOPHIA *gently by the arm. As* AEON *enters, the* DOCTOR *with the stun gun puts it to* SOPHIA's *head and fires it. She collapses to the floor.* TWO ATTENDANTS *step forward and tie* SOPHIA's *legs together. They pick up the body.* AEON *collapses and faints, his legs folding underneath him. As* SOPHIA's *body is removed, another* REFUGEE *enters. The whole sequence is accompanied by the lavish* Muzak *of the Spheres.*

84. AEON'S CELL. DAY

AEON *lies prostrate on the bed. At the end of his bed his white suit is folded very neatly. The TV monitor still plays. He looks at the television.*

85. TV IMAGE.

A nostalgic Christmas living room with a large tree covered with fairy lights piled high with presents. TOPAZ, *smiling benevolently, gives the presents to a group of little children. The twelve beam, and applaud him.*

179

86. AEON'S CELL. DAY

AEON *has buried his head in the pillow. He is sobbing hysterically. He turns around and the gun, which has been concealed all the time in his fatigues, slips out. He stares at it for a second and then picks it up.*

87. TV IMAGE.

Back on the television the little children are opening their presents. They have received an assortment of military toys — guns, tanks, cruise missiles etc. They rush to TOPAZ' *feet, kissing and hugging him.*

88. INT. AEON'S CELL. NIGHT

AEON *is now wearing his white suit. He has removed his bronze make-up. He stares at himself in the mirror with resolution, adjusting his suit. He slips the gun into his pocket, walks over to the portrait of* TOPAZ *and switches the red lights off.*

89. INT. BUNKER, CORRIDOR. NIGHT

The corridor is packed with MEN *and* WOMEN *in evening dress going to the celebration.* AEON *is swept off his feet by the crowd.*
 There is a buzz of expectant conversation and the sound of The Muzak of the Spheres. *The crowd winds like a serpent through the passages. The women wear dresses of scarlet, emerald and god.*

90. INT. BUNKER, HALL OF JUDGEMENTS. NIGHT

The vaults of the hall glisten with blinding shafts of white arc lights which resemble huge columns. The light falls on scarlet flags carried by OUTRIDERS. *They shimmer blood-*

red above the crowd. The hall is filled to capacity by the CELEBRANTS: *men in dinner jackets and high-ranking military uniforms: women in glittering evening dresses holding crystal glasses brimming with blood-red wine. Above them in front of the golden clock* TOPAZ *stands with* THE TWELVE *behind a battery of microphones. They wear evening dress decorated with medals and ribbons. Flanked on either side are military* HERALDS *with silver trumpets; they blow a fanfare.* TOPAZ *raises his hands like a generalissimo reviewing his subjects.*

CROWD: Hosannah! Hosannah!

[AEON, *in his white suit, pushes through the crowd towards the dais.*]

INTERCOM: We give thanks to thee Lord who has taken power and begun to reign the nations raged but thy wrath came. Now is the time for rewarding thy servants. The saints and those who fear thy name.

CROWD: Hosannah! Hosannah!

[*They raise their arms in salute.*

Five wounded OUTRIDERS *are wheeled onto the dais by* ORDERLIES. *They have ruby crosses on scarlet ribbons put around their necks. The trumpets blow out a fanfare. As each hero receives his medal, the* CROWD *applauds enthusiastically.*]

TOPAZ: Outside are the dogs and sorcerers, fornicators, murderers and idolators and everyone who practises falsehood.

CROWD: Hosannah! Hosannah!

TOPAZ: Behold, I will make all things new.

CROWD: Hosannah! Hosannah! Hosannah! Hosannah!

TOPAZ: These words are trustworthy and true. I am the Alpha and Omega, the beginning and the end.

[*The crowd goes wild. The shouts of* Hosannah *and the braying of the trumpets, reach a shattering crescendo.* AEON *has fought his way to the front of the crowd. He steps forward directly in front of* TOPAZ. *He slowly and deliberately pulls the gun from his pocket. No-one has noticed. He shuts his eyes for a moment.*]

181

91. DIVING

Against a glittering blue sky, AEON *dives in slow motion like a swallow. The camera follows him through the ice-blue water. In a mass of bubbles he surfaces next to* SOPHIA. *She laughs as they kiss.*

92. INT. BUNKER, HALL OF JUDGEMENTS. NIGHT

AEON *fires the fatal shot.* TOPAZ *stands as if transfixed, and then a starlike wound explodes between his eyes. He falls backwards to the ground with the force of the bullet, revealing the shattered clock face spattered with his blood.*

AEON *who has mounted the first flight of stairs to assassinate him turns to face the* CROWD *who stare in absolute silence. He seems to have been transformed. The gun has fallen to the floor. He stares at the palms of his hands. He has received the stigmata. An open bleeding wound. The blood trails from his fingertips and splashes on the floor. He stares at the silent crowd.*

93. THE WHEEL OF FORTUNE

The whole world turns scarlet, a vast waterfall and the sea, the world and a great galaxy, spin with AEON *spinning with them, to an abstract blur with the music drawn out like a long lamenting sigh. Then the sound of a lark – the purest notes.*

94. EXT. AEON'S COUNTRYSIDE. SUNNY DAY

We are back in time when the old house was built new. AEON *is a medieval pilgrim with a palmer's wide-brimmed hat and a shepherd's staff, sets out on a brilliant sunny day. He is surrounded by white doves which flutter around him in slow motion.*

SOD 'EM

SOD 'EM

In Florence to direct Busotti's *L'Ispiratzione* at the Teatro Comunale. I was overwhelmed by isolation. Florence as dead as a dodo, bleak, granitic, like being locked in the Nat West forever. I wrote this fast and furiously using a copy of Marlowe I found in a shop. It didn't take me more than two weeks, though poor HB spent hours typing it up. The clatter of computer keys haunted our lives at Phoenix House. I thought at the time the script would define the limits of my anger. I never showed it to anyone.

There is no cast in my mind. It was swallowed up by the improvisations of *The Garden*. It would have made an interesting film, a violent cut-up collage of that time.

LET'S PUT THE GREAT BACK INTO BRITAIN

This year the police force are privatised, along with MI5 and the other security forces. They have established themselves as private fiefdoms with the government as an advisory body. The death penalty has been re-introduced. Homosexuality has been recriminalised with wide ranging penalties. The police have unlimited power of search and detention.

The homophobia generated by the AIDS crisis has reached a new dimension, everyone carries identity cards (with HIV status), mass quarantining has been introduced, and holiday camps like Butlins have been requisitioned as detention centres.

The Royal Family have found their true role, de facto they were already powerless, though they presented a danger to the Tory party as a rallying point, wet Fabians like Prince Charles have been marginalised. They now appear weekly on prime time Saturday TV in The Family *a soap opera, whose scripts are vetted by Central Office.*

Movement between the regions and cities is strictly controlled, Premier Reaper and her party have emerged in their true colours as a protofascist organisation. MPs rule their constituencies as Gauleiters. Fear and loathing, the keystone of British politics, is firmly in place.

Outwardly everything is prosperous, Mr Gorbachev has sent his New Year message of goodwill.

19XX is going to be a good year.

Nothing has changed, the guards still troop the colour, the red buses still run. The hollyhocks still bloom outside the cottage door. To an American tourist, nothing seems out of place, the streets are safer, the neighbourhood watch committees have seen that the crime rate is down, the trains run on time, the supermarkets are well stocked, the heavily censored newspapers are more optimistic, family life has

*never seemed more certain, the new Archbishop of Canter-
bury has spoken out authoritatively on moral issues, the
mortgages of Mr and Mrs Average are underwritten, there is
full employment, the dole offices have been closed, people
receive their state pensions by Giro, the streets are clean, the
litter has been removed. Derelicts, drug abusers, homosex-
uals, and card-carrying members of the Labour Party have
been quietly removed. Andrew Lloyd Webber's theme for*
The Family *is number one in the hit parade. It's been a
glorious summer, but somewhere trouble is brewing.*

*The young actor, Edward, is on the run. He dreams of the
Plantagenet King Edward II, who died for his friendship
with Piers Gaveston. There is a warrant for his arrest for
playing the part in Marlowe's play, which along with the*
Sonnets *and other queer literature is proscribed. A descrip-
tion of his namesake gives a key to his character, tall and
good looking with red hair, a keen swimmer, expert at
country pursuits, hedging, ditching, etc. fond of Italian
music and theatre, with a taste for extravagance in his
clothes.*

*While reading this script it is important to imagine a
complex soundtrack which like that in* The Last of England
*will tell much of the story, incorporated in it will be
fragments of Marlowe's play. The visualisation is based on
the early nineteenth-century cartoons of Gillray, Cruik-
shank, Goya's* Disasters of War, *and the* Carry On *films.*

CREDIT SEQUENCE

With the voice of Oscar Wilde reading The Ballad of
Reading Gaol. *Over imagined headlines from old news-
papers of the great, but not so good.*

'Lord Kitchener in Guards scandal.'
'Duke of Windsor's night at the ballet.'
'Pansy Viceroy's partition.'
'Dalton and the Renters.'
'Victoria's lesbian amnesia.'
'William sucks his orange.'

1. EDWARD PLANTAGENET

A stony dungeon. EDWARD *naked, huddles in a corner, he sits with his knees to his chin shivering, its freezing cold. There is a drip of water, and the distant sound of a* JAILER, *who sings somewhere outside in the corridor.*

JAILER: Gay, gay, gay, gay,
Think on dreadful doomesday
[*fifteenth-century song*].

[*Through a close-up of* EDWARD'S *face we dissolve to a series of views of Great Britain, of castles, cathedrals, gardens, wild desolate landscapes, the White Cliffs, everything burning in an orange light.*]

EDWARD: [*Voice over*] A cold wind blows over this ruined land over the hills and dales, over mountain and marsh, down the great roads and little lanes, through the villages and small towns, through the great towns and the cities, everywhere it blows through empty streets and desolate houses, rattling the hedgerows and broken windows, drumming on locked doors. This wind is blowing high in the tower blocks and steeples, down along the river, invading houses and mansions, through the corridors and up the staircases, rustling the faded curtains in bedrooms, over the carpets, up the aisles, and down in the crypts, in public places and private, among forgotten secrets, round the arm chair, the easy chair, across the kitchen table. So icy is this wind that it rattles the bones in the graves and sends rats shivering down the sewers, moaning. My life is blowing with the wind through the night. Fragments of memory rush past and are lost in the dark. In the icy gusts yellowing half-forgotten papers whirl old headlines up and over dingy suburban houses, carrying leaders and obituaries, the debris of inaction, into the void, illuminated briefly by glimmers of lightning. The rainbows are

189

out, the crocks of gold lie rusting, forgotten as the fallen trees which strew the streets and dead meadows. I consider the lives of warriors how they suddenly left their halls.

[*At this point we hear the* JAILOR's *voice again, singing.*]

JAILER: Gay, gay, gay, gay,
 Think on dreadful doomesday.

2. THE INDEX

A computer terminal for The Index, *which files and documents criminal elements, a sequence of identity print-outs of the film-maker Derek Jarman, with an identifying number, and the words* 'Orders to Eliminate', *Shakespeare, Newton, Byron and Wilde culminating with Christopher Marlowe, all with similar text.*

3. ALL OUR DADS

KING EDWARD I, *the father, an austere military man, sits alone playing a game of chess, without ever looking up from the chessboard he says to his son* EDWARD, *who is standing with his lover* JOHNNY GAVESTON, *under armed* GUARD.

EDWARD I: No son of mine is fucking queer, I'd be quite prepared to kill both of you. [*To Johnny Gaveston*) I'm going to destroy every trace of this relationship, Gaveston. THIS IS THE WAY IT IS.

EDWARD: [*Voice over*]
 [*Which continues through the next sequences.*]
 The first steps in the repression, that led to the restructuring of Britain as a one-party state, were taken years before the education bill and Section 28, which was the first of many similar acts of legislation restricting human rights. But 28 remained famous. It was pivotal, like Kristallnacht, or the burning of the Reichstag, it fixed itself in the imagination.

IMAGE: NAZIS

[*The Nazi burning of books, and the burning of the Reichstag.*]

Using the virus as a vehicle, the popular press stirred up the hatred, pick up a copy the *Sun* and you hold in your hands the sickness itself.

IMAGE: *SUN*

[EDWARD *reading a copy of the* Sun *with one of its inflammatory headlines.*]
One day it was a GAY MURDERER, the next the headlines shrieked QUEERS BOMBED IN FULHAM, what was it that pastor Niemöller had said in Auschwitz? 'They came for the Jews and no-one spoke up, they came for the gypsies and homosexuals and no-one spoke, and then they came for me, and there was no-one left to speak.'

IMAGE: BANKS

[*Advertisement for a bank*]
The gangsters mounted the attack on all fronts, first the old state industries were privatised, then the welfare state, the pride of my grandfather, who had fought a bloody war to see it established, was starved of funds until it ceased to function. One by one the state services were ruthlessly restructured, the instrument, FEAR, coupled with disinformation, FEAR of the loss of a job, FEAR of appearing different, FEAR of an imagined enemy.

IMAGE: SPYCATCHER

[*Peter Wright walking in his garden in Tasmania.*]
Disinformation was perfected by the secret services, they had spent the 1970s trying to bring down an elected government, and since both sides of the political spectrum had, at one time or another, connived in this illegality, when it was made public there could be no real opposition. In the new climate a monotonous monoculture burgeoned, all opposition and plurality withered.

IMAGE: THEATRE

[EDWARD *in a National Theatre production as a spear carrier in the Theban band.*]
Great institutions were gutted, the National Theatre, where I worked as a spear carrier, had been forced into the marketplace along with the others. When this happened I was as confused as most.

IMAGE: TORY CONFERENCE

[*News footage of the Tory Party conference.*]
The repression was subtle, no rallies, there was no need for spectacle, it came looking like a TV announcer. Now every home was invaded by real estate agents, purveyors of life insurance, and the banks. I remember my childhood, when the adverts were for soap powders, tea, fridges, and the TV sets themselves, but now all that had disappeared. The government took to advertising itself through the success of the newly privatised industries, property climbed to dizzy heights, the whole country was mortgaged, no-one asked if the cost of all this might be FREEDOM, if not their own FREEDOM, the FREEDOM of others.

IMAGE: HAPPY FAMILIES

[*Home movie of* EDWARD *aged six, playing in a garden.*]
It never occurred to me, when I felt the first stirrings of my sexuality at six, that there could be any other land than that of REPRESSION, it was only when I was in my twenties that I began to see the lie that my friends accepted without a murmur. To be homosexual in our society was to be a chameleon, after all, everything I had ever heard about my sexuality was derogatory, FAGGOT, PERVERT, QUEER. My father Edward had used that word 'queer', when he banished my friend Johnny. I politely changed my colours to blend with his surroundings, but I asked myself if I was to be open about my love I might

better my lot. THE REPRESSION destroyed my freedom, it functioned with or without laws, when I talked like this . . .

IMAGE: STUDENTS

[EDWARD *as a student in a squat, arguing with his friends.*]
I parted company with my liberal friends. 'Just shut up and all will be right' they said, after I declared my family and the church were neither sane or reasonable. The Church was a secular institution unable to look life in the face, dispensing weak comfort for the lame and the halt. Where was the Christ that loved Saint John? Why was every pronouncement negative? DON'T DON'T DON'T they said, yet Christ had started his ministry importuning young men. This was greeted with an uncomfortable silence, 'You must understand,' I said to my friend, 'it's not you who are under assault.' I had just returned from a debate . . .

IMAGE: REVELATION

[*Video of debate with Gerald Howarth MP, Duncan Campbell and Derek Jarman.*]
In which a film-maker I admired was told by a Tory MP that he was chemically imbalanced, disgusting, and that he was bent on purging this infection from the Nation. If this man had said this of the Irish or South African blacks he would have been declared mad.

IMAGE: HOLIDAY CAMP

[*News footage of Dachau*]
I remembered Hitler had a landslide victory in another democratic state fifty years ago. What, I thought, would have happened if the JEWS had armed themselves and along with the GYPSIES and HOMOSEXUALS had attempted to fight their way out of the impasse, wouldn't they now be seen as heroes? But then I thought cautiously,

we were a minority. It would be foolish to think that the mentality that fuelled Hitler's revolution had ceased in 1945, or was a particularly German phenomenon. Half of France collaborated, and the Germans had friends in high places here, 'Don't be silly, this is Britain, a democracy, it's the eighties, we've learnt from history.'

IMAGE: TIME PAST

[*News footage of the poppy ceremony at the Cenotaph*.] A democracy? Aren't we an oligarchy overtaken years ago by the other states of Europe, the way we are treated is theological, pre-scientific.

IMAGE: GRAVITY

[NEWTON *in bed with his* BOYFRIEND *eating an apple*.] It's as if Newton had been captured by the flat earthers. Newton's boyfriend ate the apple before it fell to earth, and took on all the sins of Eve.

IMAGE: VIGIL

[*News footage of the AIDS vigil*.] Fuck it, why should I accept all this idiocy, with my friends dying, and THEM saying smugly to themselves it's OK it hasn't touched THE FAMILY yet. Do you know where all of this might end? Full circle with pink triangles in concentration camps, certainly in their minds if not in reality, can't you see those BORN-AGAIN CHRISTIANS stoking the furnaces, singing hateful songs, like 'Onward Christian Soldiers', the inheritors of a genocidal religion, that ruthlessly exterminated whole populations in its lust for expansion. And I thought, how can I represent all this?

IMAGE: MARLOWE

[EDWARD *receiving a copy of Marlowe's* Edward II *in a brown paper envelope, under the counter in a small alternative bookstore*.]

194

In Marlowe's *Edward II* that repression rebounds to consume not only its victims but the repressors themselves, here we see how the good and honest can become tyrants, and the destruction of love ends in tyranny.

4. THE BOOKSTORE 5:45 PM

The small bookstore at the end of your street has continued to stock, unknown to you, the banned works of Wilde, Shakespeare and Marlowe, a massive police raid in progress, books are being shovelled into an armoured vehicle, by POLICE *wearing full protective clothing, masks and surgical gloves, a protesting* WOMAN ASSISTANT *is brutally knocked to the floor. The rest of the* STAFF *and* CUSTOMERS, *which includes* EDWARD, *are being strip searched by women police. There is mayhem, in the background, the garbled voice of Prime Minister Reaper on the radio, and on the police intercoms we hear quotations from the* Book of Revelation, *the scene is violent, fast and frightening, as the remainder of the shop is destroyed and the windows are stoved in.*

5. INCINERATOR

Close-up of the books burning in an incinerator, the yellowing, burning pages of Marlowe's Edward II.

6. LOVE

In the flames we see, EDWARD *and* JOHNNY *making love, with the sound of a police siren over it.*
VOICE OVER: Johnny and Edward, Edward and Johnny.

7. TO THE FIFTH QUARTER OF THE GLOBE

JOHNNY *stands at the stern of a boat watching the wake disappear into the distance.*
JOHNNY: [*Voice over*] Yesternight I set out, banished by

your father from the sad city to the fifth quarter of the globe. Here winter is the coldest, the salt sea marsh is wrapped in darkness, the ocean gnaws at the shingle without ceasing, wave follows wave like the fleeting years. Spring will be frosty this year, Summer bright with sunlight far distant. Tonight the heavens burn with innumerable stars, white as the bleached pebbles in the moonlight, I walk in the night throwing long shadows, cold giants walk beside me. Few look for home here. I have brought messages for you, for the two of us, whispered so that no-one can hear our secret, but before the messenger arrives listen to the song of the sea. At the far edge of the horizon, where the moon completes her cycles I was born, blue with cold in the roaring ice, spilling salt tears over the globe.

8. SEA SHORE

EDWARD *walks along the sea shore.*

EDWARD: [*Voice over*] Sick of heart I walk with my eyes pressed to the shingle, was there happiness after my father set fire to our house? Jet black smoke smothered the sun but I barely noticed, following the meandering flotsam coughed on the shore by the motionless sea. 'Think it over before asking me to return,' you said. As the fat September moon climbed out of a burning cornfield, warming itself on the stubble fire, I stood alone. Maybe it is better this way, I watched the little ship that carried you to exile, casting long shadows across the silver water. I laughed at that full yellow moon, but my laughter stuck in my gullet like a fish hook.

9. 7TH JULY 13:07 A FATHER'S DEATH IS ALWAYS TIMELY

EDWARD I *has a seizure as his* PAGE *puts on his armour at dawn, the old man staggers around his tent, naked except for his metal helmet, he crashes into the furniture, the* PAGE *stands frozen with fear.*

10. CORONATION

EDWARD *sits in his coronation robes as the* ARCHBISHOP
OF CANTERBURY *raises the crown and places it on his head,
he says to the* ARCHBISHOP:
EDWARD: I'm having him back.

11. THE EXILE'S RETURN

JOHNNY GAVESTON *reads a letter from* EDWARD, *in bed, in
the corner of his room three young soldiers are playing a
game of dice at a table.*
JOHNNY: 'My father is deceased, come, Johnny,
And share the kingdom with thy dearest friend.'
Ah words that make me surfeit with delight;
What greater bliss can hap to Gaveston
Than live and be a favourite of a king?
Sweet prince, I come; these, thy amorous lines
Might have enforced me to have swum from France.
And like Leander gasped upon the sand,
So thou wouldst smile and take me in thine arms.
The sight of London to my exiled eyes
Is as Elysium to a new-come soul;
Not that I love the city or the men
But that it harbours him I hold so dear,
The King, upon whose bosom let me die
And with the world be still at enmity.
What need the arctic people love starlight,
To whom the sun shines both by day and night?
Farewell base stooping to the lordly peers;
My knee shall bow to none but to the king.
As for the multitude that are but sparks,
Raked up in embers of their poverty,
Tanti; I'll fawn first on the wind,
That glanceth at my lips and flieth away.

12. 10 DOWNING STREET

A TECHNICIAN *with a large jar of Vaseline is smearing a
lens,* PRIME MINISTER REAPER, *surrounded by* MAKE-UP

ASSISTANTS, *is a symphony of blue, her dress her hair, her eye shadow, even her pearls are palest blue.*
MAKE-UP ASSISTANT: A little more blue under the eyes.
REAPER: There can never be enough
 [*She picks up the telephone*]
REAPER: Scotland Yard.
 [*She turns to* GENERAL GENOCIDE, *commander of her crack troops, the SAS (Straight And Sexist).*]
 I think we should bring Scotland Yard into this, Genocide. Charlie, I want a report on the stoning of adulterous wives, it's got to be cost effective. Charlie? It's about those adulterous wives.

13. NEW SCOTLAND YARD

CESSPIT CHARLIE *the blind chief of police relaxes with his bible in his large Victorian office.*
CESSPIT: There will be a huge saving on maintenance, it will be cost effective. We are going in on February 14th.

14. DOWNING STREET

REAPER: Valentine's day, great! I'll warn the Cabinet.
GENOCIDE: [*Whispers*] Remember Cecil.

15. MI5

Huge piles of envelopes, being wheeled in to a long line of classic looking CHAR LADIES *with kettles. They steam open the Valentine cards.* CESSPIT *stands amongst them, he picks up a card.*
CESSPIT CHARLIE: Body and soul are yours, Freddy. Who's this from?
INFORMER: Mrs Smith, Delhi Cottage, Bexhill.
CESSPIT: Good work, Doris! Nothing's anonymous these days.

16. SUBURBAN VILLA, GOOD NEIGHBOURS

MRS SMITH *is stoned to death by the local* TRADESPEOPLE

in her rose garden. As they throw the stones they scream, 'In the name of the Father, in the name of the Son, in the name of the Holy Ghost.' After she is dead the ambulance picks up the body and the corporation GARDENERS *re-plant the roses. The* NEIGHBOURS *applaud the* MILKMAN *who has been particularly vicious.*

17. LAMBETH PALACE

The ARCHBISHOP OF CANTERBURY *says his evening prayers.*
ARCHBISHOP OF CANTERBURY: 20,000 stonings, Thank you Father. Thank you for Leviticus 3:8.

18. HEAVEN

A great arc of rainbow light, GOD, *a bearded lady in an enormous scarlet ballgown, sits enthroned with a gilded crown of flowers.*
GOD: Fucking mess.

19. THE CHOIR OF CLEAN CHILDREN

Terrible serious earnest choir, of little children sing 'Onward Christian Soldiers.'

20. TROOPING OF THE COLOUR

News footage.

21. THE RAT TRAP

EDWARD, *in the zoo, watches a tiger pacing backwards and forth.*
EDWARD: Time is a rat trap, which we tread like prisoners, forwards and backwards like caged tigers, or a mouse on

an endless treadmill round and round we go. This world is but a defective imitation, beyond it no time or space. Even the starry firmament is an illusion peopled by phantom oppressors and despots. The planets are customs houses and jails with demonic guards holding souls who try to escape from the perpetually reforming chains of becoming.

Time is anguish, man is engulfed by it.

22. THE EXILE'S RETURN

A telephone conversation.
REAPER: I've heard that Johnny Gaveston's slipped back.
CESSPIT: The bugger left Boulogne at 12 to 9.
REAPER: THE CHUNNEL!!!!!
CESSPIT: Disembarked at Ashford, and raised his standard there.
REAPER: Alert the force, call up the Straight and Sexist, bring Genocide and Canterbury to Chequers.

23. THE FAMILY

A series of immaculate stills of the lead characters of The Family, *a soap, dissolve through each other, as the credits roll, the voice of an announcer in a mid-western German accent.*
ANNOUNCER: [*Voice over*]
 THE FAMILY
 STARRING
 BELLE KRATZENBURGER AS BETSY BATTEN-
 BERG
 ANDROS GRECO AS HER HUSBAND CONSTAN-
 TINE, DUKE OF GLASGOW
 LILA DICKENS, HER DAUGHTER, PRINCESS
 NEWMARKET
 VIVIAN CARTLAND, AND KNIGHT ROVER, AS
 THE DUKE AND DUCHESS OF CORNWALL

PETER FISK AND RENATA PERINA, AS THE
DUKE AND DUCHESS OF BRADFORD
AND PETE DEAN, AS THE DUKE OF STRATFORD

24. ON THE RANCH

Lush Western interior, everything in its proper place, BETSY
PLANTAGENET-BATTENBERG *is carefully stitching at her
embroidery frame, under the portrait of her brood mare
Hollywood, a couple of corgis asleep at her feet.* CONSTAN-
TINE, DUKE OF GLASGOW, *paces up and down the room
angrily.*

GLASGOW: [*Played by the same actor as Edward I*]
 Stratford's no son of mine.

BETSY BATTENBERG: Constantine!

GLASGOW: I didn't mean it that way ... Fucks up the
 Marines.

BETSY: I'm not listening to any more of that language, the
 Family has to set an example.

GLASGOW: More obstacle courses, sport, banishment.
 Bradford's fine, no jet-setting, just jetting. BUT NO
 ACTING.

BETSY: Oh darling! Do sit down or you'll wake the dogs.

25. WAITING

*Edward's flat, simple room almost unfurnished, bed on
floor,* EDWARD *sits at a trestle table, he's typing.*

EDWARD: [*Voice over*] Fate is relentless it calls to mind
 hardships and cruel wars, the death of heroes. Frequently
 have I had to moan alone my cares each morning, now no
 living man exists to open the secrets of my heart.
 [*His typing is interrupted by a knock at the door. He
 opens it,* JOHNNY *is standing outside smiling broadly.
 They throw their arms round each other,* EDWARD *stands
 back and looks him in the eyes.*]

JOHNNY: I got through.

EDWARD: Welcome home my friend
 Wants thou gold?

Go to my treasury –
Wouldst thou be loved and feared
Receive my seal
Save or condemn or in our name command
Whatso thy mind affects or fancy likes.

JOHNNY: It shall suffice me to enjoy your love
I'm sorry about your father.

EDWARD: Why? you're back.

26. TIME PASSES

Big Ben and the Houses of Parliament fill the screen.

EDWARD: [*Voice over*] The hours drag themselves through the winter afternoon, the moon is up before the setting sun, the slothful minutes lie suspended on the clockface, crawl snail-like to the dark, the fearful seconds hang to the tick of the clock. Empty time, as seven whole centuries pass between the chimes.

27. THE HOUSE OF LORDS

A handful of incontinent old PEERS *some asleep, one old peer wakes up with a start.*

PEER 1: What's the time?

PEER 2: Time past.

PEER 3: Time present M'Lords.

PEER 4: Time future.

PEER 1: M'Lords, I met TIME on the great parade, bent double with age, his weak eyes set on the tarmac, he said: 'Time stops for no man, not even Time himself, what will you do with your time?'

'I've hardly thought about it,' I said, 'I spend my time quite recklessly.'

[*Laughter*]

After a long pause he said: 'I had so little time,' and dropped down dead.

PEER 2: What do you deduce from that, my Lords?

PEER 1: Time's up.
[*Laughter*]

28. OTHER GARDENS

JOHNNY *and* EDWARD *walk in an idyllic garden, by a lake
by a temple, over a bridge across limpid water, reflections.*
JOHNNY: I've been married to the virus for one year now,
it's a dull little marriage of closed horizons, it's blinded my
wandering eyes, each night I hold my breath and sink into
abysmal sleep, I fall into dead waters, my lungs are
bursting, your voice is far away, dulled by the rushing in
my ears.

29. STREET SCENE THIS IS THE WAY IT IS

JOHNNY: [*Voice over*] Two boys kiss on a street corner.
We kiss on a street corner.
The crowd passes averting their eyes.
We are not part of their world, the rejection is complete.
They began it when our eyes first met
The virus completed it
The virus which reproduces like them
Not gay at all
Though they perceive it that way.

30. THE POPE OF ROME

POPE JOHN PAUL II *blows up a condom till it bursts.*
JOHNNY: [*Voice over*] The virus is stupid and ruthless
Arbitrary and unforgiving
A good Catholic
It hates condoms
It's the hidden majority
The silent consensus
The Pope
The Prime Minister

203

The family
THE ENEMIES OF OUR LIFE

31. THE MAD HATTER'S TEA PARTY

REAPER *takes sherry with* TORY LADIES, *everyone with a different blue hat, they are all drunk,* REAPER *leads a chorus.*
REAPER AND TORY LADIES:
 Bash Argies, lefties, queers and Sovs
 Bash niggers bash yer neighbours
 Bash Paki's miners all the crew
 Bash your own kids if you have to
[*They toast each other with sherry.*]

32. AND OTHERS HAVE DONE THIS BEFORE, COUNTER STRIKE

EDWARD *and* JOHNNY *in an empty basement, target practice*

33. OH BRITISH TELECOM

CESSPIT: We could do it the good old way, castrate them and hang, draw and quarter them. Or burn the faggots.
REAPER: Can we make public execution cost effective?
CESSPIT: All the money to Party funds?
REAPER: Yes.
CESSPIT: Bring in the Philly and set it to music.
REAPER: Perfect.
THE CHOIR OF CLEAN CHILDREN: There is a green hill far away without a city wall.

34. BEXHILL

A public sea-side burning, all candy floss and toffee apples. Lots of collection buckets with Band Aid stickers. The victim looks like QUENTIN CRISP.

35. FURTHER TELEPHONE CONVERSATIONS, THE AUTHORISED PERVERSION

ARCHBISHOP: Prime Minster?
REAPER: Archbishop, we need a new Authorised Version.
ARCHBISHOP: We've got along with the corrupt one for years.
REAPER: We need tougher measures.
ARCHBISHOP: Ha ha, belt them with the Bible.

36. NEARER MY GOD TO THEE: IN HEAVEN

OSCAR WILDE, WILLIAM SHAKESPEARE, KIT MARLOWE, *and* BYRON *in drag prepare to present a petition to* GOD.
BYRON: Where can we find poetry in all this?
MARLOWE: It's invisible, as the virus.
SHAKESPEARE: No Apocalyptic imagery there.
WILDE: No heroes to be memorialised in stone, no cross on the village green.
MARLOWE: No list of fallen, writ by some patient calligrapher.
SHAKESPEARE: No remembrance.
WILDE: Everything's stolen, nothing's in place.
They approach GOD *and go on their knees*
TOGETHER: Protect Edward and Johnny.

37. A BANQUET

In the great hall of Westminster, the KING *rises to his feet. An After Dinner Speech*
EDWARD: Shall I preserve order in our remaining time?
 Or let collapse complete our lives?
 Relax in the chaos,
 Purpose fueled by enthusiasm fled,
 These stormy times have knotted my life-line
 Becoming ghosts
 Lost in a labyrinth
 Bats in the belfy
 Swooping

And twittering in the twilight
Obsessive love.
Bury me in the concrete of your desire
Feed me, light fires, fill in the silence
Exhaustion
Immobile like a galleon in a bottle.

38. A WEDDING IN VOGUE, MASSACRE!

EDWARD *as a photographer prepares a machine gun under the traditional photographer's blanket, the* FAMILIES HARPER *and* TATLER, *line up for the family album,* EDWARD *guns them down mercilessly, they collapse so the bouquets become wreaths.*

39. THE BILL RISES, TELEPHONE CONVERSATION

REAPER: Revolution! Call out the household cavalry
[*News footage of* The Trooping of the Colour]

40. JUST THE TWO OF US

In an empty room, EDWARD *and* JOHNNY, *perfectly happy, it's as if nothing had ever happened, are they rehearsing for some other play, this conversation spoken antiphonally.* EDWARD *starts.*

The days rush past
Quick as the wind
that drums on the windows
And makes me jump in the night
The dawn is up before I am
The nights are sleepless
The shadow takes on reality
I'm almost used to it
I long for dawn
Listen to the chimes of the clock

Two, three, four
Then sleep till eight
And when the dawn comes
I thank it
And the view from our window
For being so utterly perfect
For the sky
With its iron-blue clouds
Weighing down on a tea coloured sea
For the burst of scarlet sun
Dying the dried grass a terrible pink
And the larks making a nuisance of themselves
I wish you good health
As I shave in the freezing bathroom
And hope you understand
Why I find it so difficult to say to you
You're looking great
Do I?
I forget the minutes it takes to dress
Time returns
As I scrape the condensation from the window
The lavender I've planted shivers in the wind
[*Together*] We make a vow
We will pick its flowers together next summer
We've also planted
Rosemary, holly, and three dog roses
And over one hundred hips we gathered in the hedges
So one day, this house of ours
Will be hedged with briars
Like the castle of the sleeping princess.

41. VOLUNTEERS

At Pontins, Camber Sands, holiday home, now part of the military complex, MEN, WOMEN *and* CHILDREN *in convicts' uniforms, with 'HIV condemned' printed in a scarlet logo, on parade.*

RSM: Volunteers, you, you, you, and you there.

42. CHRISTMAS!

REAPER's *Xmas message to the nation, all in blue sitting in front of a blue Union Jack, a large bunch of blue roses on the table, sipping a blue drink.*

REAPER: At Christmas it behoves us to think, be it ever so briefly, of the unfortunate. Those who have fallen by the wayside. Before we pass by, as pass by we must, on the other side of the highway, to get back to God's true purpose on Monday, cultivating the garden of England with our baskets of currency, planting our stocks and shares, ensuring the good life. But today, we remember the unfortunate as we count our blessings. We thank HIM for THE FAMILY, THE FAMILY OF NATIONS, for our BRITISH WAY OF LIFE, for THE COUNTRY, that coined, such a marvellous word COINED ... COINED FREEDOM.

[*The* CHOIR OF CLEAN CHILDREN *sing* 'Jerusalem']

43. THE BLUE ROSE

The PEASANTS *are planting the Home Counties with the new blue rose 'Margaret'. Vast acres of roses.*

44. BOUQUET

MARGARET REAPER *fills a vase with a blue flower arrangement.*

45. OH CINEMA

Military practice in a film studio.

A street has been built to train the army, the VOLUNTEERS *from the holiday camp are dressed in everyday clothes in a changing room by a* FILM CREW *in full protective clothing. They are released on the street like clay pigeons for target practice. General* GENOCIDE, *VC Falklands, Field Marshal*

of Britain, REAPER *in uniform, and a craven* MILITARY
OBSERVER FROM RUSSIA.

GENOCIDE: Gulags aren't part of the British way, don't fit
 into the tradition, what?

RUSSIAN: We all learnt from comrade Stalin's mistakes.

REAPER: This is the monetarist way, supply and demand.

GENOCIDE: A final and easy solution.

REAPER: In our best interests.

GENOCIDE: Capital! Capital!

RUSSIAN: Das Kapital?

REAPER: Yes, quite. Husbanding resources.

RUSSIAN: What's this husbanding?

GENOCIDE: Husbands, fathers, father Joe.

REAPER: I'm a great admirer of comrade Stalin. 50 million
 in ten years, that's the population of Great Britain.

GENOCIDE: This is more sporting, like fox hunting.

46. NAUSEA

EDWARD *sits writing on a sheet of paper in his prison cell.*

EDWARD: [*Voice over*] 'Take care of yourself', you said,
 how do I begin to do that? A headache circles, pushing
 towards the centre, echo of dying brain cells as it pushes
 itself forward, there is no sunlight to warm me, I'm falling
 out of life, it's not self-pity just nausea. They've built these
 walls and trampled all over our garden. I wait, in the
 vacuum between tea and sunset the Theban band appears.
 [*The walls of the cell dissolve,* JOHNNY *stands with the*
SPEAR CARRIERS, *he pulls* EDWARD *to him.*

JOHNNY: This narrow room was built for you by fear
 Fight back
 Step through the wall Edward
 Remember even though the laws were changed
 Nothing changed
 It was an illusion
 Your land was already stolen
 Your love, art, life, were never given an equal place
 All was grace and favour

EDWARD: [*Voice over*]
 You stand in golden ranks on the shingle outside my
 door.
 I say to you
 The time of fucking is over.
 It's scorched earth between here and Tonbridge Wells
 Burn everything
 And then return for further orders
 BE OFF, VANISH.

47. AUNTY GETS IT

A progressive shit chat, hosted by WOGAN, *tonight's guest is*
CESSPIT CHARLIE.

CESSPIT: As I saw them swimming around in a cesspit of
 their own making, the Lord Jesus spoke to me:
 'My chosen Charlie.'

48. CHARLIE'S DREAM COMES TRUE

EDWARD *paddling around desperately in a cesspit, trying to
save himself with a cross. The* CHOIR OF CLEAN CHILDREN
sing: 'There is a Green Hill Far Away.'

CHARLIE: [*Voice over*] 'CHARLIE', THE LORD SAID,
 'CHARLIE, YOU ARE MY INSTRUMENT, MY
 CHOSEN ONE, TO YOU I GIVE THE GIFT OF
 TONGUES, STAMP ON THE TOADS AND LIZ-
 ARDS AND THOSE WHO DENY ME, ALL
 CREEPING THINGS, THE HANDMAIDS OF THE
 EVIL ONE.' FOLKS, I HAD TURNED A BLIND
 EYE TO THE BEAUTY OF MY LORD JESUS, BUT 1
 OPENED MY HEART AND HE FLOODED IN. HE
 BROUGHT FIRE AND BRIMSTONE ON MY ENE-
 MIES, HALLELUJAH, SODOM AND GOMOR-
 RAH HALLELUJAH. HE TURNED LOT'S WIFE
 INTO A PILLAR OF SALT, AND I SERVED HER
 ON TABLES IN SOUTH KENSINGTON. HE
 BLASTED FIG TREES AND TRAMPLED DOWN

THE WALLS OF JERICHO, AND SENT SEVEN
PLAGUES ON EGYPT, SAYING: 'I AM THE LIV-
ING GOD, WHO BRINGS SUCCOUR TO THE
GENOCIDE, WHO BLESSES THE FLAGS, AND
BRINGS SOLACE TO THE SPECULATOR, HAL-
LELUJAH, I AM THE GOD OF THE OIL SLICK,
OF NUCLEAR FALLOUT, WHO BRINGS THE
ACID RAIN. AND POKES HOLES IN THE
OZONE. I AM THE GOD OF THE FATHERS,
AND THE FATHERS FATHERS FATHERS
FATHERS.'

[*As* CESSPIT *reaches a frothing crescendo there is a
sudden commotion,* EDWARD *and* JOHNNY *appear out of
the* AUDIENCE *with the* SPEAR CARRIERS, *carrying
machine guns. They gun* CESSPIT *down, blood and gore
at peak viewing time for the nation. In the commotion*
JOHNNY *is captured and* EDWARD *escapes.*]

EDWARD: [*Shouting*] WAKE UP BRITAIN, BEFORE
THEY SWITCH OFF THE LIFE-SUPPORT
MACHINE, OR ARE YOU ALREADY DEAD? DID
YOU EXPIRE IN '78? DID I HEAR YOUR DEATH
RATTLE AS THEY FEASTED ON CORPSES IN
DOWNING STREET, KILLING AND MAIMING
IN THE NAME OF SAINT FRANCIS FOR THE
RIGHT ANGLE ON THE NEWS?

49. THOSE WHO HAVE GONE BEFORE

GOD: One for us.

WILDE: They are turning the military bases into prison
camps.

SHAKESPEARE: My emerald isle.

BRYON: Oh to be in England, now that April's here.

MARLOWE: For whoever wakes in England sees some
morning . . .

WILDE: They've grubbed up the hedgrows. April is by far
the cruellest month.

GOD: Should I abdicate?

WILDE: What do you make of that, Will?
SHAKESPEARE: To be!
 To be!
 That's the answer, Ma'am.

50. THE WORST ARE FULL OF PASSIONATE INTENSITY

In the great hall of Westminster, Cesspit Charlie lies in state under the all blue Union Jack.

ANNOUNCER: [*Voice over*] ... And now deep in the night the People of Britain file past the Catafalque with its blue roses. Cesspit Charlie, Chief Constable of Britain, lies in state in this beautiful historic hall, resting place of so many Kings and Queens ...
 [*A drum roll ushers in the* CHOIR OF CLEAN CHILDREN *singing 'Nearer My God to Thee.'*
 The MOURNERS *file past, they are chained to each other like convicts,* GUARDS *stand in the shadows with machine guns.*]

51. FUNERAL ORATION

Set up like the Last Supper, with REAPER *as centre and the twelve* CABINET MINISTERS *all wearing dark glasses. Sequence cut with the* CHOIR OF CLEAN CHILDREN *who change their tune.*

THE CHOIR OF CLEAN CHILDREN: THE BELLS OF
 HELL GO TING A LING
 FOR YOU BUT NOT FOR ME
 OH DEATH WHERE IS THY STING A LING A
 LING?
 OH GRAVE THY MYSTERY
REAPER: Are you with us?
 Or against us?
 For the enemy's within
 And the enemy's without
 My cabinet and I will search and destroy the enemy

Even to the fifth quarter of the globe
Are you with us?
Or against us?
[*On the screen appear the words, 'With us? Or against us?'*]

52. THE HEARTH

In an ideal home, the IDEAL MOTHER *and the* IDEAL FATHER *and their ideal 2.2* CHILDREN *sit watching the ideal TV attentively, a big-close up of* REAPER *fills the screen.*

REAPER: You the citizens of this country, in the privacy of your own homes, have charged me with a duty to preserve the security of the land and as a family man I tell you I will protect my children from the kind of deviation they represent, revolting, chemically imbalanced, no part of the Almighty's plan, for this the Chief Constable of Britain has been assassinated.

53. TORTURE

GENERAL GENOCIDE *oversees the torture of* JOHNNY *on a medieval rack*

GENOCIDE: We'll break every last bone in your body, mate, unless you tell us where your accomplices are.
 [JOHNNY *remains silent.*]
 It's nature's law, the survival of the fittest, the survival of the race, lets put the GREAT back in BRITAIN.

JOHNNY: [*under his breath*] I love him, I love him, I love him.

CHOIR OF CLEAN CHILDREN: Oh love divine all loves excelling.

JOHNNY: In The First Light of Dawn
 [JOHNNY *alone with his broken legs lies in a cell*]

JOHNNY: [*Shouting*]
 Eternity eternity
 Where will I spend eternity?
 Heaven or Hell

Which shall it be?
Where will I spent eternity?

54. AS WHITE AS SNOW

In an empty yard JOHNNY *is shot by a firing squad.*

55. AND WHY DO WE RUN?

Interior of the sewers, EDWARD *is on the run,* ARMED
POLICE *with intercoms track him down. The sequence with
ominous music and the sound of gunfire is cut with lyrical
sequences. Flashbacks to moments of pure happiness with
Johnny:*
Swimming.
Sailing in a small yacht.
A crazy pillow fight.
Sleeping in each other's arms.
EDWARD: [*Voice over*] Hadrian wept as he lifted Antinous
 from the waters, he embraced the drowned boy, calling on
 the god:
 Osiris!
 Give back the boy of my heart
 Give back the boy of my waking dream
 Turn back the sun in the heavens
 Turn back
 Turn back
 Give me the sunlit days in the garden
 My love flies like a swallow
 My love runs like a deer
 My love leaps like a fish in the water
 His eyes dark as the cedars
 His lips scarlet as roses

56. WHEN THE TEMPLES NO LONGER SERVE THEIR PURPOSE THEY SHALL BE RAZED

EDWARD *facing his* TROOPS.
EDWARD: In the old world no one categorised love on the
 basis of gender. There was no distinction. Emperors

214

married the men they loved and built temples to them, as my father built crosses to my mother Eleanor throughout the land, Hadrian built temples to Antinous where his people worshipped.

[*Montage of the great monuments on fire, Salisbury cathedral dynamited.*]

So many FEEL with me but do not show their feelings.

ANTIPHONAL CHOIRS:	THE SPEAR CARRIERS:
Who is the enemy of our love?	Christ Jesus
Who is the enemy of our life?	Christ Jesus
Who is our torturer?	Christ Jesus
Who murders us?	Christ Jesus

57. I ANSWER SOME OF YOUR QUESTIONS

Q) Who are those who man the walls of the ghetto?

A) They are the institutions.

Q) Who are they?

A) They are the Church and Parliament, the Doctors and Broadcasters.

Q) Who are our enemies?

A) Those who are full of fear.

Q) Name the fearful?

A) The fearful are countless.

[*A list of names of British homophobes comes up on the screen*]

Q) What shall we do?

A) Burn them out of the history books, burn their values.

Q) Who are you?

A) I am THE TRADITION.

Q) Who goes with you?

A) Those of good heart.

Q) What do you say to the fearful?

A) I say Damn you, for stealing love,
 Damn you, for corrupting affection,
 Damn you, for giving us self-hatred
 Damn you, for the numbness
 Damn you, for murdering Johnny

For falsifying our history
Damn the fathers
Who steal the minds of their daughters
Who steal the sex of their sons
Who steal the minds of their sons
Who steal the sex of their daughters

And On And On And On And On

58. THE FAMILY

THE DUKE OF GLASGOW: There's slander in the land, you
 can't miss it.
BETSY: Sit down, Constantine.
THE DUKE OF GLASGOW: They are attacking you, Ma'am,
 taking the Family in vain.
BETSY: So what's new, even soaps run out.
THE DUKE OF GLASGOW: Do something, Betsy.
BETSY: Set the corgis on them? Let the sods get on with it.
THE DUKE OF GLASGOW: Your oath Betsy! Your oath!
 Defender of our faith.
BETSY: Faith? Fuck it!
 [*She exits*]

59. THE BONFIRE OF VANITIES

Around which the SPEAR CARRIERS *gather and throw their
earthly belongings, taking this oath, they shave their heads.*
CHORALE: We the perfect ones,
 Renounce possession,
 Releasing our spirits,
 Trapped in matter,
 Profiting from our loss,
 We free friendship from its chains,
 Each singly and together,
 We take the vow,
 To love each other,

In infinite becoming,
Now and forever,
Amen.

60. A REVISION OF LOVE

Two SPEAR CARRIERS *make love.*

CAPTION: One day this black space will be replaced by two
 young men making love, this love is not simulated, it is a
 passionate depiction of the sexual act, nothing hidden.
 [*Blank, Black Leader.*]

ROLLER CAPTION: It is necessary to reveal
 Our innermost secrets
 To dispel fear
 This is the task of all creative spirits
 In this black void
 Two young men of the band of spear carriers
 Make passionate love
 We see the sexual act
 Nothing here is left to imagination
 Everything is revealed
 For a society that cannot face the reality of love
 I have plunged this screen into pornographic darkness

61. REST IN PEACE

EDWARD *sleeps peacefully in the dawn before the Battle for
Britain. (This poem is by Peter Abelard.)*

VOICE OVER: More than a brother to me Johnny
 One in soul with me
 How could I take evil advice
 And not stand by your side in the battle
 How gladly would I die
 And be buried with you
 Since love may do nothing greater than this
 And since to live after you
 Is to die forever
 Half a soul
 Is not enough for life

62. THE BATTLE FOR BRITAIN

*Graphic sequences of street warfare in which Margaret
Reaper's crack troops, the* STRAIGHT AND SEXIST, *are
taken on by* EDWARD *and the* SPEAR CARRIERS.
*Cars burn.
Buildings burn.
A great conflagration.
At any moment it seems either side might win.*

63. COLD TURKEY AND BOMBE SURPRISE

Yet again the BATTENBERGERS *celebrate your family
Christmas,* BETSY *sits at the head of the table.*
THE DUKE OF GLASGOW: Cold turkey?!!
BETSY: We're pulling our belts in
CORNWALL: Pass.
 [CONSTANTINE *glowers at him*]
THE DUKE OF GLASGOW: Nut cutlet.
 [BRADFORD *takes a huge helping*]
BRADFORD: Winner takes all.
BETSY: Pudding.
DUKE OF GLASGOW: Hang on, What's the hurry?
BRADFORD: Bags the Maundy.
 [*Eyeing up the pudding*]
BETSY: You light it.
 [*The* DUCHESS OF BRADFORD, *drunk as a duke, pulls a
 hip flask from her cleavage.*]
BRADFORD: Bags I.
 [*The* DUKE OF GLASGOW *leans over with a leer and grabs
 the hip flask.*]
THE DUKE OF GLASGOW: Droit de seigneur.
 [GLASGOW *takes a huge swig of the alcohol and using the
 silver candelabra, turns himself into a flamethrower,
 lighting the pudding, the holly fizzes like a 'classic' bomb.*
 GLASGOW *grabs the* DUCHESS OF BRADFORD.]
Old flames.

[*The Family collapse with laughter* THERE IS A HUGE EXPLOSION]
BETSY: LONG LIVE THE REVOLUTION.

64. DYING SUDS

A slow-motion explosion in which bits of the family turn gracefully in the flames and smoke. The Imperial State crown floats through it.

The CHOIR OF CLEAN CHILDREN *sing* a capella, '*God Save The Queen.*'

65. SEVEN O'CLOCK NEWS

NEWSCASTER: Channel Four News tonight is brought to you on behalf of the Conservative Party. Would you like 'The Family' to end here, or would you like a different ending? The referendum forms have a straight yes or no, present your form with your poll tax number at any post office.

REAPER: Britain's working.

66. LOVE'S LAST STAND

Deep in the underground, beneath Piccadilly, EDWARD *is surrounded by the* STRAIGHT AND SEXIST, *gunfire and smoke.*

NEWSCASTER: [*Voice over*] As dawns's bright fingers gild the city towers and zones of enterprise
Edward, our hero, makes his final stand deep underground in Piccadilly
Above him, Eros barricaded, fires his arrows blindly
Scoring a bullseye on the Coca-Cola ad.
Symbol of the better life, that came and went with 60's
Harold and his winds of change
Those far-off days are gone, quite gone,
Now Reaper tills the fields of Blighty,
Blessed by the Lord Almighty,
She cuts the national cake
Misquoting, Francis Augustine and Paul,

Those times, she said were out of joint,
And killed a mouse to prove the point
The fires she unleash'd ran quickly through the nation
Turning old city streets to rubble
Edward puts up a last defence
Deserted by all
He falls at dawn among the first commuters from the
jammy South
Another victim of the market forces
Now all is peaceful in the blessed isle
The choirs sing ''allellujah''.
MONEY MAKETH MAN
Is writ in gold across the union flag
A day of national unity declared
The bells ring out
Reaper leads the nation's thanks
Another victory won
Crécy, Armada, Waterloo, Dunkirk,
Add Piccadilly to the roll
Here love went down
The nation lost its soul.

67. BERKELEY CASTLE

EDWARD: These looks of thine can harbour nought
but death.
 I see my tragedy written in thy brows;
 Yet stay awhile, forbear thy bloody hand
 And let me see the stroke before it comes
 That even then when I shall lose my life
 My mind may be more steadfast on my God.
EXECUTIONER: What means your highness to mistrust me
thus?
EDWARD: What means thou to dissemble with me thus?
EXECUTIONER: These hands were never stained with inno-
cent blood
Nor shall they now be tainted with a king's.
EDWARD: Forgive my thought for having such a thought;

One jewel have I left, receive thou this.
Still fear I, and I know not what's the cause,
But every joint shakes as I give it thee.
Oh if thou harbourest murther in thy heart,
Let this gift change thy mind and save thy soul;
Know that I am a king; oh, at that name
I feel a hell of grief; where is my crown?
Gone, gone! and do I remain alive?

EXECUTIONER: You're overwatched, my lord, lie down
and rest.

EDWARD: But for the grief keeps me waking, I should sleep,
For not these ten days have these eyes'-lids closed;
Now as I speak they fall, and yet with fear
Open again; Oh wherefore sit'st thou here?

EXECUTIONER: If you mistrust me, I'll be gone, my lord.

EDWARD: No, no, for if thou meanest to murther me,
Thou wilt return again, and therefore stay.

EXECUTIONER: [Aside]
He sleeps.

EDWARD: Oh let me not die; yet stay, oh stay awhile.

EXECUTIONER: How now, my lord?

EDWARD: Something still buzzeth in mine ears,
And tells me if I sleep I never wake;
This fear is that which makes me tremble thus
And therefore tell me, wherefore art thou come?

EXECUTIONER: To rid thee of thy life; Matrevis, come.

EDWARD: I am too weak and feeble to resist;
Assist me, sweet God and receive my soul.

EXECUTIONER: Run for the table.

EDWARD: Oh spare, me or dispatch me in a trice.

EXECUTIONER: So, lay the table down, and stamp on it,
But not too hard, lest that you bruise his body.

68. THE JUNTA

Cabinet room 10 Downing Street, REAPER, *the* CHIEFS OF
STAFF, ARCHBISHOP, *and* GENERAL GENOCIDE.

REAPER: Now all mine enemies are dispatched.

ARCHBISHOP: The ship of state lies fair upon the waters.

GENOCIDE: The hour is come.

CHIEFS OF STAFF: To that we say 'hear hear'.

REAPER: Bring me the golden crown without the Tower.
 I mean to crown myself within the hour.

ARCHBISHOP: God and the FAMILY willing.

REAPER: The Family are dispatched, the soap's run out.
 The Theban band are routed.
 I've shoved a poker up that faggot's arse.

GENOCIDE: Here is the crown.

REAPER: This day another dynasty is born,
 I name myself Margaret the First of England Queen,
 Dictator and Defender of the Faith.

69. WESTMINSTER ABBEY

The STATE TRUMPETERS *blow a fanfare, the* CHOIR OF
CLEAN CHILDREN *sing*.

THE CHOIR OF CLEAN CHILDREN: Vivat Vivat
 Regina Margareta

REAPER: Your duty Archbishop.

ARCHBISHOP: In the name of the family, the pound
sterling, and the armed forces.

REAPER: I, Margaret the First, inaugurate a millennium of
good housekeeping.

70. A PURGATORY IN BORROWED TIME

[*Here* EDWARD *greets* JOHNNY *in the afterlife*]

EDWARD: We lived in borrowed time, therefore I saw no
reason in the world why our hearts grew not dark.

JOHNNY: Time was scattered, the past and the future, the
future, past and present, our lives erased by the great
dictator.

EDWARD: The screech of her pen across the page, your
name.

JOHNNY: Our names.

EDWARD: Now throughout the world stand wind-blown
halls, frost-covered buildings, the wine halls crumble.

IMAGE: A GREAT VORTEX OF SNOW

The kings lie dead, deprived of pleasure, all the steadfast band dead by the wall.

IMAGE: A MASS OPEN GRAVE IN THE SNOW

How can this fragile candle banish the shadows, how can we raise a light in the inky black and send our enemies flying?

TOGETHER: Who will hear these words?
 I love you with all my heart.

71. THE GOOD GOD

SHAKESPEARE, BYRON, MARLOWE, *etc. glower into the lens of a camera obscura, with various views of the earth.*

GOD: What's up, Sir Isaac?

NEWTON: It's the tenth year of the thousand years of Good Housekeeping, the jails are overflowing, everything is bought and sold, she's privatised your church, it's bought by Saatchi and Saatchi.

GOD: [*Shrugs her shoulders*] What else?

NEWTON: The new year celebrations fill the filthy tabloids.

GOD: My millennium!

NEWTON: Fireworks, public executions, she's burning Betsy Battenberg in Liverpool, on a pile of your Sonnets. Will. You're on The Index, Oscar, under 'P' for Pansy.

WILDE: Why don't you stage a second coming, darling?

GOD: With the Theban band? Shall I raise Edward from the dead?

MARLOWE: Why not? And Johnny too.

BYRON: And put the house in order for a second time

72. NEW YEAR'S EVE – 31 DECEMBER 1999

Funeral pyre of Betsy Battenberg, Liverpool.
Suddenly in a bolt of lightning, GOD *materialises, seizing* BETSY *in her arms, a* CHOIR OF BLACK ANGELS *appear, singing gospel rock.*

THE GOOD ANGELS: Do not despair ma'am
 Your good God comes
 To rescue you ma'am
 From these no good bums
 She's a lady your Christ
 She's fair and black
 She's no soap you dope
 She can dish out the flak
 Christ is coming
 Christ is coming
 Christ is coming
 Back

[*Cut to news footage of the Coronation of Elizabeth II.*]
Meanwhile . . .

Two ANGELS *seize* REAPER *along with the* ARCHBISHOP *and* GENERAL GENOCIDE, *they are thrown into the bottomless pit, falling in a flaming vortex through their own past, a video nasty of the Falklands, the miner's strike and Toxteth.*]

73. THE JAWS OF HELL

Close-up of MARGARET REAPER *pronged by a golden trident, she is mashed in the mouth of hell, horrible mush of masticated blue blood runs down the screen.*

74. VISIONS

SPEAR CARRIERS *smash crucifixes.*
JOHNNY *kisses* EDWARD.
GOD *blesses them.*
The CHOIR OF CLEAN CHILDREN *strip off in a frenzy.*

75. THE GREAT DRAG BALL IN HEAVEN

LUCHINO VISCONTI *films the great drag ball in Heaven.*
WILLIAM SHAKESPEARE *in the arms of* PLATO.
SHAKESPEARE *kisses* PLATO, *All's Well That Ends Well.*

The whole vision dissolves, in the dissolve god shouts
GOD: Wake up, wake up Edward, wake up Johnny.

76. SQUAT

EDWARD *and* JOHNNY *in bed, wake up.*
JOHNNY: I'll make the tea.
 [EDWARD *relaxes in the pillows*]
EDWARD: [*Voice over*]
 [JOHNNY *makes the tea*]
 This morning, etched bright with sunlight, precise as the shadows cast by my life, I emptied my pockets of time, the eternal that neither endures or passes, lay in my hand, world without beginning or end, always and now.
 [JOHNNY *brings in a cup of tea. They kiss.*]